MAN MADE

MEN AND MASCULINITY
Michael Kimmel, Editor

MAN MADE

Thomas Eakins and the Construction of Gilded Age Manhood

MARTIN A. BERGER

UNIVERSITY OF CALIFORNIA PRESS
BERKELEY LOS ANGELES LONDON

University of California Press
Berkeley and Los Angeles, California

University of California Press, Ltd.
London, England

© 2000 by the Regents of the University of California

Library of Congress Cataloging-in-Publication Data

Berger, Martin A.
 Man made : Thomas Eakins and the construction of Gilded
Age manhood / Martin A. Berger.
 p. cm. — (Men and masculinity ; 6)
 Includes bibliographical references and index.
 ISBN 0-520-22208-3 (cloth : alk. paper)—
 ISBN 0-520-22209-1 (pbk. : alk. paper)
 1. Eakins, Thomas, 1844–1916—Criticism and interpretation.
 2. Masculinity in art. 3. Gender identity in art. 4. Art and
society—United States—History—19th century. I. Eakins,
Thomas, 1844–1916. II. Title. III. Men and masculinity
(Berkeley, Calif.) ; 6.
 ND237.E15 B47 2000
 709'.2—dc21 00-022764
 CIP

Manufactured in the United States of America

09 08 07 06 05 04 03 02 01 00

10 9 8 7 6 5 4 3 2 1

For the Bergers and the Mayers

Contents

Illustrations

Plates *(following page 104)*

Figures

Acknowledgments

I have long been intrigued by authors who begin acknowledgments with thanks to institutional sponsors. Given the energy I expend in the chapters that follow, arguing, in part, that agency is never fully circumscribed by the structures of one's society, I am going to begin by thanking people.

To Seth Garfield, Jill Gordon, Karl Kusserow, and Vicky Gwiasda, I give thanks for their consistent emotional and intellectual support. Without their friendship, my life—never mind this book—would remain incomplete. I thank Seth, additionally, for sustaining me during my year in North Carolina and for being a junior professor with me; and I acknowledge Jill both for her willingness to listen and for her ever thoughtful advice; I recognize Karl for his selfless support, aware that no one is happier for me when I succeed. And I admire Vicky for being the one person I know who is actively practicing what most of us just teach.

I cheerfully confess my great debt to David M. Lubin, my teacher and friend. Without his unbounded inspiration, counsel, and humor, the academy would be a very different place.

This book had its genesis in a dissertation guided by Jean-Christophe Agnew and Bryan J. Wolf that was directed by Jules D. Prown. All three contributed immensely to my growth as a scholar, through their inspired teaching, rigorous and attentive readings, and personal warmth. Without their contributions this project would be incalculably poorer.

For careful readings of various chapters I am indebted to Brian Allen, Charles Bassett, James Boyles, Chris Castiglia, Jill Gordon, Jürgen Heinrichs, Helen Hills, Marni Kessler, Karl Kusserow, Mark Marshall, Nancy Marshall, Richard Moss, Chris Reed, Stephen Rice, Cristina Ruotolo,

Dan Sherman, Chris Sterba, and Trysh Travis. To Chris Castiglia and Chris Reed I am particularly grateful, for no matter how busy they were with their own work, they invariably made time to produce sensitive and intelligent critiques of my endless drafts. For responses to talks that eventually made their way into this book, I thank Bill Andrews, David Barquist, Sarah Cash, Nicolai Cikovsky Jr., Thom Collins, Katie Drowne, Kenneth Haltman, Michael Harris, Trudier Harris, Chris Huber, Laura Katzman, Karen Lucic, Julie McGee, Richard Meyer, Angela Miller, Kenneth Myers, Roger Stein, David Steinberg, Bill Stern, Jonathan Weinberg, and Janet Wolff. For help in tracking down images and in photographing archival materials, I am indebted to Pamela Bannos, Cathy Gudis, Chris Kahler, Roman Stansberry, and Beth Zoph.

Several scholars shared with me their writings and research on Eakins and masculinity prior to publication. I thank Julie Berkowitz, Doreen Bolger, Sarah Cash, Whitney Davis, Kathy Foster, Douglass Paschall, and Rebecca Zurier for allowing me to read their work. Of this group of generous scholars, I am particularly indebted to Kathy Foster, who was always quick to provide detailed and accurate answers to all my Eakins-related questions.

While neither Michael Fried nor Elizabeth Johns was directly involved in this project, I owe each of them a substantial intellectual debt. Their distinctive (some might say antithetical) books on Eakins established many of the paradigms I engage. Without their works, my project would be inconceivable.

I gratefully acknowledge the encouragement of my series editor, Michael Kimmel, as well as that of my sponsoring editor, Naomi Schneider. The press's fine arts editor Stephanie Fay deserves thanks for her meticulous editing and helpful responses to my numerous questions. To Susan Ecklund I am indebted for her careful and sensitive editing of the book. The press's various readers offered thorough and intelligent evaluations, which have greatly improved the manuscript. I am especially grateful to two readers, Angela Miller and Alex Nemerov, for providing me with sustained and engaged critiques that forced me to rethink many aspects of my argument.

The color plates in this book were made possible through the generosity of Dean Kerry Grant, who provided me with a subvention from the Dean's Research Fund, College of Arts and Sciences at the State Uni-

versity of New York at Buffalo. Costs incurred in acquiring black-and-white illustrations and paying fees to reproduce them were reimbursed by the Julian Park Publication Fund, also of SUNY. Finally, I wish to acknowledge the very generous support of the Social Sciences and Humanities Research Council of Canada.

Method

Man Made examines the art and life of the nineteenth-century American painter Thomas Eakins (1844–1916), though it is neither a biography nor a standard art historical study. In exploring the role of Eakins's art in fashioning manhood for both the painter and his white, middle-class contemporaries, *Man Made* produces a cultural art history.

Rather than imagining Eakins's canvases as rarefied, high-art objects— divorced from the concerns of Gilded Age society—I understand them as participants in a cultural *discourse* of masculinity. I invoke the term "discourse," borrowed from the work of Michel Foucault, as an organizing set of beliefs and social practices that build, modify, and naturalize cultural constructs such as gender.[1] It is within this framework that Eakins's paintings take part in the construction of masculinity, by serving as both a material expression of, *and* site for, gendering beliefs and practices. Bound into a web of social relations, the paintings do not merely reflect cultural concerns, but are engaged in both legitimating and forming conceptions of Victorian manhood.

The discourses of gender in Eakins's paintings are contingent not only on the canvases' narratives but also on their manner of production, display, reception, and circulation, as well as on various institutional forces that delimit and prescribe potential meanings.[2] Because discourses constitute a *process* of cultural formation, I take them to embody the agency of both artists and audiences as well as the constraints imposed by language and other social structures. Thus the analysis of discourse allows for the consideration of how a painting's gendered constructions are formed by the interplay of—or, more precisely, the friction between—a community's structures and its people. Manhood certainly determines the

identity of individuals, even as people work in often conflicting ways to shape manhood. More than simply tracing the shifting masculine associations of Eakins's canvases, I suggest how the painter and his contemporaries used the works to refashion their conceptions of masculine identity. Given masculinity's malleability and its conspicuous role in inducting men into American culture, I postulate that many of the canvases were embraced for their metaphorical potential to regulate, moderate, or improve men's masculine standings.

While discourse theory supplies my method, and art (in conjunction with documentary sources) offers my evidence, manhood contributes the frame for my study. Such a frame is relevant for two interrelated reasons: first, that during an era in which manhood was of enormous social concern, Eakins was singular in his obsession with being manly; and second, that throughout American history masculinity has represented *the* normative category of gender. Because American cultural products have long been created and consumed from an implicitly masculine perspective—even as that viewpoint is infrequently analyzed for the unspoken ways in which it determines social norms—masculinity needs to be understood as one of our most significant cultural paradigms. By making visible the heterogeneous discourses by which manhood is forged, my study breaks down unitary notions of masculinity, casting it, not as the norm against which other gendered positions are measured, but rather as one in a range of social constructions.

In speculating on the period discourses of the canvases, I do not imagine that *Man Made* unproblematically recovers the past through art, for my method is tempered by post-1960s scholarship that calls into question our ability to recuperate the past. Aware that interpretation produces historical facts, that patterns of history are fashioned rather than discerned, that language, far from offering a transparent medium of communication, actually structures understanding, and that no *coherent* past awaits retrieval, I acknowledge that my study itself constructs history. A past that never existed in any discernible sense is created over time through the historical narratives we promote; the writing of history begins the process of creating history. For precisely that reason, I have written *Man Made as if* history were possible—guarding against exclusively presentist approaches while trying to expand the nature of historical evidence—aware that the narratives presented here are part of the process of historical formation. The "Thomas Eakins" of this study is consequently less a reclamation of

the individual who lived in nineteenth-century Philadelphia than a portrayal of an ongoing historical construction. During the late nineteenth century and the early twentieth, Eakins's paintings helped the artist and his contemporaries grapple, not with their "true selves," but rather with perceptions of themselves—with the personal and social constructions that gave them identity. To acknowledge such a fluid model of identity, however, is not tantamount to accepting meaning as the imaginative free-for-all that critics of poststructuralism have frequently decried. While *Man Made* posits "identity" and "history" as supple constructs, their meanings are ultimately circumscribed through their relation to specific canvases in particular economic and cultural contexts. Rejecting fixed meaning is decidedly not the same as giving up on meaning altogether.

The numbered chapters of my text focus on Eakins's images of men characterized by physical activity, mental engagement, and nudity. Chapters 1 and 2 examine Eakins's canvases of athletes and intellectuals from the 1870s, exploring the participation of the works in the cultural discourse of manhood. Arguing that Eakins failed to achieve a number of the era's principal markers of manhood, I explain the paintings in these chapters both as ideological sites expressing impersonal structural forces and as individual metaphorical strategies for the formation of masculine identity. While these early canvases picture two distinct approaches to enhancing Eakins's position, they do so largely through their acceptance and promotion of the dominant terms by which men in the 1870s were judged manly.

Chapter 1 focuses on physically active men, represented by *The Champion, Single Sculls (Max Schmitt in a Single Scull)* (1871; see Plate 1), various images of the Biglin brothers sculling (1872–74; see Plate 2, Fig. 7, and Fig. 16), and *Rail Shooting (Will Schuster and Blackman Going Shooting for Rail)* (1876; see Plate 3). On the simplest level, Eakins's athletic canvases offered symbolic reassurance by linking the artist to a series of unimpeachably masculine characters and professions. Accepting the ideal of the self-made man as *the* model for manhood, the canvases work to associate Eakins with a handful of men widely understood by period audiences to epitomize that ideal. As the chapter demonstrates, the manliness of Eakins's athletes was a function not simply of their participation in sports, but also of their success, modernity, and "whiteness." Besides offering narrative

reassurance, the paintings augmented the masculine position of the artist—and his male viewers—by establishing a dialectical relationship between the canvases' protagonists and their audiences. Given the impossibility that any single person could possess all the characteristics deemed essential for proper manhood, athletes and viewers came to reconcile each other's masculine standing through a sharing of attributes that the other lacked.

Chapter 2 concentrates on men who are mentally engaged, examining *William Rush Carving His Allegorical Figure of the Schuylkill River* (1877; see Plate 4), *Professor Benjamin Howard Rand* (1874; see Plate 5), and *The Chess Players* (1876; see Plate 6). If the dominant strategy employed in Eakins's early athletic canvases is to pair the artist with conspicuously masculine elements of Gilded Age culture, then the primary tactic of his portraits of intellectual men is to complicate the identity of their sitters. Through the use of pictorial "doubles," Eakins depicts a series of prominent men with both "masculine" and "feminine" traits, thereby suggesting the normalcy of his own ambivalent status. Because he carefully selects men who underwent significant personal or professional development over the course of their careers, his canvases reject fixed models of manhood, thus downplaying the artist's failings by suggesting that masculinity is best understood as a developmental process. Given that many of the athletic and scientific themes of Eakins's paintings were borrowed from popular culture, these works, in their high-art venues, ultimately fostered discourses that helped masculinize not only Eakins, but also his art.

Chapter 3 considers Eakins's depictions of the nude from the 1880s until the turn of the century, examining *The Crucifixion* (1880; see Fig. 33), *Swimming (The Swimming Hole)* (1885; see Plate 7), and *Salutat* (1898; see Plate 8). Notwithstanding the ways in which nudes might suggest to audiences a biological basis for gender, Eakins carefully linked the narratives of his paintings to particular sites and then exhibited the works at specific venues that compelled Gilded Age audiences to confront the socially constructed nature of gender. In embracing a social constructivist model of identity formation, these canvases distanced themselves from the narrative of the self-made man. Realizing the futility of defining masculinity on that basis, Eakins allowed his late nudes to address the structural forces—downplayed in his paintings from the 1870s—that made it impossible to achieve the contradictory attributes of manhood. Eakins's paintings, rather than picture such constraining social structures, appro-

priated them as models for fashioning identity in the artist's own community. Once he appreciated how he had been made by forces in larger Philadelphia society, Eakins was able to retreat to a community of students, family, and friends. While this constructed community could surely not divorce itself from the larger American society, it could foster a private culture in which Eakins's masculine position was understood in a more favorable light.

Eakins's paintings demonstrate identity as conflicted: Victorians, constrained by complex codes that prescribed norms of masculine identity, were also empowered by the malleability of those very codes. Because the complex and contradictory dictates of masculinity made it impossible to attain a perfect manhood, men refashioned their masculine positions in the broad framework demarcated by period norms, crafting identities that helped them meet the symbolic requirements of their local social groups. Ultimately, in picturing identity as a developmental process, Eakins's canvases suggest how creative and interpretive activities are subtle forms of social agency and personal control.

Chapter 1

Manly Associations

Rejecting the oriental and mythological subjects of his French mentor Jean-Léon Gérôme, Eakins began his career painting the familiar people and activities of his boyhood home. Eakins's canvases of the early 1870s capture family and friends in the parlors, in the fields and marshes, and on the rivers of his native Philadelphia. Fully half the paintings of this period portray athletic scenes of hunting, sailing, baseball, and rowing, all sports that were much on Eakins's mind even as he studied in France, for, as Earl Shinn tells us, the artist spoke of little else when he arrived in Gérôme's atelier.[1] Given Eakins's affinity for athletics, and his entire family's involvement in them, it hardly seems surprising that sports presented him with some of his most often recurring themes. What is unusual, however, is the sexual bifurcation of the painter's images. Although all the Eakinses participated in sports, not one of his athletic scenes portrays women.[2]

Scholars have noted that while the males in Eakins's early art are often shown outdoors, playing sports or hunting, the artist's female figures are almost always shown inside, reading, playing a musical instrument, or engaged with animals or children. Eakins's early paintings appear to substantiate the claims of twentieth-century historians that males and females occupied separate spheres in late-nineteenth-century American society; but they do this only because they offer a highly selective view of Eakins's family members and their circle.[3] The canvases may conform to various twentieth-century notions of the division of roles in nineteenth-century culture, but they did not in fact correspond to what Eakins himself experienced.

In the most simplistic sense, Eakins's sporting canvases are coded masculine by the artist's pictorial segregation of the sexes. They are masculine, in other words, if masculinity is defined by nothing more than the sitters' sex. However unsatisfying such a blunt, transhistorical definition may be for its masking of the specificity with which gender has been historically constructed, it is one traditionally applied by scholars discussing the masculine character of Eakins's work. In both the nineteenth and twentieth centuries, critics have consistently labeled Eakins's work "manly," but rarely have they analyzed the ideological underpinnings of the term.[4]

In the nineteenth century, critics saw no need to clarify their assertions, given their implicit belief in the self-evident and fixed nature of gender categories. The ease with which middle-class critics asserted the manliness of Eakins's images of scientists and swimmers (see Plates 5, 7), surgeons and boxers (see Fig. 1 and Plate 8) ultimately belies the complex processes by which the paintings and their sitters have been historically produced as manly. Yet despite the critics' failure to interpret the masculine nature of the artist's work, the very language of their discussions offers proof of how masculinity was unconsciously constructed in Victorian society. To read the range of critical commentary over time is to understand that the masculinity of the 1870s differed greatly from that of the 1910s.

During the final quarter of the nineteenth century, most critics faulted Eakins's monumental *Gross Clinic* of 1875 (Fig. 1) for the violence of its realism. Reviewing the work in 1879, one Philadelphia critic claimed that "the scene is so real that [viewers] might as well go to a dissecting room and have done with it." The painting, the reporter continued, was "a picture that even strong men find difficult to look at long."[5] After the turn of the century, however, critics began consistently to interpret the artist's bluntness as a strength. In *A History of American Art* (1902), Sadakichi Hartmann asserted that only Thomas Eakins and Winslow Homer (1836–1910) fought against "the lack of rough, manly force and the prevailing tendency [of American art] to excel in delicacy." Of those who encountered *The Gross Clinic*, "nearly every one . . . exclaims, 'How brutal!' And yet it has only the brutality the subject demands. Our American art is so effeminate at present that it would do no harm to have it inoculated with some of that brutality."[6] While the graphic violence of *The Gross Clinic* was never questioned, critics understood the painting's significance differently

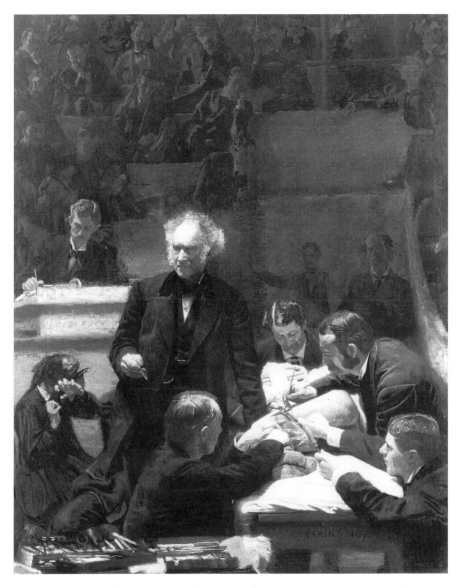

Figure 1. Thomas Eakins, *The Gross Clinic,* 1875. Oil on canvas, 243.8 × 198.2 cm. Thomas Jefferson University, Philadelphia, Pennsylvania.

as societal values evolved. If the painting made strong men ill in the 1870s, by the next century it had become an antidote to effeminacy.

The attention Eakins's contemporaries paid to masculine themes hardly seems surprising given modern-day sociologists' observations that for societies experiencing social unrest gender issues take on special urgency. As Carroll Smith-Rosenberg has proposed, sweeping social changes lead individuals to "seek through imagery and myth to mitigate their feelings of helplessness by deflecting and partially distorting change and thus bringing it within control of the imagination." Unable to contain or reverse unsettling social conditions, individuals turn inward, reshaping familial and sexual relations over which they retain some control.[7]

In the aftermath of the Civil War, questions of gendered identity gained ascendance as white, middle-class men struggled against sweeping national transformations.[8] Passage of the Fourteenth, Fifteenth, and Sixteenth Amendments, as well as the Civil Rights Acts of 1866 and 1877, appeared to threaten white racial power, just as women's increasingly vigorous calls for suffrage, higher education, and equal pay jeopardized the gender inequalities upon which patriarchal power rested. Economic and class issues also caused concern, as the anxiety that middle-class households experienced during the economic depression of 1873 was only compounded by the decade's labor unrest. The Great Railroad Strike of 1872, the political and armed struggle of the Molly Maguires during the mid-1870s, and the riots in New York City's Tompkins Square in 1874 all served to convince Americans that they were living during a particularly troubled time.

After pointing to the social and economic turbulence that characterized the Reconstruction era, many studies of manhood are quick to invoke a "crisis of masculinity" plaguing period men. I resist such a move, despite its interpretative power, for I am leery of the ways in which a crisis presupposes gender as otherwise stable at the same time that it posits unprecedented pressures on the era's males. Not only is gender a fluid construct, but the obvious tensions of postbellum society—while certainly acute— were by no means exceptional in American history. If unsettling social change per se was nothing new, the *particular* nature of instability in the final third of the century did provide a historically specific context in which Gilded Age men and women worked to realign the borders of gender. Manliness, I posit, is always under construction, as segments of society advance and then negotiate competing claims of masculine identity.

If it is historically inaccurate to slight the fluid nature of masculinity, it is also problematic to gloss over those attributes of manhood that held consistent sway during the latter years of the nineteenth century. Just as it is essential to resist the construction of a normative gender, it is similarly important to acknowledge elements of manhood that—while not universal—held dominance during the course of Eakins's career. Buffeted by broad social changes, Eakins was also beset by a series of personal failings: he had bought his way out of Civil War service, was long unmarried, lived and worked in his parents' home, was engaged in a profession that had consistently held effeminate associations, and was unable to earn his own living. Eakins had, in other words, failed to pass a number of important milestones of manhood.[9]

Of all these failings, Eakins's lack of professional success and his attendant financial reliance on his father would have proved most problematic for both the artist and his contemporaries. Whereas middle-class men of the eighteenth century drew their identity from their families, social positions, and personal achievements, men of the century that followed took their social identity largely from their success or failure at work. As one historian of American manhood has noted, work "lay at the heart of [a Victorian] man's role; if work was a problem, so was manhood," for manhood was "defined by notions of success at work."[10]

In the earliest surviving letters from the artist, Eakins articulated the anxieties he felt in being financially sustained by his father. While completing his artistic training in France, the painter wrote home with painfully detailed accounts of all his expenditures, pointedly expressing his desire for self-sufficiency. "Humiliated" that he required his father's financial support, Eakins explained that spending his parents' money was his "only great anxiety."[11] In a letter written in 1868, Eakins provided his father a typically detailed description of his expenses, even though Benjamin Eakins had assured his son that such itemizations were unnecessary. After listing all his expenditures for the preceding months, Eakins wrote that "spending your money which came to you from hard work I am touched by the delicacy of [your] not wanting the items but only the sum left, but I will nevertheless continue to give them, as I have always done. . . . I am getting on faster than many of my fellow students and could even now earn a respectable living I think in America painting heads."[12] A later letter from Paris touched on similar themes: "I will never have to give up painting for even now I could paint heads good enough to make a living

anywhere in America. I hope not to be a drag on you a great while longer[;] . . . all I can do is work."[13]

In each of these letters the artist linked his progress in the studio with his ability to earn a living. His letters consistently stress his abilities as a competent painter, but they also make a case for the practicality of becoming an artist. Eakins was confident that he was "good enough to make a living anywhere in America"; yet self-sufficiency apparently mattered more to him than his chosen profession, for his correspondence also indicates that he understood his obligation to "give up painting" if he "was not good enough to make a living."

Eakins's letters may be read as a reflection of what he thought his father wanted to hear rather than an accurate indication of his own psychological state; after all, the artist was trying to convince his father both of his anxiety at being supported and of his resolve to become successful. But even if he meant his letters primarily to assuage his father's fears, writing them compelled Eakins to confront his own failings. The letters consistently reminded him that he had not, by the standards of his time, achieved middle-class manhood.

These biographical speculations suggest how representative social pressures conditioned perceptions of the artist and his male contemporaries. Despite our understanding that the "Thomas Eakins" of this study is necessarily a historical construction, it should also be clear that a *version* of this construction played a significant role in structuring the real-life existence of that late-century Philadelphia painter. Arriving at the true Eakins—if such an Eakins ever existed—is less consequential than considering the social perceptions of the artist, for such perceptions are intimately tied to identity's construction.

Just as Eakins in his letters may have pursued a strategy that dampened his filial anxiety at being unable to support himself, so I understand the painter's early scenes of athletic men as his first tentative steps toward controlling his public persona. Early in 1871 Eakins produced his first and perhaps most celebrated rowing canvas, *Max Schmitt in a Single Scull,* known originally as *The Champion, Single Sculls* (see Plate 1).[14] Eakins's painting is dotted with single sculls, a heavy double scull, a steamboat, and a train, with three prominent boats forming a triangle in the center of the canvas. In the foreground rests the scene's protagonist, Max Schmitt, who,

allowing his oars to drag in the water, glides slowly to the viewer's left. Schmitt, a lawyer and amateur oarsmen, was for a number of years Philadelphia's single-scull champion. Just behind Schmitt, in the middle distance, a single scull is being vigorously propelled toward the far right bank. In the background, parallel to the railroad bridges, two men row a red boat, as a third man sits idly in the craft's stern.

The two nearest scullers are lightly attired in contemporary dress (white sports shirts and dark pants) while the men in the distant boat wear Quaker garb (long-sleeved tops, with one sporting a tricornered hat) (Fig. 2). The Quaker costume, instantly recognizable to Eakins's Philadelphia contemporaries, would also have been understood as old-fashioned, even anachronistic.[15] The Quakers' cumbersome craft, developed from the heavy workboats used to haul passengers and cargo across rivers, was the prototype for modern sculls, but by the 1870s it was as obsolete as its rowers' dress. With its roots in rowing's utilitarian past, the heavy boat and its crew provide an interesting foil to Schmitt's recreational rowing and his light racing scull.[16] The imaginary line joining the Quakers and Schmitt hints at the history of American rowing, from its commercial beginnings as a means of transportation employing wage earners to a hobby for the leisure class. Encouraging the sport's development, of course, was the industrial revolution, whose visible traces on the canvas are evident in the railroad bridges, the train itself, and the steamboat in the distance.

But the *third* rower in the triangle may also be pulled into the equation. Dressed in a fashion similar to Schmitt's and also occupying a single scull, he nonetheless pulls more vigorously, like the rowers in the distant red boat. This recreational sculler is working hard like the Quakers, perhaps training in the hopes of achieving the success of the amateur champion Schmitt. But that imaginary line from the Quakers to Schmitt also points to an evolution from a community in which individuals, supervised by elders, work together for the common good, to a society in which men strike out on their own for personal fulfillment. Supervised by their coxswain, the Quaker rowers pull together toward the middle of the river, while Schmitt seems to glide along his course independent of outside guidance. Formally distinct, yet joined to both Schmitt and the Quakers, the sculler in the middle distance appears as a sort of transitional figure, metaphorically bridging the gap between older and newer systems of work and success.

That middle sculler is Thomas Eakins. Under his tiny self-portrait, on the stern of the scull, Eakins printed his surname and the year of the painting in neat red letters (Fig. 3). As the artist's only signature on the canvas, the inscription signals both his authorship and his pictorial presence. By signing the painting *on* his scull, Eakins named his craft much as Schmitt's scull is named *Josie* on its port side. In the nineteenth century nearly every rower—amateur and professional—named his scull. Some were christened *Phantom* or *Argonauta,* others bore the names of famous political leaders like Washington or Jefferson, while still others were named for their makers. The Biglin brothers, for example, the rowers whom Eakins most often depicted, named one of their sculls *Judge Elliot* after the boatbuilder who designed and built that vessel.[17] By naming his boat after himself, Eakins effectively likens his creation of the painted scull to the boatbuilders' craft.[18]

Such an association has telling implications, given the evolving nature of boatbuilding during the 1860s and 1870s. These decades heralded such technological advances as iron outriggers, swivel oarlocks, sliding seats, and paper hulls. Successful boatbuilders were no longer slavish copyists, constructing stock designs, but instead scientists and even artists. Robert Johnson's *History of Rowing in America* (1871) echoed the sentiment of scullers and sculling enthusiasts by noting that modern boatbuilders required "high mathematical knowledge and rare mechanical skill."[19] Another writer, reporting for the Aquatics column in the *National Police Gazette,* pointed to a boatbuilder's "artistic skill," which he understood as a talented blend of "mathematical accuracy" and "scientific nicety." This reporter went on to note "that in races of any magnitude [the boatbuilders] come in for a great share of attention."[20] So important were they that newspaper and journal reports on rowing regattas almost always named the boats' makers; and so important were the sculls that race reports often listed their precise dimensions for each contestant.[21]

Just as *The Champion, Single Sculls* suggests a visual link between Eakins and Schmitt, it symbolically couples the painter's practice with that of the respected boatbuilders by selectively associating elements of their professions. For a painter insecure in his manhood, linking himself with successful rowers and esteemed craftsmen was surely fortifying.[22] And yet it should be clear that Eakins's ties to the boatbuilders go beyond simple visual linkages in the paintings, for both the painter and the boatbuilders share some of the responsibility for Schmitt's fame. Just as the boatbuilders'

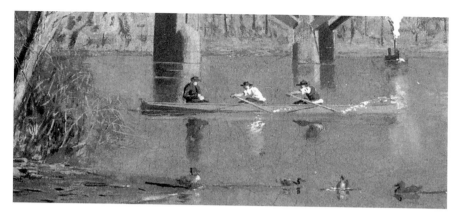

Figure 2. Thomas Eakins, detail of Quaker boat in *The Champion, Single Sculls*, 1871. The Metropolitan Museum of Art, New York, purchase, 1934, Alfred N. Punnett Fund and Gift of George D. Pratt.

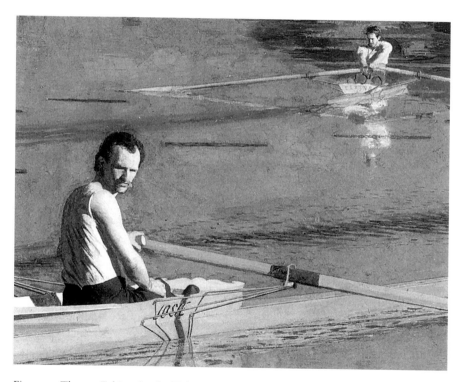

Figure 3. Thomas Eakins, detail of Schmitt and Eakins in *The Champion, Single Sculls*, 1871. The Metropolitan Museum of Art, New York, purchase, 1934, Alfred N. Punnett Fund and Gift of George D. Pratt.

project is integral to the rowers' success, so Eakins's painterly work memorializes Schmitt's prowess as a champion sculler. Without Eakins's record, Schmitt's achievement would certainly be forgotten today. Even the painter's original title for the work, *The Champion, Single Sculls*, points to his historical project. If the builder of the race-winning scull enabled Schmitt's success, Eakins did his part by perpetuating Schmitt's accomplishments.

Eakins's finished canvases offer narratives that metaphorically link the artist with a respected class of scientific workers, but the paintings' very construction also demonstrates his scientific mind-set. In other words, more than merely suggesting a series of general ties between artists and scientists, painters and rowers, Eakins's working process *embodied* his scientific credentials. And this process, no less than his choice of subject matter and depicted narratives, helped shore up his masculine position by permitting him an unprecedented degree of control.

Throughout Eakins's career, the vast majority of his paintings were preceded by fastidious preparatory drawings in which the artist would construct a horizontal grid, on which he plotted every detail of the final work (Fig. 4). For each canvas Eakins carefully calculated the ideal viewing distance from the work, appropriate recessional lines, the angle at which he wanted to place the boat, even the various reflections of individual waves that were to appear in the final painting.[23]

At least since the Renaissance, artists have employed scientific methods in the production of art for the express purpose of achieving accuracy of portrayal. In an Albrecht Dürer woodblock print of around 1528 (Fig. 5), the artist employs a grid to frame, map, and then replicate the nude woman before him. His use of the grid—as a sign of his scientific process—allows the male artist both to master perspective, thus advancing the professionalization of his occupation, and to codify the model's subordinate status. Dürer's woman is quite clearly but the raw material for the artist's scientific production of art.

In Eakins's case I will argue, however, that the grid is more than an invisible armature, allowing the painter to replicate the reality of life around him. The point is perhaps best made by comparing Eakins's grids to those of the late-twentieth-century artist Chuck Close. The grid in Close's portrait *Janet* (1992; Fig. 6) is not simply an invisible tool for translating a small photograph into the heroic scale of the final canvas; it serves as a visible structuring presence. Most modern viewers will assume that Eakins uses

his grid to replicate reality while Close deploys his in an attempt to create for himself—and then surmount—difficult technical problems. But as various scholars have pointed out in recent years, Eakins quite cleverly employed his perspective system to alter settings and figures to enhance his compositions. Despite the apparently photographic appearance of *The Champion, Single Sculls,* the artist's working methods allowed him to represent his figures and setting in a very "unreal" manner. The finished painting, for example, gives viewers a vantage point unavailable at any spot along the Schuylkill's banks. The painting straightens out bends in the river and moves the bridges closer together for pictorial effect.[24] Moreover, although Eakins's scull, the Quaker boat, and the railroad bridges are represented at a great distance from the viewer, they all retain the sharp focus of Schmitt's single scull—not because they would appear this way in life but because they are central to the canvas's narrative.

The constructed nature of Eakins's scene is even clearer when we consider that the section of the Schuylkill pictured in *The Champion, Single Sculls* flows through Fairmount Park in Philadelphia. As Bryan Wolf notes in his discussion of the painting, the park was a relatively new creation—an artificial enclave designed to look natural, placed in the center of urban Philadelphia. Not only did Eakins take liberties in representing the scene, but he selected a modern and recently developed section of the park that was *as* contrived as his arrangement of the canvas.[25]

What this analysis of Eakins's working process illustrates is the degree to which it served him as a means to a particular narrative end and the extent to which his technical procedure—specifically his careful use of grids—enabled him to elevate the role of the artist. Much as Close's portraits relegate the canvas's subject matter to a secondary role—as they promote the abilities of the painter to manipulate form—so Eakins's system illustrates the force behind these ostensibly real images. For Dürer, Close, and Eakins the grid is less a system for mimetically reproducing the world than a means for illustrating the artist's dominance over his environment.

The various strategies I have illustrated by which Eakins augmented his masculine position in *The Champion, Single Sculls* may be fairly termed associative; that is, Eakins made himself seem more masculine by associating himself with virile athletes and scientific craftsmen and by employing a working process with positive links to science that simultaneously afforded him a great degree of artistic control. This associative model of

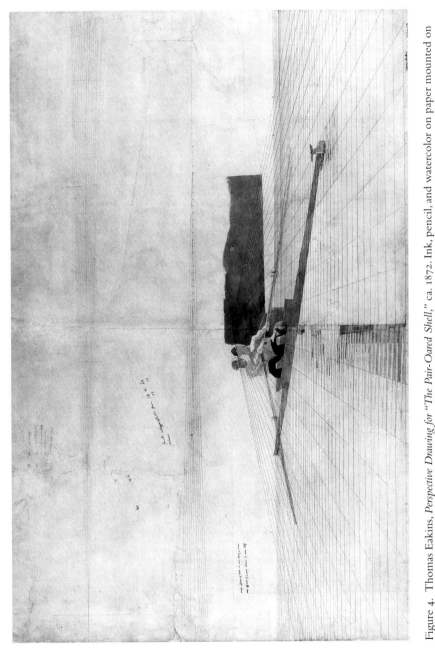

Figure 4. Thomas Eakins, *Perspective Drawing for "The Pair-Oared Shell"*, ca. 1872. Ink, pencil, and watercolor on paper mounted on cardboard, 96.5 × 121.9 cm. Philadelphia Museum of Art: purchased, Thomas Skelton Harrison Fund.

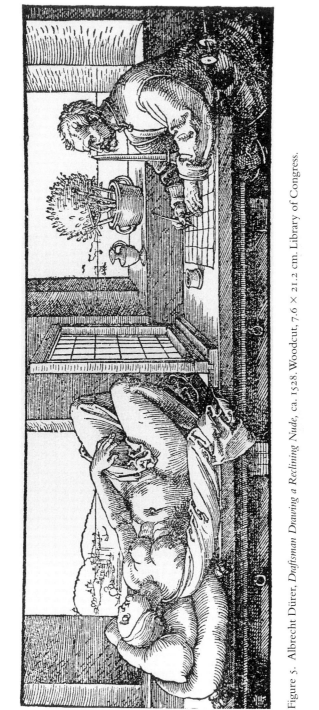

Figure 5. Albrecht Dürer, *Draftsman Drawing a Reclining Nude*, ca. 1528. Woodcut, 7.6 × 21.2 cm. Library of Congress.

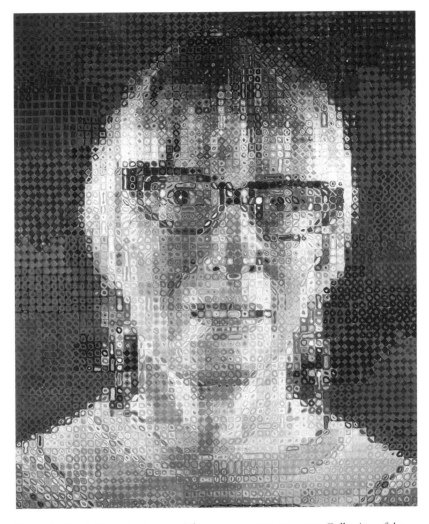

Figure 6. Chuck Close, *Janet*, 1992. Oil on canvas, 254 × 213.4 cm. Collection of the Albright-Knox Art Gallery, Buffalo, New York, George B. and Jenny R. Mathews Fund, 1992.

manliness is, however, complicated in many of the artist's later rowing canvases, where he compensates for his personal masculine failings by pointedly illustrating the complex and unstable nature of Victorian manhood.

If Schmitt's portrait allowed Eakins to counter perceptions of his own masculine failings by linking himself to manly pursuits, the artist's three paintings of the Biglin brothers allowed him to negotiate larger cultural

inconsistencies inherent in Victorian definitions of work and manhood. Completed shortly after his portrait of Schmitt, this series portrays the popular professional team of John and Barney Biglin during the brothers' victory in 1872 in a famous pair-oared race on the Schuylkill River in Philadelphia. The match was arranged after the New York–based Biglins challenged any two men in England to row against them in a five-mile race. Although no Englishmen took up the challenge, Henry Coulter and Lewis Cavitt of Pittsburgh offered to meet them.

The Biglins' race, in addition to being reported in a dozen Philadelphia newspapers, was covered extensively by the *New York Times;* the *Spirit of the Times;* the *New York Clipper; Turf, Field, and Farm;* and the *Aquatic Monthly.*[26] This last journal provided a colorful description of the scene, corresponding closely to Eakins's renderings of the race:

The river presented a pleasant aspect, being dotted over with myriads of small boats, and the handsome barges and shells of several of the clubs comprising the Schuylkill Navy. Two small steam pleasure yachts and the propeller Edith, gaily decked with bunting, as they plied up and down the stream made the scene quite animated. At about 4 o'clock the Biglins made their appearance in their boat, the Judge Elliot. . . . The occupants of the boat were dressed in blue flannel half-breeches, close fitting shirts, and wore a blue silk handkerchief about the head.

In the middle distance of *The Biglin Brothers Turning the Stake-Boat* (see Plate 2), directly above Barney Biglin's head, appears the red-kerchiefed Pittsburgh team, rowing toward the red stake flag marking the midpoint of the race just as the Biglins round their blue flag. The brothers are in mid-turn, with John reversing his stroke and "backing" as Barney checks the craft's position and pulls forward, thus pivoting the scull around the flag. By rowing in opposite directions, the rowers stay in place, rotating their scull around the stake and into position for the final pull back toward the finish line.[27]

Like most of Eakins's extant renderings of rowers, the artist here achieves an illusion of motion by showing the scullers at the conclusion of their strokes. The effect is impressive yet paradoxical, given that the motion of one brother largely counteracts the exertions of the other. Although the ability to pull together is perhaps *the* most crucial skill for successful pair-oared teams, Eakins chose to render the Biglins at the one point in the race during which they must work "against" each other.

The importance of this odd "pivotal" moment was not lost on the painter's contemporaries. Impressed with Eakins's decision to show the

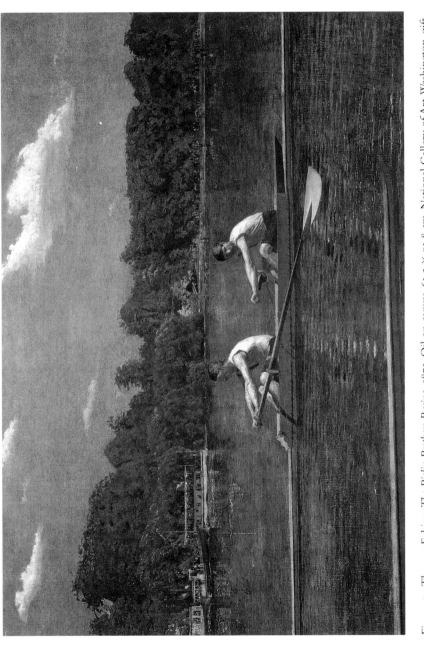

Figure 7. Thomas Eakins, *The Biglin Brothers Racing*, 1872. Oil on canvas, 61.2 × 91.8 cm. National Gallery of Art, Washington, gift of Mr. and Mrs. Cornelius Vanderbilt Whitney.

brothers pulling in opposite directions, one critic, reviewing the work for the *American Architect and Building News,* wrote that "it is a very strong drawing, and the moment is cleverly chosen when the stroke [John] backs water and his action is in contrast with that of his mate [Barney]."[28] The dialectical tension established by the brothers' efforts is "clever" because it highlights the disparate components of rowing usually subsumed in an apparently seamless whole. In my argument, these internal contradictions are also important for the ways in which they dramatize diverse and similarly contained elements of the era's conception of masculinity. In other words, just as the painting draws attention to the apparently contradictory efforts of the rowers, it may also illustrate rarely articulated ideological oppositions in nineteenth-century manhood.

On the most basic and perhaps conscious level, *The Biglin Brothers Turning the Stake-Boat* points to rowing's reliance on both physical and mental skills. As in *The Biglin Brothers Racing* (Fig. 7), Barney glances in the viewer's direction, checking the craft's position. If John's shaded head—coupled with his sun-drenched back, legs, and arms—hints at the importance of his physicality, then Barney's sideways glance and the sliver of light along his face might be seen as an allusion to the decision-making skills that he brings to the team. Positioned in the bow, Barney is responsible not only for pulling, like his brother, but also for controlling the boat's rudder by means of a pair of ropes at his feet. A nineteenth-century essay on rowing reminds us that in pair-oared rowing, "the bow-oar [Barney] steers and directs, whilst the stroke-oar [John] merely pulls steadily and follows the directions of the bow-oar. . . . Let one man steer and direct, the other merely following the directions and not slacking or pulling harder without orders."[29]

Given the Biglins' fame, many contemporary viewers would have understood the physical-mental differentiation of roles based on their knowledge of the rowers' personal lives. According to business directories, during the 1860s and 1870s John Biglin worked variously as a "mechanic," "laborer," "foreman," "fireman," and "boatman." The year after Eakins painted *John Biglin in a Single Scull* (1874; see Fig. 16), Biglin's profession was listed as "laborer" in *Goulding's New York City Directory for 1875–1876.* While John was engaged in hard physical labor, Barney was absorbed in predominantly mental work, having won election in 1872 to his first term in the New York State Assembly.[30] By uniting the brothers, each with his distinctive skills, *The Biglin Brothers Turning the Stake-Boat*

suggests that success derives from the teamwork that balances the crews' mental and physical abilities.

In positing such a balance, Eakins's canvases of the Biglins were, on one level, simply following in the wake of the century's self-culture tracts. Beginning in the first half of the nineteenth century, and becoming increasingly fashionable toward the 1870s, self-culture books counseled Americans to balance the activities of mind and body. In these decades, both mental and physical activity were thought necessary for sound health, just as each could cause a breakdown if taken to extremes. As the author of a popular book entitled *The Intellectual Life* (1873) observed: "The excessive exercise of the mental powers is injurious to bodily health, and . . . all intellectual labor proceeds upon a physical basis." In 1874 another writer argued against those who thought that mental activity alone could promote good health, warning that a dearth of exercise would result in "the clogging of the wheels of the internal parts of the fleshy frame, and various shades of stomachic and cerebral discomfort."[31]

While present-day viewers may find the painting's call for a balancing of mental and physical exertions prosaic, the specific nature of that balance betrays constructions of manhood specific to Eakins and his period. At least since the time of the ancient Greeks, Western societies have consciously valued the balancing of head and hand, yet rarely have these "balances" been defined in exactly the same manner. Consider, for example, the distinctive formulation in colonial America expressed in John Singleton Copley's portrait of Samuel Adams (ca. 1772; Fig. 8). Copley's canvas depicts Adams at a moment of confrontation, with the patriot demanding Governor Thomas Hutchinson's removal of British troops from colonial Boston. Staring directly at the viewer, Adams points to the colony's charter with one hand as he clutches a petition signed by the citizens of Boston with his other. Because he is stripped of accessories and dressed in a dark wool suit that blends into the shadowy background, Adams's identity is most forcefully expressed by his oversize spotlit head and hands. Yet we should be clear that Adams's head does not stand unproblematically as a symbol for the mind, or his hands, for the body. Despite the long-standing convention of hands as indices of an individual's physical nature, Copley illustrates Adams's hands, not as synecdoches for manual labor, but rather as signs of the sitter's mental facility. Gripping and pointing to the documents arrayed before him, Adams's hands act as visual cues, highlighting the canvas's promotion of the mind's creations.

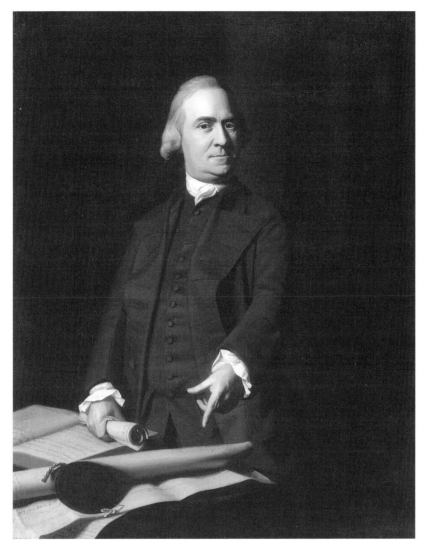

Figure 8. John Singleton Copley, *Samuel Adams,* ca. 1772, deposited by the City of Boston. Oil on canvas, 127 × 102.2 cm. Courtesy, Museum of Fine Arts, Boston.

As with the tiny Quakers in the distance of *The Champion, Single Sculls,* Adams's identity is formed through his ability to contribute to the communal good. Despite the portrait's clear de-emphasis of the sitter's physicality, and notwithstanding Adams's failure to earn a livelihood—he ran his father's malt business into the ground and was supported largely by his wife's income—Adams remained manly by the standards of his day through his exercise of his mind and his oratory skills, which enabled him to forcefully press the colonists' cause.

If Copley's portrait of Adams presents a balance that leans toward the mental half of the equation, that of Eakins's rowers clearly leans the opposite way. Notwithstanding both the rhetoric of rowing and the admonishments of late-century self-culture tracts, which emphasized the blending of mental and physical skills, it is clear that the canvases illustrate athletes in roles that are overwhelmingly physical. It was precisely for this conspicuous physicality that the Biglins were popularly known. Despite their considerable professional success, and the obvious mental labor associated with Barney's professional life, neither brother was seen to have fulfilled the competing requirements of Gilded Age manhood, given that they were publicly defined by their rigorously physical sport. The brothers' "deficiencies" illustrate how failure was effectively hardwired into the masculine equation, for if even they were unable to meet the intricate standards of manhood, who might we imagine possessed a perfect masculine identity?

John and Barney may have failed individually to secure their masculinity, but there is a way, of course, in which the canvas links men together, providing for more perfect gender positions than any individual could attain on his own. Just as Barney's mental effort balances John's wholly physical tasks, so in a larger sense Eakins's mental, artistic practice counterbalances the Biglin brothers' athletic profession. Not only would Eakins improve his masculine standing through his association with the successful racers, but the scullers would also solidify *their* positions by being more forcefully linked to Eakins's intellectual art. Artist and athletes, Eakins suggests, ultimately cooperate, each contributing a component of Gilded Age masculine identity that the other seemed to lack.

And given the class differences between the brothers, Eakins's images of the Biglins went beyond merely alleviating general contemporary concerns to balance mental and physical exertion. In industrial America, working-class men were obliged to perform predominantly physical

work, while males of the middle and upper classes were engaged solely in labor that the physician and scientist S. Weir Mitchell called "brain work." The practices of late-nineteenth-century industry circumscribed the decision-making capabilities of laborers while limiting the physical activities of managers.[32] Given the class division of roles, arriving at the mental-physical balance that so many advocates of good health demanded was difficult. Rowing, however, provided both a site and an activity that could bridge the gap, offering laborers the opportunity to make choices and command their own bodies, and wealthier participants the chance for physical exertion absent in their daily routines.[33]

The message contained in the Biglin canvases—of Eakins's associative manliness, and of the possibilities for reconciling divergent strands of Victorian manhood—is one expressed in many of the artist's paintings of athletic men. *The Artist and His Father Hunting Reed Birds in the Cohansey Marshes* (ca. 1874; Fig. 9), which illustrates a similar coexistence of masculine attributes, also implicates Eakins directly in such a masculine economy. This dark painting represents Thomas in the stern of a shallow skiff, poling through the marsh, as his father, Benjamin Eakins, waits at the boat's prow with his shotgun at the ready. As the figure responsible for propelling the boat, Thomas has what appears to be a primarily physical role in the hunt, while his father's task may be characterized as essentially mental, given the hand-eye coordination he must exhibit for the hunt to succeed. Much as Eakins united the Biglins in differing roles, so he portrayed himself and his father in a similar union.

Given their correspondingly dark clothing and three-quarter poses, the distinctive roles that the canvas constructs for father and son are ultimately conveyed less through the individuation of the men's physical features than through the distinguishing props each figure holds. If the elder Eakins seems to wield greater authority in the scene, that is because the obvious physical and symbolic power of his shotgun outweighs that of his son's wooden pole. Their similar portrayals should certainly be taken both as a sign of their unity of purpose and as an indication of the interchangeability of their roles. Through the mere exchange of implements, the canvas suggests, Thomas might assume his father's guise.

The canvas's fluidity of roles is significant, for it suggests a means by which certain groups of men might reconcile the often conflicting tenets of masculine identity. If the requirements of Victorian manhood were too complex and contradictory for any one person to attain, the canvas illus-

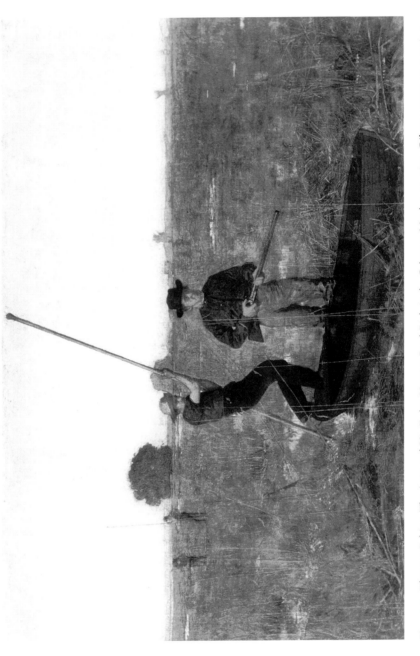

Figure 9. Thomas Eakins, *The Artist and His Father Hunting Reed Birds in the Cohansey Marshes*, ca. 1874. Oil on canvas, 43.5 × 67.3 cm. Virginia Museum of Fine Arts, Richmond. Gift of Paul Mellon.

trates how men might progress into more dominant roles in later stages of life. We come to understand that while Eakins is presently a "physical" poleman, he might someday take the "mental" hunter's place. But we need to be aware that in both Eakins's canvases and Victorian culture, the fluidity of identity allowed the artist and his father is predicated upon the essential fixity of roles for those in less dominant groups.

At first glance Eakins's *Rail Shooting* (1876; see Plate 3) appears to offer a close adaptation of the artist's earlier hunting scene. In this canvas the figure of Thomas is replaced by that of an African American poleman, and the skiff has been rotated into a position nearly parallel to the picture plane. If Eakins's largely physical role was signaled through both his task and his implement, that of the African American is additionally expressed through his physical appearance. Depicting a moment just before the shotgun's blast, Eakins positions the poleman with knees bent and weight slightly back, steadying the craft, as the white hunter leans forward, taking aim. Whereas the gunman's shirt and pants are painted with flat, broad strokes of color that reveal little of his body beneath the clothing, the poleman's shirt is accentuated with brilliant white highlights and deep recesses of shadow that establish the three-dimensionality of his torso. Not only that, but the poleman's exposed forearms are painted with tight brushstrokes that emphasize his muscular physique. If the hunter's body lacks form, his head and hands are painted with microscopic attention to detail, while the poleman's face is cast in deep shadows, making it very difficult to read. At the moment depicted, the poleman is nothing more than the force required to keep the boat motionless for the hunter's impending shot, just as the bodiless hunter is signed as intellect by the detailed head from which his shotgun projects. While stressing the unity of the men, and each partner's distinctive role in the successful pursuit of their prey, the work clearly codes mental tasks as exclusively the domain of whites.

That the work is not simply an expression of the poleman's physical role is made clear both by Eakins's portrayal of himself in *The Artist and His Father Hunting Reed Birds in the Cohansey Marshes* and by Victorian hunting manuals that stress the need for mental agility on the part of *both* hunters and polemen. Period guidebooks illustrated the thinking component of the pusher's role and frequently described his work as more complex than that of the gunman. As an 1866 chapter on rail hunting notes, the hunter's "labors are easy; but the punter requires many different qualities; and upon his excellence mainly depends the final result. He

must possess judgement to select the best ground, strength to urge the boat unflaggingly, and an inordinate [knowledge] of the bump of locality to mark dead birds." [34]

Invoking Eakins's realist credentials, one might assume that the African American's features are indistinct simply because *Rail Shooting* transcribes a moment in which his head was cast in shadow. But given that Eakins produced the work during a period when he is known to have avoided marshes, for fear of being reinfected with malaria, the painting was almost certainly created in his Philadelphia studio.[35] More than a decade after completing his boating canvases, Eakins explained to his students how many of the paintings were constructed: "I made a little boat out of a cigar box and rag figures, with the red and white shirts, blue ribbons around the head, and I put them out into the sunlight on the roof and painted them."[36] These miniature models and Eakins's numerous, detailed preparatory drawings attest generally to his methodical nature as well as to the absolute control he exercised over each detail of his final compositions. In the end Eakins's construction of the hunter as intellect and the poleman as brute strength has more to do with Victorian perceptions of blacks than with either the division of roles laid out for men in the hunt or the "reality" of the men's appearance.[37]

Despite their obvious differences, Eakins's various hunting canvases forcefully defend and promote patriarchal social orders: in *The Artist and His Father Hunting,* the dominance of the father offers reassurance, insofar as we understand the younger Eakins's potential for assuming his father's commanding role—Thomas, we come to appreciate, will one day enjoy the benefits of such a system. While *Rail Shooting* avoids any suggestion that the men's roles are fluid, it too offers reassurance to white males through its maintenance of a social order in which black men are always subservient.[38]

The model of white patriarchal control proffered in *Rail Shooting* is not restricted to Eakins's hunting scenes, or even to canvases illustrating interactions between white and black figures, but is rather a structuring presence in all the artist's images.[39] Consider Eakins's apparently innocuous *Negro Boy Dancing,* originally titled *The Dancing Lesson* (1878; Fig. 10).[40] Moments ago the slender elderly figure at the center of the scene completed his dance step. Having placed his top hat and cane on the chair to his right, he stepped back to watch the painting's youngest character replicate his dance to the accompaniment of a banjo. Given the figures' casual clothing and relaxed deportment and the plain domestic furniture of the

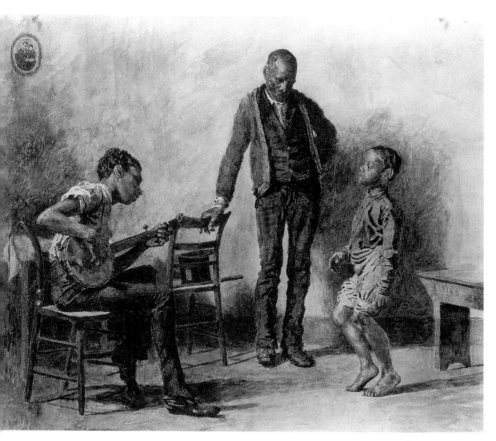

gure 10. Thomas Eakins, *The Dancing Lesson (Negro Boy Dancing)*, 1878. Watercolor on paper, 46 × 57.4
n. The Metropolitan Museum of Art, New York, Fletcher Fund, 1925.

scene, as well as the framed image on the back wall, *The Dancing Lesson* appears to depict a private family moment.

On the most basic level, Eakins's intimate family scene of dancing blacks instantly distinguishes itself from nineteenth-century renditions of comic minstrel figures (Fig. 11). In many ways the painter's watercolor could scarcely be further removed from such Jim Crow caricatures of African Americans. Representing a white fantasy of dancing and singing planta-tion slaves, the Jim Crow character was widely disseminated by Stephen Foster and Dan Emmett during the mid–nineteenth century. Northern members of the Democratic party, Foster and Emmett were apologists for the South's slave system and worked, if not quite to champion slavery, then at least to show it as a benevolent system. If white Northern audiences, many of which were partially sympathetic to the abolitionist cause, could be convinced that blacks were contented, childlike creatures, then slav-ery might be explained as a necessary evil. Foster's and Emmett's minstrel acts entertained Northern audiences with portrayals of African Ameri-cans as inferior beings who would be helpless on their own.[41]

Just as it is historically inaccurate to view Eakins's dancing blacks as ideologically interchangeable with earlier minstrel figures, it is imprecise to ignore the genealogy of his figures, which are the ideological children, or perhaps grandchildren, of earlier Jim Crow scenes. Far from depicting a race-neutral theme, Eakins's watercolor offered Gilded Age audiences a subject that was overdetermined as black. While present-day scholars have routinely labeled the image "progressive" on questions of race, such asser-tions flatten the historical record, obscuring the vantage from which nineteenth-century audiences viewed the work.[42] A review of the water-color, which appeared in the mainstream press in the 1870s, referred to the work's "goblin humor," illustrating what the reviewer understood as the "comedy of plantation life."[43] Notwithstanding the desire of twenti-eth-century critics to recuperate Eakins as a "progressive" artist, the cul-tural context in which the work first circulated led viewers to understand the figures as humorous, even childlike.

The framed portrait that Eakins includes on the room's otherwise blank wall only encourages such a reading of the characters. The image, a bit murky to modern eyes, would have been instantly recognizable for audi-ences after the Civil War as Mathew Brady's photograph of President Lin-coln and his son Tad, a popular portrait that circulated widely in postbel-lum America (Fig. 12). The photograph's inclusion immediately cues us

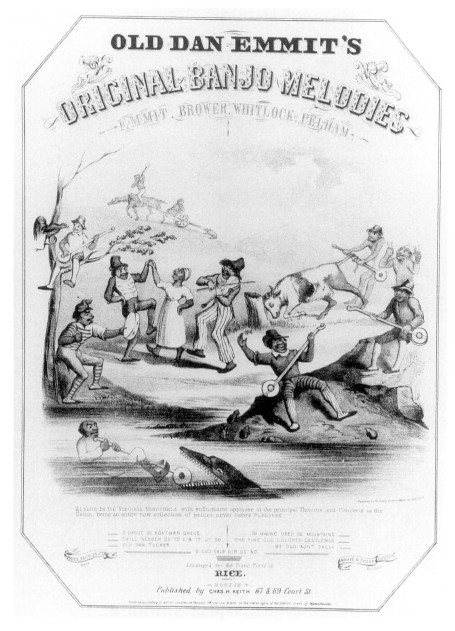

Figure 11. *Old Dan Emmit's Original Banjo Melodies,* 1843. Cover illustration. Library of Congress.

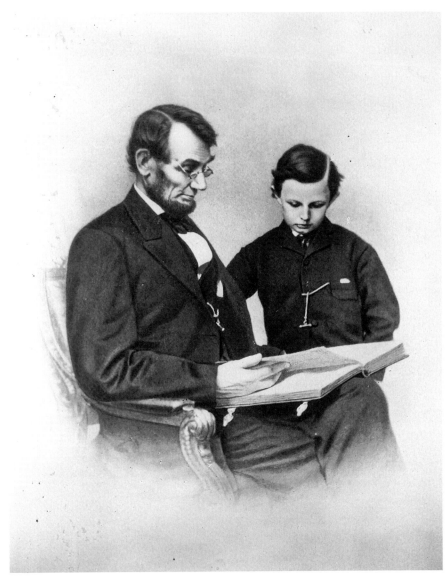

Figure 12. Studio of Mathew Brady, *Abraham Lincoln and Tad,* 1864. Photograph. Library of Congress.

to the fact that the depicted African Americans are emancipated, but it also illustrates how their freedom is tied to the benevolence of whites, to whom these figures owe at least a moral debt.

If the work suggests that blacks remain tied—and indebted—to their white countrymen, such associations are fostered by Eakins's reliance on visual traditions that reveal white patriarchal concern for black Americans. Consider the model offered in *Emancipation Group* (1865), the sculpture by Thomas Ball that was dedicated in Washington, D.C., in 1876 (Fig. 13). Here Lincoln offers a benediction of sorts to the slave whose shackles he has just severed. The president does not stand on an equal footing with this newly freed man but rather towers above him, as benefactor and protector. Instead of illustrating the equality of the races, a concept most Victorians would have found unsettling, postbellum images of liberation tend to translate emancipation narratives into familial terms, illustrating the dynamic between a father and his child.[44] In Eakins's painting the paternal role of Lincoln is established through the photograph—with its depiction of a benevolent father towering above his son—and then replicated in the watercolor, with Lincoln hovering over his African American children. The point is even more forcefully made when we consider that the image of Lincoln and Tad, while popular, was arguably not the most famous photograph of the president. While Eakins could have selected a more dignified portrait of Lincoln to include in his scene (Fig. 14), he picked one of only two images taken in Brady's studio that illustrated the president as father.

By juxtaposing Lincoln's photograph with the African American family, Eakins established certain equivalencies between the fathers: illustrated in domestic settings, and engaged with children, each man is depicted as an attentive teacher, imparting knowledge to the next generation, just as both men are portrayed as dominant, controlling figures. Much as Lincoln stands in a paternal relationship to both his son and his symbolic children, so the African American man is evidently also a patriarch. Given his central placement, as well as the title of the work, he is clearly in charge of the boys. But whereas Lincoln's image identifies the president as a private father, so counterbalancing his public persona as *the* national patriarch, the central African American figure is anchored firmly in the domestic sphere, with no obvious national role. Yet without losing sight of the acute *inequality* of power inherent in the types of control exercised by the two fathers, we can note the significant parallels in their depictions, and the novelty of an image that

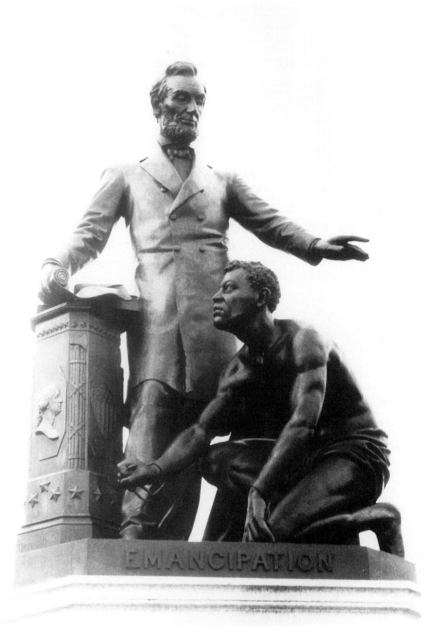

Figure 13. Thomas Ball, *Emancipation Group,* 1865. Cast bronze, 275 cm. Lincoln Park, Washington, D.C.

Figure 14. Studio of Mathew Brady, *Abraham Lincoln*, 1864. Photograph. Library of Congress.

shows a black man exercising any degree of patriarchal control. After the Civil War, when African American families went to extraordinary lengths to establish patriarchal family roles that had been denied them by the slave system, few visual depictions showed black men in control.

As Eric Foner explains, the family structure into which the majority of blacks hoped to unite family members after the war was solidly patriarchal. African Americans not only rushed to legitimate marriages that had had no legal standing under slavery but also embraced the nineteenth century's "cult of domesticity." To the consternation of white plantation owners, black families largely removed women from the agricultural labor pool to sequester them at home.[45] As a southern editorial complained in 1869, "The freedmen . . . have almost universally withdrawn their women and children from the fields, putting the first at housework and the latter at school."[46] For many African Americans, such a middle-class patriarchal family arrangement represented one of the most significant milestones of freedom. Even as many of the social and economic advances of Reconstruction were turned back after 1877, the consolidation of the black family as a patriarchal unit remained one of the long-term signs of reform.

The exercise of, and limitations upon, patriarchal license in both Eakins's and Brady's images are expressed most forcefully by the fathers' pedagogical approaches: while Lincoln educates with the knowledge acquired through books, the central black figure teaches through demonstration. The black father educates the next generation by teaching one of the few roles white society has consistently deemed appropriate for African Americans. In offering up this message about the value of the father's learning, Eakins's painting enters into a racial discourse on education that is remarkably consonant with the visual culture of the postbellum era. At the same time that artists worked to construct an image of Lincoln as a self-made man who had fashioned himself from books, painters imagined African American figures who seemed unable or unwilling to appreciate the potential of the written word.

The appeal of Eakins's image was, I believe, closely tied to the ways in which it offered ideological support for such racialized pictures of post-Reconstruction life. The black father's lesson (which was safely familiar, entertaining, and visually available to white audiences) may have offered viewers concerned with the roles of African Americans in post-Reconstruction society a message of continuity, just as the white father's instruction—its lesson unspecified, hidden in a book whose pages we

cannot glimpse—might have suggested the multiple opportunities available to white youth of the period. In the end, the painting owed its popularity largely to its reaffirmation of the status quo, for it not only illustrates African American figures in the roles long established for them, but also demonstrates, more significantly, how the experiential approach to learning practiced by the black father is necessarily limiting. Given the cultural hierarchy white audiences would have understood during this period—of book learning over oral traditions—the work suggests how African Americans are mired in the past, with the younger generation destined to "know" only as much as their fathers' old-fashioned generation. In conjunction with an experiential approach to learning, the notion of black patriarchal control that looks potentially so radical becomes precisely the means by which African Americans are held socially and culturally in suspended animation.

Eakins's depictions of blacks preserve a social order in which white men are perpetually dominant, providing Eakins and his white contemporaries signs of agency unrelated to their economic success. Because the African Americans in *Rail Shooting* and *The Dancing Lesson* have been consistently interpreted as uncaricatured, naturalistic representations, one might conclude that they are particularly effective at promoting the racialized social order of the Gilded Age. Whereas images deemed overtly racist tend to be subjected to a high degree of scrutiny by scholars and the public, those assumed to be objective are underexamined for their claims on race and gender, allowing their implicit messages to circulate freely and inflect contemporary racial constructions. But to root the paintings' power in their naturalism is to confuse cause and effect. My claim is that their power is demonstrated—and decidedly not created—by their continuing ability to look naturalistic. In other words, Eakins's canvases look "natural" because their underlying ideology still resonates with us today, not because their naturalistic style tricks us into accepting their political assumptions. If we truly disagreed with the paintings' messages, then their naturalism would suddenly drop away.

Despite the subtle circumscription of the agency of blacks in Eakins's canvases, I do not mean to establish a neat black-and-white division between "contained" African American characters and whites who supposedly enjoy unlimited freedom. Even for white, middle-class men, Eakins's athletic canvases had their limitations. If the works allowed a metaphorical balance for some men's lives, they could not offer the free-

doms afforded the wealthiest Americans. While sports may have granted their adherents the opportunity to command their own physical and mental activities, and while they promoted the appearance of symmetry between the lives of white- and blue-collar workers, athletics did not offer participants control over their alienated labor in the marketplace. What sports did provide, however, was a reconciliation of masculine ideologies. In the end, the immense popularity of sports may well have been linked to the very *impossibility* of successfully negotiating the disparate demands of Victorian manhood.[47]

Eakins's symbolic strategy of associating himself with manly elements of Gilded Age society—be they famous athletes, modern sports, admired professions, artistic production methods, or even racial groups—had obvious limitations. Such an approach not only necessitated that the artist use preexisting definitions of masculinity, but it also compelled him to formulate his identity from cultural products whose meanings were necessarily multiple. No matter how manly Max Schmitt may have appeared to Gilded Age audiences, his "meaning" to Eakins's contemporaries was obviously not embodied solely in masculinity. Not only was Eakins unable to control the associations his work generated in viewers, but his metaphorical negotiations were complicated by the simultaneous masculine and feminine charge of the very elements that helped the painter develop his identity.

Despite the common assumption today that nineteenth-century Americans regarded realism as unambiguously masculine, the realism of the 1870s clearly contained feminine resonances. Such mixed gendered associations are perhaps inevitable for a style that has been so broadly defined, encompassing, as it does, cultural products as diverse as Sarah Orne Jewett's *Country of the Pointed Firs* (1896) and Stephen Crane's *Red Badge of Courage* (1895).[48] Despite the malleability of the realist label, Eakins's identification as one of *the* American realists (shared with one of his contemporaries, Winslow Homer), was unquestioned over the course of the nineteenth century. For most critics of the period, Eakins's realist credentials sprang consistently from his contemporary American subject matter, the rigor of his scientific method, and his mimetic accuracy of portrayal. His realist style worked, of course, to masculinize the artist by setting him apart from such contemporary sentimental painters as John George Brown

and Seymour Joseph Guy, whose immensely popular works were long associated with feminine culture.[49] But if the *dominant* associations of Eakins's realism tied him to a masculine world, the conspicuous detail of his canvases constituted a feminine subtext in his works that affected his contemporaries' understanding of them—detail having had long-standing ties with feminine culture. Eakins himself was aware of the gendering of detail, for in a letter to his father in 1868, the painter favorably contrasted what he took to be the rough "head work" of oil sketches with the detailed "ladies' work" of finished canvases.[50]

Neither the painter's realist style nor his treatment of rowing as subject matter had exclusively masculine meanings; gendering in both was conflicted. During the third quarter of the century, Gilded Age women demonstrated (and were encouraged to demonstrate) as much interest in the sport of rowing as men. Periodicals from the 1860s and 1870s make it clear that women regularly made up half the audience for popular sculling matches, and editorials promoted women's participation in athletics (Fig. 15).[51]

To counter problems stemming from the multiple meanings his paintings surely generated, as well as to avoid being defined by preexisting norms, Eakins proactively used his art to amend the means by which men were made manly during the century's third quarter. Eakins's canvases achieved this end, not through a wholesale reinvention of Gilded Age manhood, but rather by selectively adapting and presenting emergent masculine strains. While manhood's complex and contradictory tenets made attainment of a perfect manhood impossible, the very heterogeneity of masculine ideals provided Gilded Age men with the flexibility to redefine their identities. By judiciously promoting elements of 1870s masculinity that corresponded to public perceptions of his makeup, Eakins began a discreet reworking of his manhood. Eakins's single most important failure, the achievement of financial and artistic "success," was precisely what many of his rowing works sought to redress.

Eakins's works capitalize on a subtle alteration in the meaning of success during the early 1870s—it was coming to mean more than simply a man's accomplishments in his profession. During these years many types of labor performed by men—successfully or not—were likened to industrial processes, and so masculinized by industry's long-standing ties to masculine culture. Eakins's 1874 painting of John Biglin—he was also one of America's most successful *single*-scull racers—illustrated and advanced this

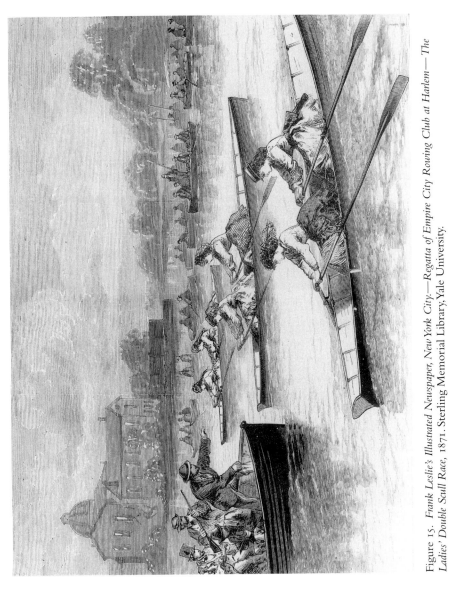

Figure 15. *Frank Leslie's Illustrated Newspaper, New York City:—Regatta of Empire City Rowing Club at Harlem—The Ladies' Double Scull Race*, 1871. Sterling Memorial Library, Yale University.

transformation. The firmly locked wrists and rigid arms evident in *John Biglin in a Single Scull* (1874; Fig. 16) attest to the rower's physicality as well as alluding to the mechanical nature of his exertion.[52] Biglin's left arm meets the oar at an acute angle, redirecting the oar's diagonal thrust toward his chest. The sharp angular meeting of oar and arm is echoed by the angle at which the rower's calf meets his thigh and by the pairs of iron outriggers meeting at the oarlock. Visually, Biglin seems but one part of the machine that he propels. As one sporting editorial in 1872 aptly noted, Biglin was a "tough, sinewy specimen of human mechanism."[53] Late-Victorian journal and book accounts of rowers described them variously as "machines," "watch springs," and "pistons."[54] One author even likened rowers to steam engines, maintaining that to be successful, "the fire-grate and chimneys of the human engine must be kept clear and in perfect working order." This writer was so taken with this metaphor that he referred to sweat almost exclusively as "steam."[55]

The visual and literary descriptions of "Biglin-as-machine" are directly tied to the rise of productivism in nineteenth-century American culture. Widely accepted later in the century, this theory held that the shared processes of production linked machines, workers, and natural forces.[56] Intrigued by productivism and what he calls "machine culture," Mark Seltzer claims that the increasingly blurred boundaries in Victorian literary descriptions of the users, makers, and managers of machines were a peculiar problem of the later nineteenth century. Drawing on the work of the historian Perry Miller and others, Seltzer argues that beginning at midcentury, the association "of steam power and generation [was] part of a larger celebration of technology by which Americans viewed the machine, and especially the steam engine . . . as a replacement for the human body." For Seltzer machine culture is interesting not so much for its equation of human and mechanical productions as for its tendency to naturalize and elevate the machine over the body.[57]

On one level, Eakins's rowing paintings can be seen to embody the pervading machine culture that Seltzer detected in literary works of the late nineteenth century. In light of the written and visual records coupling rowers to "pistons" and "steam engines," and given nineteenth-century rhetoric on the generative power of industrial machinery, Eakins's image of Biglin can be readily understood as an emblem of productivity. Certainly Biglin—as a sign for production—was of particular interest to

a man whose own artistic "productions" were so infrequently consumed by patrons.

But in a more specific sense, the painting's links to machines and to generative production also helped Eakins reinforce ties between his artistic practice and the masculine domain of industrial America. The American home, which early in the nineteenth century had been the site of production as well as consumption, became associated almost exclusively with consumption after midcentury. As men left their homes in increasingly large numbers, entering the industrial economy as paid workers (skilled and unskilled laborers as well as clerks and managers), the site of production shifted from home to factory. Increasingly left alone with child care and household work, women became closely associated with consumption, while their husbands, laboring primarily in offices and factories, were connected with production.[58]

Given this growing bifurcation between female (consuming) and male (producing) cultures in late-nineteenth-century America, Eakins might well have unconsciously appropriated the masculinized symbols of production by allying himself closely with male traditions of work and distancing himself from labor that was gendered female. By forging links with innovative boatbuilders, famous rowers, and the industrial machinery of production, Eakins symbolically strengthened his links to the male world.

On another, more suggestive, level the canvases' associations with machines and production construct ties between the spheres of work and leisure. At a time when Americans were ambivalent about leisure pursuits, the widely exhibited rowing canvases helped legitimate an emerging recreational culture.[59] As the historian Daniel Rogers has argued, the American ethos that valued work above all else began to decay in the 1850s, evolving by the 1870s into an ideal that balanced work and leisure. Beginning in the 1870s, leisure came to be viewed, not as mere idleness or indolence, but rather as an antidote to the excesses of Gilded Age labor practices. In the early 1870s, *The Christian Reader* contended that Americans now had "the duty of play."[60]

Such standard late-nineteenth-century admonitions were echoed by Eakins's friend the Philadelphia physician S. Weir Mitchell. Ministering predominantly to Philadelphia's wealthy, Mitchell helped his patients cope with the strains brought on by the rapid pace of urban life. In contrast with the Victorian "self-culture" tracts that encouraged the integration of

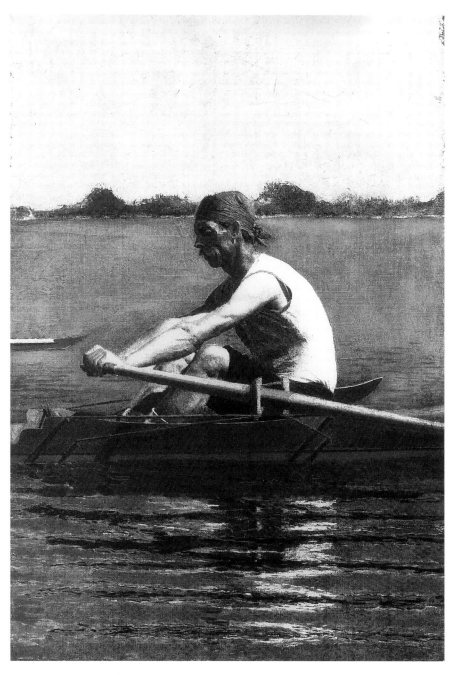

Figure 16. Thomas Eakins, *John Biglin in a Single Scull,* 1874. Oil on canvas mounted on aluminum, 61.7 × 40.7 cm. Yale University Art Gallery. Whitney Collections of Sporting Art, given in memory of Harry Payne Whitney, B.A. 1894, and Payne Whitney, B.A. 1898, by Francis P. Garvan, M.A. 1897, M.A. (Hon.) 1922.

intellectual and physical labors at work, Mitchell's doctrine tacitly accepted the impossibility of joining mental and manual tasks in the modern middle-class workplace. In *Wear and Tear, or Hints for the Overworked* (1871), Mitchell acknowledged the class-based division of labor, recommending a balance of mental work with physical play. In an era when the interconnections between the mind and body were only beginning to be understood, Mitchell assured his patients that "nothing is now more sure in hygienic science than that a proper alternation of physical and mental labor is best fitted to insure a lifetime of wholesome and rigorous intellectual exertion."[61]

Such cultural prescriptions would have appealed to Eakins, for they initiated a shift in the societal calculation of male identity. Assessments of mental exertion (work) alone as unwise, even reckless, and physical activity (sports) as beneficial articulated a middle-class standard of manhood that was not predicated on work alone. By advocating men's participation in physical activities that were not directly job related, the period's writers effectively articulated a reevaluation of manhood. This evolving rhetoric, which sought to balance work with leisure and mental with physical activity, was significant in opening the door to a conception of masculinity that was not predicated on traditional notions of success alone.

If Eakins had sold more paintings during his lifetime, those canvases would have stood as symbols of his success and, in turn, as a partial measure of his manhood. Having failed metaphorically to secure his masculinity through the marketplace, Eakins symbolically bolstered his masculine standing in his athletic canvases, both by linking himself to manly attributes and by subtly realigning Victorian definitions of manhood. By judiciously negotiating a path through the conflicted demands of Gilded Age masculinity, the painter offered images of athletes that reassured white, middle-class American men about their masculine identities.

Complicating the Heroes
of Modern Life

Given the intricate and conflicted strictures of late-nineteenth-century manhood, many American men found themselves unable to accommodate society's masculine ideals. Biographers of Henry James (1843–1916), one of Eakins's contemporaries, have frequently recounted the writer's difficulty in conforming to dominant models of Gilded Age masculinity. Noting his bachelorhood, passivity, ambivalent attitude toward women, and avoidance of Civil War service, both nineteenth- and twentieth-century observers have claimed that the writer's gender position combined both feminine and masculine traits. It is interesting to note, then, that many of James's novels employ strategies quite similar to those found in Eakins's canvases for coping with an awkward and often feminized social position.[1]

In the early pages of James's *Portrait of a Lady* (1881), the novel's heroine, Isabel Archer, is rescued from the isolation of upstate New York and brought to Europe by her wealthy aunt. Pretty, young, and articulate, Isabel attracts the interest of nearly all the novel's characters and is pursued by several suitors. Isabel's engagement is long anticipated by the reader, even if her choice of husband strikes us as somewhat odd. Although surrounded by men with clearly defined gender identities—from the effeminate Ralph, who is called sickly and feeble and takes after his "motherly" father, to the masculine and "supremely strong" Casper Goodwood, who is linked to armored warriors and Civil War officers—Isabel chooses the one character in the novel whose gender appears ambiguous.[2] Explaining her choice of suitor, the heroine makes it clear that she values Gilbert Osmond for his very "unknownness." She appreciates him precisely because he does not clearly fit into one of her preconceived categories.[3]

As cardboard cutouts representing the extremes of period conceptions of male identity, Ralph and Casper are twinned by the novel. They are joined by the very disparateness of their portrayals, placed at opposite poles of a sexual axis. But in the gendered economy of the novel, neither Ralph's femininity nor Casper's masculinity seems to be of value, for it is Osmond's blending of extremes that ensnares Isabel so completely.

As with James's characterization of Osmond, the vast majority of Eakins's portraits depicting men in interiors offer complicated accounts of their sitters. Such a construction is evident in the artist's series of works, painted over a thirty-year period, entitled *William Rush Carving His Allegorical Figure of the Schuylkill River.* Eakins's earliest rendering, completed in 1877 (see Plate 4) presents the hazy interior of Rush's dimly lit studio. We see the back of a standing nude woman, her left side highlighted, placed slightly to the right of the canvas's center. The model is bracketed on her right by a seated female chaperone who is knitting and on her left by a Chippendale chair, draped with the young woman's discarded dress and undergarments. Toward the rear of the studio we glimpse the figure of Rush with mallet and chisel, bending over the allegorical sculpture as he faces out toward his model.

Scholars generally explain that Eakins used Rush to illustrate the long tradition of American artists copying the naked female form in the hope of lending legitimacy to his own use of the nude model. Because Eakins was often criticized for using middle-class women as models in his classes and because his use of nudes contributed to his forced resignation as director of instruction at the Pennsylvania Academy of the Fine Arts, scholars and critics have always thought Eakins's (apocryphal) portrayal of Rush fitting.[4] Reviewing the painting in 1878 for the *Nation,* one critic observed that Eakins "seemed to have a lesson to deliver—the moral, namely, that good sculpture . . . can only be produced by the most uncompromising, unconventional study and analysis from life."[5]

Recent discussions of *William Rush* have pointed to the control exercised by the male sculptor over his female model, but they have often failed to mention how Rush himself is indirectly constructed by the nude figure. It is clear that by instructing his model to disrobe Rush strips her, in effect, of her respectable social identity and then re-creates her in the allegorical garb of his nymph.[6] But it is equally true that the shipcarver's identity, and by association Eakins's, is forged largely in relation to the female nude. Through his lifelong project of illustrating Rush's reliance

on the female nude, Eakins inexorably links the craftsman's identity to the naked female form. If only by tying Rush (a clothed active male) to his culturally accepted opposite (a naked inactive female), these works define Rush's manhood by emphasizing a polar understanding of male and female identities.[7]

At the same time that the canvas pictures the sculptor's relation to the nude figure, it also highlights links between Rush and the model's chaperone. If the tension established by Rush and his model points to a polar model of gender formation, the juxtaposition of Rush and the chaperone (whom I read as his double) suggests a more complex and nuanced formulation of the sculptor's identity.[8] Placed in opposite corners of the canvas, both carver and chaperone are positioned behind (and facing) the dominant verticals established by the figures of the statue and model. That Eakins carefully considered the placement of his figures is made obvious in his preparatory oil sketch of 1876 (Fig. 17); here we see that he initially considered depicting the chaperone turned away from the model but rejected such an arrangement in the final canvas. Over thirty years later, in his 1908 rendering of the scene (Fig. 18), he again positions the chaperone facing the model in much the same way that Rush is positioned before his sculpture.

In both finished canvases the sculptor and knitter are bent over their work, absorbed in their creations, apparently oblivious of the nude model before them. The seemingly disparate activities of Rush and the chaperone actually link the painting's characters through the ways in which each works to represent the naked woman. Rush's refashioning of the model is obvious; by carving his allegorical figure, he represents the woman in the guise of a mythological water nymph. The chaperone, however, remakes the model simply by being present in the scene. By overseeing the artist, the older woman transforms the model from a prostitute or "fallen" woman into a respectable figure.

But the work also allows us to read the chaperone's role in a more active light. Mimicking Rush's placement before his sculpture, she may be seen physically to reconstruct the nude in much the same way as the carver. Just as the artist carves (figurative) clothes for the naked model, the chaperone knits (literal) clothing for the everyday Victorian world. Both the garments she creates and the respectability she brings to the scene are efforts to maintain (and replicate) the values of proper middle-class culture. Each figure, then, begins with the model's naked body and then

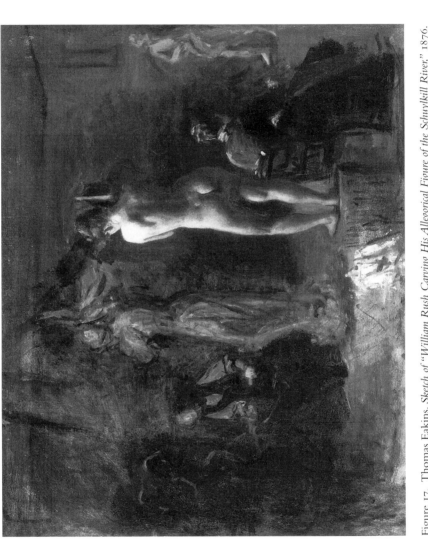

Figure 17. Thomas Eakins, *Sketch of "William Rush Carving His Allegorical Figure of the Schuylkill River,"* 1876. Oil on canvas, 51.3 × 61 cm. Yale University Art Gallery. Collection of Mary C. and James W. Fosburgh, B.A. 1933.

Figure 18. Thomas Eakins, *William Rush Carving His Allegorical Figure of the Schuylkill River*, 1908. Oil on canvas, 89.7 × 121.3 cm. The Brooklyn Museum. Dick S. Ramsay Fund.

attempts to represent the woman in ways appropriate to their respective visions of society. For Rush the model is something that must be stripped down to the "natural" bodily state in order to provide him with inspiration, while for the chaperone the body is something to be shielded. Both artist and chaperone want to build upon the nude form, but they have radically different conceptions of how the model should be recast. Rush's vision is primarily creative, while that of the chaperone is essentially replicative.

By doubling the artist and the chaperone, by linking them through both their formal qualities and their activities, Eakins complicates readings of Rush's identity. The chaperone helps make clear that Rush is far more than a sign for the "artist as genius"; his ties to the chaperone hint at the replicative and functional nature of his craft. He not only draws on classical myths for inspiration but also constructs a working fountain that was designed to spew water from the beak of the bittern on the nymph's shoulder. In an early-nineteenth-century painting by John Lewis Krimmel, *Fourth of July in Centre Square* (by 1812; Fig. 19), we can see Rush's sculpture placed in its original setting in the heart of Philadelphia. Rush's artistic project may be largely creative and ornamental, but, as Eakins's painting suggests, these were not the only facets of his art.

Rush's doubling is significant because the replicative and functional elements, illustrated as components of the carver's art, link him to craft traditions that in the late nineteenth century were closely associated with feminine culture. Embracing an artistic hierarchy that continues to hold sway today, Eakins's contemporaries understood crafts as largely replicative, functional, and female, whereas fine arts were taken to be the highest form of artistic expression, the exclusive product of male genius. Because of economic and ideological imperatives (initiated during the Renaissance and firmly in place by the mid–nineteenth century), women were effectively prevented from engaging in many high-art pursuits. Rozsika Parker and Griselda Pollock have argued that women's crafts were both devalued and understood as feminine precisely because women took them up. According to Parker and Pollock, the isolation of women's art and women artists was essential "to provide an opposite against which male art and the male artist [could] find meaning and sustain their dominance."[9] By associating Rush with a feminine craft tradition, Eakins problematized reductive divisions of "male" and "female" arts, at the same

Figure 19. John Lewis Krimmel, *Fourth of July in Centre Square,* by 1812. Oil on canvas, 57.8 × 73.7 cm. Cour-
of the Museum of American Art of the Pennsylvania Academy of the Fine Arts, Philadelphia. Pennsylvania
demy purchase (from the estate of Paul Beck Jr.).

time that he suggested the societal legitimacy for feminine elements con-
tained within his own artistic productions.[10]

In explicating the unconventional construction of gender evidenced
in the *William Rush* series, I am not trying to label Eakins as a champion
of gender equality. Given a number of his paintings that unproblemati-
cally tie women to historically feminine traditions, such as *In Grandmother's
Time* (1876; Smith College Museum of Art, Northampton, Mass.),
Courtship (ca. 1878; Fine Arts Museum of San Francisco), and *Portrait of
Mary Arthur* (1900; Fig. 20), such a conclusion would appear simplistic.
But neither do I wish to claim that the expanded vision of femininity
presented in *William Rush* is simply incidental to the artist's larger proj-
ect. While it is likely that Eakins possessed an unconscious interest in
breaking down various boundaries between male and female identities—
for the sake of naturalizing his own liminal subject position—his can-
vases' constructions of gender are not simply reducible to his desire to
appear manly.

Eakins's willingness to create more expansive images of femininity, even
when such images did little to secure his own masculine standing, is evi-
dent in canvases such as *Home Scene* (ca. 1870; Fig. 21), portraying his sis-
ters, Caroline and Margaret, in a warm Victorian parlor. Caroline lies on
a richly patterned carpet; with her left hand she props her head, and with
the other draws on a small slate. Margaret sits directly behind Caroline on
a piano stool. With her head also propped, Margaret turns from her musi-
cal score and piano to play with a kitten on her shoulder. Eakins's genre
scene illustrates the potential for many different kinds of play. Caroline,
whether writing or drawing, actively plays with her slate. Margaret plays
with the kitten, and the piano alludes to the potential for musical play.

Each figure, positioned with a hand on her head, hints at the necessary
connections between mind and physical activity. On the blank slate before
her, Caroline is free to create images and words that please her; with no
script to dictate her activity, she works on her tabula rasa. Margaret, who
sits before a page of commercially printed sheet music, has the option of
interpreting the music, but the black notes before her denote the cre-
ativity of another. While Caroline imagines her drawings, Margaret appears
to have been following her music. Placed in the opposite corner of the
composition, the black slate with its white markings will provide a telling
contrast with the white sheet music and its black notes. These emblems

Figure 20. Thomas Eakins, *Portrait of Mary Arthur,* 1900. Oil on canvas, 61 × 50.8 cm. The Metropolitan Museum of Art, New York, gift of Miss Mary Arthur Bates, 1965.

Figure 21. Thomas Eakins, *Home Scene,* ca. 1871. Oil on canvas, 55.9 × 46.3 cm. The Brooklyn Museum. Gift of George A. Hearn, Frederick Loeser Art Fund, Dick S. Ramsay Fund, gift of Charles Schieren.

of creation are formal and symbolic "reversals" of each other, marking the divide between imagination and replication.

The Eakins children may present an opposition between imaginative and replicative pursuits, but as with Rush and the chaperone, Caroline and Margaret must also be seen as sharing space along a developmental continuum. If the continuum of the Rush series offered an expansive view of gendered identity, suggesting the continuity between various "male" and "female" pursuits, *Home Scene*'s continuum seems to describe an essentially conservative trajectory for the development of middle-class girls. In many ways, the painting echoes the period's assumptions about education's role in "finishing" young women. As the principal of a prominent girl's school suggested to her graduating seniors in 1868, "How long a course of training has been required to prepare you for this day! From your first rude attempts to form letters with a pen, from your first imperfect efforts to express your thoughts in writing. . . . And how long and laborious has been your application to the science of music, to prepare you to perform with skill and execution the most difficult pieces of the greatest masters of the science of harmony."[11] Moving from basic writing skills to the mastery of complicated piano pieces, this principal's students went from unformed girls to educated women. The orator makes clear the purpose of all these hours of labor when she admonishes students not to "expect in this place to hear much upon the *rights of women,* while her *duties* will claim most of our attention [emphasis in original]."[12]

Caroline may begin by drawing and writing her name on the slate, but in time she will be expected to progress to the piano where her sister now sits. Caroline creates, but she is poised on the brink of committing herself to replicate the works of other "masters." And yet, that *suggested* developmental continuum (from creative to replicative pursuits) is not ultimately the dominant ideology advanced by the canvas. While hinting at such an evolutionary route for Victorian girls, the painting illustrates a more novel course of maturation. Whether playing with the kitten or gazing wistfully at her sister, Margaret pointedly turns from the replicative potential of the piano, while Caroline ignores both her sister and the cat in order to pursue the imaginative possibilities of her chalkboard. Perhaps most intriguingly, Eakins provides subtle links between himself and his youngest sister. Not only does Caroline draw, but her framed rectangular slate, oriented vertically, echoes the shape and orientation of Eakins's framed canvas. In the lower right-hand corner of the canvas, directly across

from Caroline's chalkboard, Eakins scratched his name into the paint sur-
face, leaving a trail of tiny white letters, almost as if Caroline had reached
across and scribbled it with her small piece of chalk.[13] By creating visual
links between himself and Caroline, Eakins's work blurs the traditional
trajectory of female development. If Caroline's advancement toward copy-
ing offers the dominant route, her continued interest in creating might
here be proffered as another possibility. While clearly aware of the dom-
inant paradigm, *Home Scene* circumvents it, picturing alternative paths of
development that—while socially progressive—have little to do with
securing the artist's masculine standing.[14]

Although he included doubles in the *William Rush* paintings, Eakins only
infrequently paired the women and men of his canvases. In most of the
portraits that complicate masculine identity, Eakins stresses the fragmen-
tary and often feminine qualities of his sitters through the selection of set-
tings, juxtaposition of characters, and arrangement of props. Despite the
efficacy with which doubles may be employed to problematize dominant
configurations of gender, a double's inclusion makes it difficult to avoid
reading a painting's characters in terms of facile binary oppositions.
Because the majority of Eakins's paintings do not present a simple pair-
ing of women with men, his canvases avoid the reductive one-to-one
opposition that such a juxtaposition necessarily encourages.

On the most basic level the resonances of Eakins's paintings depicting
men in interiors are more complex than those set outdoors, given that
the "inside" was a site the sexes shared. The nineteenth-century shifts in
production and consumption (discussed in chapter 1) coded not only cer-
tain jobs as "male" and "female," but also the spaces associated with those
tasks. Given the home's relationship to women's domestic work, the iden-
tities of Eakins's male sitters inhabiting interiors were modified by the
feminine nature of the spaces they occupied.[15]

Showing little concern with distancing his sitters from the feminine
resonances of domestic spaces, many of Eakins's paintings work instead to
entangle his male subjects in feminine culture. Instead of depicting men
in an office or factory setting, dressed in their business clothes, Eakins's
canvases show most of his subjects in casual clothing, either inside the
home or in an ambiguous setting. While I am not trying to argue that
Eakins problematized the masculine identities of his male sitters merely

by placing them in a domestic interior, I do maintain that many of these portraits stress their sitters' intricate construction as characters that possess both "male" and "female" traits and that certain of these works make a concerted effort to undermine the masculinity of their sitters.

Such an effort to destabilize dominant masculine definitions is evident in one of Eakins's earliest portraits, *Professor Benjamin Howard Rand* (1874; see Plate 5). The painting portrays the artist's former high school chemistry instructor seated in an ornately carved high-back chair behind a large partners desk. Nestled in a dimly lit interior, Rand is flanked on his right by a series of shiny brass scientific instruments and on his left by a rose, along with a clutter of quills, papers, and fruit. Toward the rear of the painting, the seated professor is bracketed by a column of shelved books and a dark swath of curtain. In the foreground are strewn a heaped fur rug, filled wastepaper basket, and a brightly colored shawl draped over the back of a chair. Rand strokes the back of a dark cat perched on top of his desk, as he marks his place in a large book with his right hand.

Because Rand's portrait was infrequently exhibited outside Jefferson Medical College, to which it was donated by the sitter in 1878, there exist few nineteenth-century reviews of the work. Two known commentaries, from the painting's first showing at the United States Centennial Exhibition in Philadelphia, offer interesting glimpses of how the work was interpreted by audiences in the 1870s. The first, a brief mention, appeared in the *Philadelphia Evening Bulletin,* where a critic surveying the Centennial's American paintings wrote that *Benjamin Rand* was "a portrait which is made a picture by the many accessories introduced and . . . is one of the best contributions to the section."[16] A month later, another critic writing in the *Evening Telegraph* offered this more lengthy judgment: "Dr. Rand," the reviewer noted,

is shown seated behind his library table—upon which are scattered a number of articles, such as a microscope, books, papers, etc.—with one hand petting a Maltese cat, and with a finger of the other following the lines on a page in a book before him. The composition . . . is rather too elaborate for a portrait and the eye is confused by the multitude of objects that are introduced. The picture is carefully and consistently worked out however and although it lacks the simplicity that is desirable in a portrait it is an admirable example of genuinely artistic workmanship.[17]

Although the two reviewers disagreed over the effect produced by the props Eakins included in his painting, they both considered the objects

central to one's experience of the work. For the first critic the "accessories" converted the portrait into a picture, while for the second the props made the scene "too elaborate for a portrait." In each case the reviewer understood Eakins's manipulation of accessories as pushing at the bounds of the portrait genre.

Unlike traditional American portraits, in which the sitter's profession was frequently signaled by the careful placement of a select number of props, the identity of Rand is muddled by Eakins's insistence on filling the painting with a profusion of objects. Whereas strikingly sparse portraits such as John Singleton Copley's *Paul Revere* (1768; Fig. 22) allow us to contemplate the sitter's facial features while the inclusion of a select number of his silversmith's tools identifies his profession, Eakins's work distracts the eye from Rand's face and prevents us from making such quick judgments about the sitter.[18] Eastman Johnson's antebellum portrait entitled *Genio C. Scott* (1859; Fig. 23), while admittedly more crowded than Copley's depiction of Revere, similarly subordinates its props to the sitter. The stack of books on the left and the fishing pole on the right of the canvas point to Scott's profession as a publisher and to his favorite pastime without overwhelming the figure.

We may assume, however, that the confusion noted by the critic for the *Evening Telegraph* relates not merely to the number of objects portrayed but also to the mixed signals that those objects send, for if the multitude of objects offered a consistent message about the sitter's identity, they surely would have furthered the aims of portraiture. Eakins's portrait *Mrs. William D. Frishmuth* (1900; Fig. 24) is just as crowded as his depiction of Rand, but here the obvious musical theme of the illustrated objects advances, rather than hinders, our understanding of the sitter.[19] If Frishmuth's musical instruments, Revere's shiny teapot and tools, and Scott's books and fishing equipment are pictorial articulations of their sitters' identities, what may we deduce from the cacophony of discordant objects that surrounds Rand?

It is intriguing to note that even in the twentieth century, consideration of Rand's accessories has remained central to art historians' discussions of Eakins's work. Writing in 1946 Margaret McHenry observed:

Eakins painted Professor Bejamin H. Rand seated behind a table rather over-full of a surprising collection of things. On the left stand a microscope, test tubes and other instruments, setting a precedent Eakins followed the rest of his life of including in a portrait something to suggest the achievements of the person

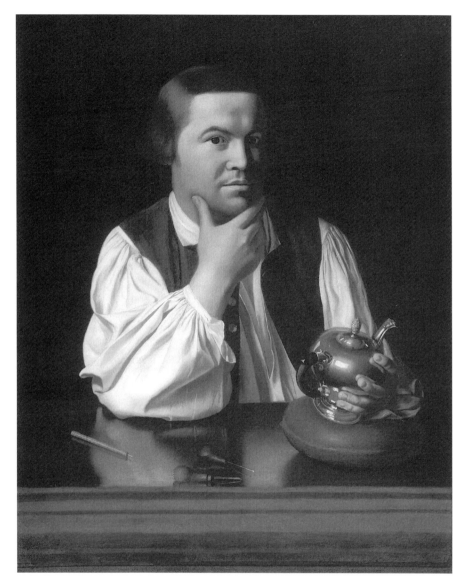

Figure 22. John Singleton Copley, *Paul Revere,* 1768. Oil on canvas, 88.9 × 72.3 cm. Gift of Joseph W. Revere, William B. Revere, and Edward H. R. Revere. Courtesy, Museum of Fine Arts, Boston.

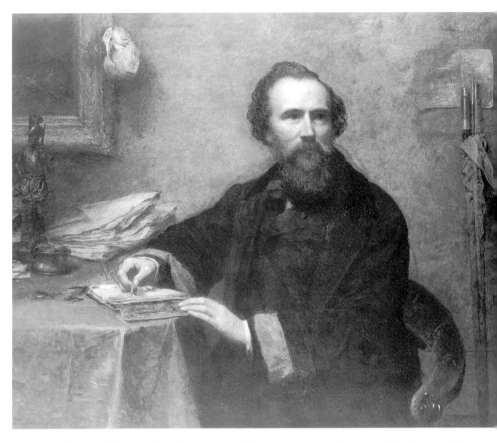

Figure 23. Eastman Johnson, *Genio C. Scott,* 1859. Oil on canvas, 102.3 × 127 cm. The Cleveland Museum of Art, Mr. and Mrs. William H. Marlatt Fund.

Figure 24. Thomas Eakins, *Mrs. William D. Frishmuth,* 1900. Oil on canvas, 243.8 × 182.9 cm. Philadelphia Museum of Art: given by Mrs. Thomas Eakins and Miss Mary Adeline Williams.

posing. The liquid in one test tube is brilliant red, and the brass of the micro-
scope shines. On the right of the table is a black cat which Professor Rand holds
by the back with his left hand while with his right he points to a page of an open
book. A spot of color is achieved by a pink rose, green leaves, lying on the book,
a piece of bluish crinkled paper hanging down from the table over a blue cover,
and a vivid piece of reddish purple cloth with tassels over a chair in front of it.
These props from the artist's studio thrust onto a man of science created an effect
which Eakins never strived for again. They are conspicuously absent from his
other portraits.[20]

Once more we see that the confusion of the scene results not only from
the number of objects portrayed but from the differing messages articu-
lated. McHenry is careful to distinguish two distinct "camps" of objects
within Eakins's "surprising collection": that of the sitter, comprising the
microscope, test tubes, and other instruments, and that of the artist, com-
posed of the pink rose, crinkled paper, and cloth with tassels. The critic is
certain that Eakins's props do not blend into the scene but instead appear
"thrust onto a man of science." For McHenry the canvas is neatly divided
into two halves, the left side containing linear objects that fit Rand's pro-
fession, the right side holding painterly props more appropriate to the
artist's craft.[21]

 The curiosity shown by both nineteenth- and twentieth-century crit-
ics regarding the canvas's props is perhaps understandable given the cul-
tural gendering of those objects. By presenting an obvious contrast
between the hard, metallic objects of science and the soft, organic objects
associated with home life, Eakins established a visual and metaphorical
tension in his canvas. Noting that Rand "is seated in a room that contains
not only a rose (that may or may not have belonged to an absent woman)
but also a crimson shawl flung over the chair for whom it is hard to imag-
ine a male owner," Marcia Pointon details the ways in which a number
of the portrait's props are linked to a feminine presence.[22] As a "sign" for
the feminine, the brightly colored rose and shawl balance the brass com-
pound microscope, beam balance, knife, and test tubes placed at the oppo-
site side of the composition. As allusions to the "male" and "female," these
distinct groups of objects may be taken to represent opposite points on a
sexual pole. But, running as they do along the surface of Rand's desk, the
two disparate clusterings hint at a model of gender that might best be
understood to reside on a continuum.[23] A continuum is further suggested
by the manner in which both groups are cropped at the sides of the can-

vas, intimating that they continue beyond the boundaries of the portrait, and by the intermingling of the objects along the plane of the desk. A knife from the left and the rose and tissue paper from the right seem to converge at the center of the canvas, meeting at the figure of Rand.

By pointing out such positivist oppositions as hard/soft and metallic/organic, I do not make claims for the innate "maleness" or "femaleness" of particular objects, nor do I suggest that masculinity must be understood in opposition to femininity. Rather, I wish to illustrate how the various objects would have been consciously interpreted by nineteenth-century audiences, most of whom surely would have perceived gender in such binary terms. *The Consecration, 1861* (1865; Fig. 25), by George Cochran Lambdin, illustrates the clarity with which Gilded Age viewers would have grasped the meeting of the distinctly "male" knife and "female" flower directly in front of Rand. The painting depicts a young woman kissing the sword of a Union officer as she bids him good-bye; the soldier returns her gesture by kissing a flower. Lambdin's chaste depiction of lovers parting certainly avoided shocking Victorian audiences, even as it left little doubt about the significance of their gestures.

Placed at the center of the composition, at the intersection of the canvas's contending "male" and "female" props, Rand is illustrated at the nexus of masculine and feminine cultures. But it is not exclusively visual evidence that locates Rand at the center of this gendered continuum. His profession further complicated his identity because it possessed mixed gendered associations for late-nineteenth-century audiences. Rand worked in a low-status field that was poorly paid and dominated by women. But he taught at Philadelphia's prestigious Central High School, which had no female instructors; teachers there were paid the highest salaries in the state and were referred to by the honorific title of "professor."[24] Rand's profession bound him to a largely female group that possessed little influence, but his appointment at Philadelphia's only normal school tied him to a powerful group of male colleagues. Furthermore, by the time Eakins painted his former teacher's portrait, Rand had left Central High School to become professor of chemistry at Jefferson Medical College.[25] *Professor Benjamin Howard Rand* certainly pays tribute to the artist's old high school teacher, but at the same time it acknowledges his ascendancy to a new position at Jefferson. By hinting at Rand's professional evolution, the work may have offered encouragement to the marginalized artist: just as Rand moved from a profession that was ambiguously placed between male and

Figure 25. George Cochran Lambdin, *The Consecration, 1861*, 1865. Oil on canvas, 61 × 47 cm. Indianapolis Museum of Art, James E. Roberts Fund.

female cultures to one more securely within the male orbit, so too might Eakins move from his awkward social position to one more closely allied with the masculine in Victorian America.

As if to further stress the intermingled nature of male and female constructions, Eakins allows for the reading of a second continuum, from the top back to the bottom front of the portrait. The dangling tissue paper and draped shawl offer a visual bridge from the domestic objects on the right side of the desk to the patterned carpet, overflowing wastebasket, and fur rug in the immediate foreground. These household objects at the base of the desk are soft (in both texture and focus), offering a strong contrast to the hard, linear instruments on the left. Even Rand's body seems to lose definition below the level of the desk. While his face, torso, and hands are carefully delineated, his lower body melts into indistinct, undifferentiated splotches of dark pigment. The divisions of hard and soft, linear and painterly, that were evident along the surface of the desk are repeated above and below the table, with Rand again placed at the center of the continuum.

It is worth noting that McHenry assumed the shawl (along with most of the other props from the right side of the desk) to be from Eakins's studio, for such an assumption sustains a connection between the artist and the "feminine" side of the canvas. Even if McHenry is mistaken in ascribing ownership of the props to Eakins, the artist is linked to the near side of the desk: this is where he stood to paint the scene, and his signature is included along the desk's upper left-hand drawer. It is not difficult to imagine the artist, placed before Rand's partners desk in the space now occupied by the painting's viewers, as the scientist's "partner" along the depicted gender continuum.

The visual evidence connecting Eakins the artist with Rand the scientist is augmented by period descriptions of Eakins and his painting. Many reviewers of the 1870s and 1880s were startled (often unfavorably) by what they perceived to be Eakins's ability to couple the disparate fields of science and art. Commenting on Eakins's *May Morning in the Park (The Fairman Rogers' Four-in-Hand)* (1879; Fig. 26), one such critic cautioned that the painting "may be scientifically true; but is apparently, and so, I think, artistically false." While the majority of nineteenth-century commentators disparaged Eakins's reliance on science, a few critics were impressed by this aspect of his work. Thomas Eakins, proclaimed an admiring critic, painted "by a kind of brutal exactitude which holds in a vise-

grip the scientific facts."[26] Another like-minded reviewer reporting from the Centennial Exhibition gushed over Eakins's controversial *Gross Clinic,* which was hung, not in the art department, but with the army's medical displays. As the reporter wrote, in the medical department "may also be seen a large oil painting of professor Gross performing a surgical operation, a splendid work of art in itself, while hanging on the walls are micrographs of various medical and scientific subjects, with transparent specimens of the same kind in the windows."[27] While acknowledging the painting to be "a work of art," the journalist describes the *Clinic* as fitting seamlessly into the world of science. His description melds the painting into the display as if it were just another micrograph along the wall. Given that nineteenth-century commentators could not agree on the compatibility of art and science, it seems significant that the critics consistently discerned such a link in Eakins's art.

In fact, many of the strategies that I credit with improving Eakins's masculine standing were noted by nineteenth-century critics. Period commentators may not have interpreted Eakins's interest in scientific and athletic subjects, nor his rigorous production methods, as masculinizing strategies, though they were very much aware that such "idiosyncrasies" separated Eakins and his art from more typical artists and their works. On one level this separation may have hindered Eakins's sales by ensuring that his paintings would never be associated with mainstream art, yet it also managed to strengthen his masculine standing by isolating the painter from feminine associations that beset the vast majority of American artists. Because art has long been connected with "domesticity" and "culture," both of which possess long-standing ties to the feminine sphere, and because women were often *perceived* to be art's primary consumers, nineteenth-century American artists have consistently occupied a liminal social position, wherein their masculinity was frequently questioned.[28]

But just as the canvases helped masculinize Eakins, there is a way in which we can see his paintings as masculinizing the very nature of his art. In other words, the metaphorical associations that allowed the paintings to serve as sites through which the artist and his contemporaries might rework their masculine identities came, in turn, to redefine the nature of the works themselves. As modern-day scholars have noted, Eakins's renderings of scientists and athletes—which seemed so novel on the walls of art museums and galleries—had long been standard fare in the period's specialized medical and sporting journals.[29] If the canvases were unique,

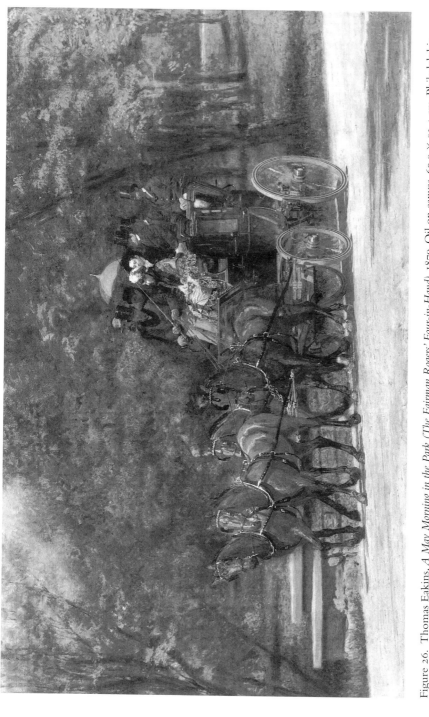

Figure 26. Thomas Eakins, *A May Morning in the Park (The Fairman Rogers' Four-in-Hand)*, 1879. Oil on canvas, 60.9 × 91.4 cm. Philadelphia Museum of Art: given by William Alexander Dick.

this had more to do with their installation in institutions dedicated to high art than with their purportedly novel subject matter. Yet once displayed within these institutional settings, Eakins's prosaic subjects came to alter period perceptions of what constituted manly art.

It is my contention, for example, that in applauding the artist's athletic canvases for their "pure natural force and virility," the critic covering the 1875 Water-Color Society Exhibition for the *Nation* was taken with the paintings precisely because of their unusual context.[30] Had Eakins's images of athletes been published in a sporting periodical such as the *Aquatic Monthly*, it is unlikely that the pictures' "virility" would have been remarked upon. It was only within the femininely charged institutional space of the art gallery, where the novelty of Eakins's works was unmistakable, that they became manly, so establishing a precedent for the types of images that American critics and the public would come to view as masculine. While neither athletic races nor medical procedures were manly in and of themselves, the mere fact that such images were consumed by men, in sporting weeklies and academic periodicals, gave them a masculine quality within the feminine world of the high-art gallery. But since viewers apprehended the canvases' masculine nature without conscious regard for how the images' shifting context gendered the paintings, masculinity appeared rooted in nothing more than the canvases' subject matter, thus promoting a very modern understanding of manhood. Eakins's canvases helped advance the shift from manhood as a lengthy developmental process in the nineteenth century to masculinity as a kind of performance in the twentieth.

Up to this point my examination of Eakins's work has focused on how the canvases complicate simple binary notions of gender, thereby normalizing the artist's feminized social position. I now want to consider how his paintings helped alleviate what I take to be his uncomfortable familial position. To begin, I pick up on a theme already central to my discussions of Rush and Rand, namely, the portrayal of time. Much like the work of the grand-manner history painters, whose heroic canvases advance didactic lessons, Eakins's prosaic scenes of everyday life frequently deliver a message. But whereas traditional history paintings use time to illustrate the "timeless" nature of their moral, Eakins's works recognize time precisely for its ability to enable change. Just as *William Rush* pointed

to the evolution of public taste over the course of the nineteenth century, and *Benjamin Rand* made reference to the teacher's professional advancement during the 1860s and 1870s, Eakins's canvases continually stress the promise of change over time. The significance of these diachronic works lies in their ability to stabilize the artist's masculine identity through allusions to his potential for professional and personal advancement. If the works in and of themselves were unable to make Eakins more manly, they at least suggested the transient nature of his feminized social position.[31]

It is with this potential for change in mind that I consider Eakins's intimate genre painting *The Chess Players* (1876; see Plate 6).[32] This diminutive picture presents the interior of a dark, wood-paneled room in which Eakins's father, Benjamin, stands observing the progress of a chess game, flanked on his left by George Holmes, a painting instructor and artist, and on his right by Bertrand Gardel, a teacher of French. Directly behind the men, a partially obstructed hearth and mantelpiece are visible, bracketed by bookcases. Along the back wall of the restrained Victorian parlor, Eakins accents the scene with a tall hookah, ornate clock, and large globe.

The painting catches the players at a contemplative moment, as they consider the state of their game. Focused intently on the board before them, the men deliberate the future, for proficient players consider not only their next moves but also the alternative moves for both themselves and their opponents many turns ahead. The board arrangement and missing pieces offer signs of the game's duration; that neither side is currently in checkmate suggests that the game will continue. Just as the game alludes to the passage of time, so too do the men themselves, for each is depicted at a distinct stage of life. From Holmes to Benjamin and then to Gardel, the men's ages advance. At the open space at the near side of the chess table, a fourth figure, either older than Gardel or younger than Holmes, might be inserted without disrupting the logic of time's flow. Time is further suggested by the globe, its shaded half hinting at time's passage through the rotation of the earth, and by the men's heads, which like heavenly spheres themselves at distinct points of rotation, display shadows similar to those on the globe. The clock points to the passage of hours; the globe, of days; and the men, of lifetimes.

Given the painting's attention to time and aging, it is not difficult to imagine this chess game as a model for life. Promoted by the scene's narrative, such an understanding is also encouraged by Eakins's artistic process. In a preparatory sketch for *The Chess Players,* Eakins's perspective

grid clearly replicates the grid of the game board (Fig. 27). The sketch's inclusion of tables and chairs furthers the effect by mimicking the arrangement of a giant chess game. With the addition of men in the final painting, we are led to understand the figures as human chess pieces placed on the "board of life." [33] The connection is confirmed by the fact that *The Chess Players* was painted, not on canvas, as was more typical of Eakins's practice, but on a wooden board. By painting his men on a board, the artist puts them into play, just as the characters play their tiny chess pieces.

But in the nineteenth century chess was more than a general metaphor for life, given the frequency with which it was conflated with violence. Period literary texts often likened the game to "the battle of life." [34] Paintings and prints told a similar story. From Gérôme's *Chess Players* (1859; Fig. 28), which hints at violence through its depiction of three orientalized sword-bearing soldiers, to J. B. Irving's unlocated painting *The End of the Game* (1872), illustrating a player slain over a chess game gone awry, visual renderings of chess reinforced the game's associations with real-world strife. [35] Despite what might be the game's largely benign nature today, the violence of nineteenth-century depictions was central to the game's ideology.

In *The Chess Players,* the cultural coupling of chess with violence is presented most obviously in the miniature game between Holmes and Gardel. Eakins's rendering of the game is so precise that the board arrangement can be largely re-created, confirming that Holmes (the younger figure on the viewer's right) is winning. [36] Holmes's black queen stands commandingly in the center of the board, where the piece has the freest rein of movement, while Gardel's captured white queen rests ineffectively inside the chess table's drawer. Holmes leans forward over the board, perched aggressively on the edge of his seat. His right hand cups his eye in concentration, while his left waits on the table, index finger slightly uncurled in preparation to make his move. In contrast, Gardel sits with the small of his back at the rear of his chair, with shoulders and head slumped toward the table and hands held protectively against his body.

Eakins's intention in contrasting the men's appearance is confirmed by an oil study of Gardel made for *The Chess Players* (ca. 1875; Fig. 29). In the sketch Gardel cups his chin in his hand while considering his next move. The pose seems to foreground the player's intellectual potential by pointedly linking head and hand. Yet in the final painting such an association is flatly rejected. By placing Gardel's hand weakly in his lap, even as

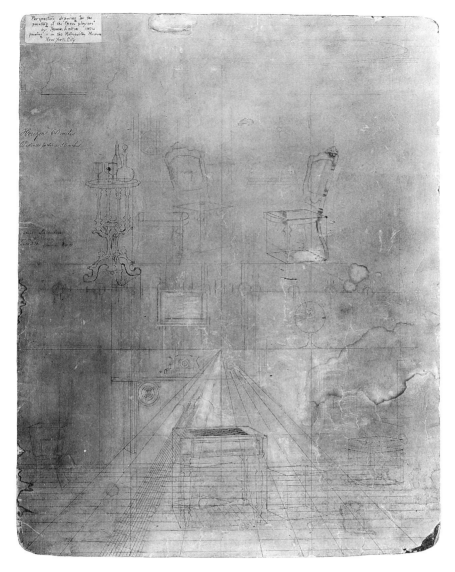

Figure 27. Thomas Eakins, *Sketch for "The Chess Players,"* 1876. Graphite and ink on cardboard, 61 × 48.3 cm. The Metropolitan Museum of Art, New York, Fletcher Fund, 1942.

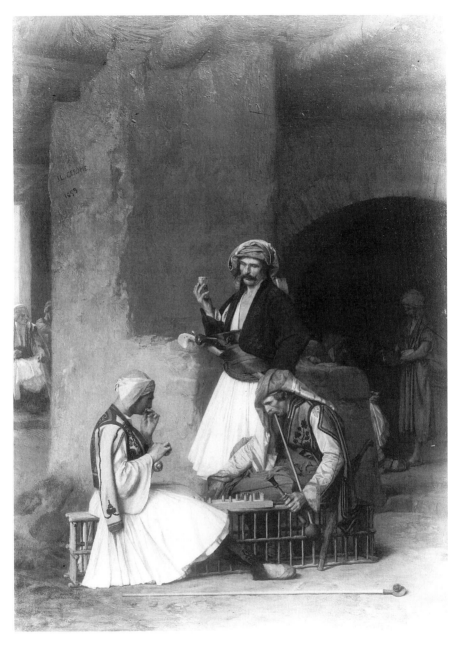

Figure 28. Jean-Léon Gérôme, *The Chess Players,* 1859. Oil on panel, 40.3 × 28.6 cm. The Wallace Collection, London.

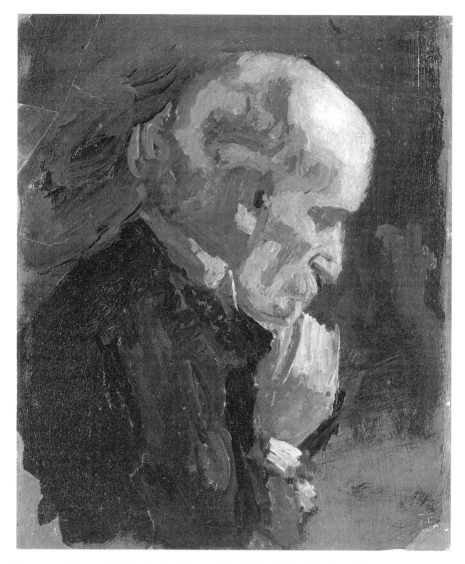

Figure 29. Thomas Eakins, *Sketch of Bertrand Gardel: Study for "The Chess Players,"* ca. 1876. Oil on paper mounted on cardboard, 31 × 25.4 cm. Philadelphia Museum of Art: gift of Mrs. Thomas Eakins and Miss Mary Adeline Williams.

Holmes holds his head, the artist reinforces differences between the play-
ers. In a written description mirroring Gardel's portrayal in *The Chess
Players*, Eakins called him a "poor good old man, a little, very little cun-
ning but so very very weak."[37] Holmes is young, alert, and anxious, while
his partner seems old and tired, apparently cowering under the weight of
competition. Linked by their black suits, their crisp white cuffs, and their
participation in a common game, Holmes and Gardel are nonetheless
coupled as opposites across the chessboard.[38]

By pairing two men as opposites, *The Chess Players* expands the param-
eters of masculine definition in a manner not possible through the jux-
taposition of male and female players.[39] Because most nineteenth-
century viewers understood male and female traits as oppositional, the
inclusion of a woman would have complicated efforts to illustrate vari-
ety in a single sex. Only by contrasting men could Eakins problematize
the notion of a single masculinity for period audiences. But even for
twentieth-century viewers who believe genders to be relational, with def-
inition of one not possible without consideration of others, *The Chess
Players* offers a similar lesson. As Andrea Cornwall and Nancy Lindisfarne
have noted, the use of a relational model inadvertently establishes an
opposition between genders that separates masculinity from femininity
merely in terms of difference. Such an approach slights not only the sim-
ilarities between genders but also the competing ideological strands in the
same gender.[40] By depicting Holmes and Gardel with (almost caricatured)
period attributes, stereotypically tied with either male or female gender,
Eakins highlighted a range of difference within masculinity. Just as Casper
Goodwood and Ralph Touchett demarcate the extremes of Victorian
"maleness" in James's *Portrait of a Lady*, so Holmes and Gardel work sim-
ilarly to expand the hypothetical bounds of masculinity. By picturing such
extremes, Eakins's painting stresses the range of attributes possessed by the
period's men, as it makes room for the artist's particular gendered posi-
tioning along the continuum of nineteenth-century manhood.

Given the younger Holmes's attempts to kill the older man's king, and
considering the cultural associations of chess with violence, it seems
inevitable to read the work as one that grapples with Oedipal issues.[41]
Such a reading is only strengthened by an examination of Eakins's rela-
tion to his father, for in addition to providing lifelong financial support,
Benjamin Eakins guided many facets of his son's life. After his graduation
from high school, Thomas worked under his father's tutelage as an

engrosser of documents, for some years listing himself in Philadelphia city directories as a writing teacher. Following his father's hobby of painting, Eakins enrolled during the 1860s in art classes at the Pennsylvania Academy of the Fine Arts. And when he set off for Europe to continue his artistic education, the trip was begun, not at Thomas's instigation, but over his objections. Even the artist's engagement to Kathrin Crowell in 1874 was said to have been undertaken at his father's insistence. More often than not, the direction taken by the younger Eakins during his early manhood was charted, not by himself, but by Benjamin.[42]

Benjamin's relationship with his son was patterned after the style of fatherhood dominant in the seventeenth and eighteenth centuries, what E. Anthony Rotundo calls "patriarchal fatherhood." Typified by land-based, agrarian economies, this version of fatherhood drew its strength from a father's ability to determine when a son would acquire land, and hence when he would attain independence and manhood. In such a system the father held considerable sway over his son's development, being responsible for instructing him in the practice of his livelihood (which in the eighteenth century the son would be likely to take up), providing his moral education, and overseeing his selection of a wife. While by the time of Eakins's birth patriarchal fatherhood had largely been replaced by what Rotundo calls "modern fatherhood," a series of idiosyncrasies in Benjamin's profession ensured that the older style of fatherhood dominated the Eakins's household. The absent father and economic decentering of the home that forced the reformulation of fatherhood in the early nineteenth century was not a reality of Thomas's childhood. Benjamin continued to work at home, as had men from the previous century, and involved all his family in his business of engrossing documents, thereby tying his children closely to his profession. While Benjamin's economic clout was not land-based, through his unusual (one might say eighteenth-century) profession he retained the paternal dominance of fathers in agrarian economies.[43]

Just as the two seated men engage in an allegorical battle across the chess board, so Eakins and his father may be read as playing out a psychological conflict between the board's other two sides.[44] Given the formal arrangement of a chess board, a game could theoretically be played between either pair of opposing sides.[45] This idea of intersecting dialogues taking place across the plane of the surface was a familiar one to Eakins and his contemporaries. When Thomas was in Europe, he wrote letters to

his parents by first filling up a sheet of paper; then, rotating the page ninety degrees clockwise, he would continue the correspondence in a lighter shade of ink, cross-hatching over the original inscription. This common period economy, to minimize transatlantic postage charges, is illustrated in a letter that Thomas wrote to his father from France in October 1866 (Fig. 30). If the chess board in the painting were rotated in a similar fashion, Benjamin would be playing in place of Gardel. And Thomas, I would suggest, takes up his position in the only area of the foreground that allows access, on the fourth side of the table.

If Thomas's relationship with Benjamin was indeed complicated by an ongoing Oedipal conflict, this might help explain the "ambivalence" of the father's portrayal, for the work seems to simultaneously affirm and negate the father. In the painting Benjamin is given an elevated status in a number of significant ways. The vanishing point of the work, which is corroborated by one of Eakins's detailed sketches (see Fig. 27), is located directly behind Benjamin's head, while the geometric center of the painting is found at his genitals. On the open drawer of the chess table, painted in small red letters, Eakins included the Latin inscription "BENJAMINI. EAKINS. FILIUS. PINXIT. 76" (The son of Benjamin Eakins painted this, '76). The inscription is interesting for two reasons: first, that Eakins chose a classical language to make his dedication, and second, that he chose to sign the work in such a way that he was negated, or at least diminished. Nowhere in the painting does the younger Eakins indicate that Thomas Eakins painted this work. Although he created the painting, Thomas was content to take his recognition solely through association with his father. The work, a gift to Benjamin, can be seen, then, as a personal statement of Thomas's devotion.[46] Benjamin, as the central figure in the painting and as the artist's father, explicitly provides Thomas with his identity.

But from the physical evidence of the work we can also see signs of Benjamin's negation. Eakins's father has his face largely obscured by shadows. His head is bowed so far that we cannot see his eyes and can discern only a hint of his mouth. From our view his right leg has been cut off, and his hands are both partially blocked from sight. In Eakins's portrayal of his father, *The Writing Master* (1882; Fig. 31), Benjamin's hands take on a larger-than-life appearance. With his face again bowed, the father's essence is expressed most clearly by those solid hands that fill the foreground. These were the hands with which Benjamin earned his living as a "writing master," supporting both himself and Thomas's art. The act of blocking those

Figure 30. Thomas Eakins, Letter to Benjamin Eakins, dated October 13, 1866. Courtesy of the Pennsylvania Academy of the Fine Arts Archives, Philadelphia.

hands in *The Chess Players* offers a subtle slight given that so much of Benjamin's identity and familial position was achieved through them. But most telling, perhaps, is Benjamin's negation through the very title of the painting. We know from Eakins's own records that he named the painting *The Chess Players*.[47] But if the title of the work is taken to refer literally to the two *obvious* chess players in the scene, the painting also serves in a strange way to remove Benjamin from the main narrative. Although the painting was dedicated to the artist's father, Eakins chose to label it in such a way that Benjamin was eliminated from any obvious narrative.

In marked contrast with the pairing of Holmes and Gardel as opposites, Thomas and Benjamin, I would argue, are twinned by their similar depictions. The ambivalent portrayal of Eakins's father makes it difficult to imagine his opposite across the board, but rather encourages an understanding of Thomas's identity as interpenetrated with Benjamin's. Because the father's construction is not easily articulated, the painting suggests that the son's identity is similarly complex. If Eakins's pairing with Rand stressed the legitimacy of feminine elements in the artist's profession, his coupling with Benjamin might be seen to naturalize his liminal familial position. By depicting his father as both dominant and submissive within the syntax of the painting, Eakins advances an understanding of the patriarch expansive enough to contain his own awkward familial position.

While the work may have served a personal function for the artist, in grappling with particular anxieties he felt in being dominated by his father, the painting certainly possessed more general resonances that help explain its enormous popularity among period critics.[48] The ambivalence that I have argued the artist felt toward "the father" might well have been shared by the men of Eakins's generation who came of age in postbellum America, for they reached adulthood at a time when the "rules" for separating oneself from one's family were becoming increasingly complex. Just as the metaphorical battle of the chess game alludes to the artist's personal Oedipal struggle, so it points out the generational conflicts between fathers and sons that came to a head in the years immediately following the Civil War. Much as Eakins struggled to attain manhood against the smothering controls of Benjamin, the artist's contemporaries were similarly engaged in renegotiating the restrictions of modern fatherhood.

As modern fatherhood rapidly gained ground in the second half of the nineteenth century, its own internal contradictions caused it to mutate, allowing for more flexible interpretations of a father's role. Because this

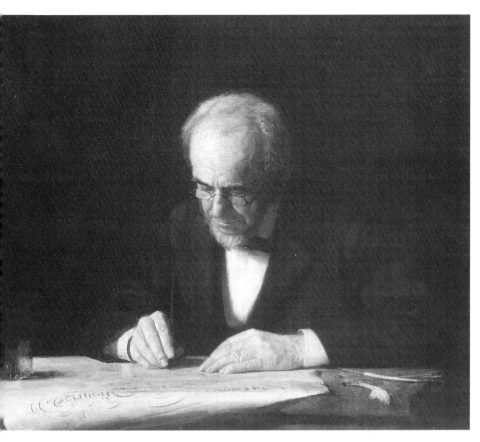

Figure 31. Thomas Eakins, *The Writing Master,* 1882. Oil on canvas, 76.2 × 87 cm. The Metropolitan Museum of Art, New York, Kennedy Fund, 1917.

form of fatherhood freed men from responsibility for their sons' moral education, fathers were allowed fully to withdraw from their children; at the same time, they were also permitted to forge playful, tender relations with their sons, for without the responsibility of acting as moral guides, they no longer feared that intimacy might spoil their boys. From the 1880s, fathers and sons increasingly sought to balance these apparently irreconcilable courses as they charted new familial relations that permitted them to exhibit both tenderness and detachment.[49]

Having examined a large sampling of correspondence written between soldiers and their families during the Civil War, Stephen Frank argues for the war's profound impact on patterns of Gilded Age fatherhood. At a time when the power of fathers to control their sons was already eroding, the war presented sons with a kind of shortcut to manhood. By offering boys a salary, the war allowed them to escape their financial dependence, as it stripped fathers of their most potent means of control. Now financially independent, sons who fought in the war were given added status by society's long-standing association of soldiers with manhood.[50] By quickly promoting boys to men, the Civil War caused a series of unexpected social problems. As Frank writes, "By making men of boys who were still bound to their fathers' households, the war bred conflict within a patriarchal family structure that did not readily accommodate two 'men' under one roof. This was especially problematic for fathers at a time when parental authority was . . . increasingly subject to challenge."[51]

If *The Chess Players* may be seen to inscribe the complex state of father-son relations in the 1870s, it may simultaneously be interpreted as promoting a resolution to the conflict. While the scene presents a complex dynamic of generational relations, it also strongly suggests that the fathers' days are coming to a close. The elderly men have decimated each other's forces at the table, much as their generation had done to their sons in the Civil War. Rooted by their advanced age to the first decades of the nineteenth century, the men appear as relics, surrounded by signs of late-Victorian culture. Not only do they sit in chairs, and at a table, of postbellum vintage, but their time is kept by a modern clock of the 1870s. Out of date with their surroundings, they have passed into the evening of their days, playing, as a nineteenth-century critic observed, "a game of chess that has lasted well into the twilight."[52]

The men, as I have already suggested, are placed on the board of life, but we may also read them as having finished their game. Consider how

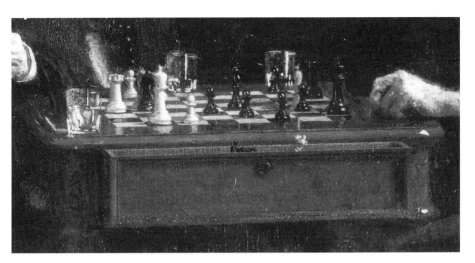

Figure 32. Thomas Eakins, detail of chess table drawer in *The Chess Players*, 1876. The Metropolitan Museum of Art, New York, gift of the artist, 1881.

the room's red carpet relates visually to the red felt inside the chess table's drawer. And notice how the captured game pieces, protruding slightly from their drawer, mimic the positioning of the players, sitting in a red-lined wooden box whose interior we only partially glimpse (Fig. 32). The standing Benjamin has the closest connection to the queen, while the other two less prominently displayed men echo the positions of the shorter black pieces, only slightly projecting from the drawer's left side. The players are cast simultaneously as powerful directors of the game on the small board and its hapless casualties on the larger board of history. If *The Chess Players* may be understood, in part, as a son's reflection on the evolving relations between fathers and sons, the scene's emphasis on the passage of time, on the future, and on the redundancy of the fathers seems particularly appropriate. Given the likelihood that both the artist and the youths of his generation would have looked forward, eager for the societal transformations that were weakening their fathers' power, *The Chess Players* must have offered an appealing note of change.

If the dominant strategy employed in Eakins's scenes of athletic men was to link the artist to the canvas's "masculine" protagonists, his paintings of men who are intellectually engaged may be seen to strengthen Eakins's

own masculine position by problematizing those of his sitters.[53] In his portraits of Rush, for example, Eakins tied himself to a respected artist whose craft was closely linked to feminine culture. In *Benjamin Rand,* Eakins links himself to a prominent scientist who sits at a nexus of competing male and female spheres, yet who "progressed" from an ambiguously gendered occupation to one more securely within male culture. Finally, in *The Chess Players,* Eakins took pains to illustrate a range of the period's masculinities. Pictorially wedded to his dominant father, who is nonetheless depicted in ambivalent terms, Eakins suggests the normalcy of his own awkward familial position. What binds all three canvases is their shared ability to make creative use of preexisting masculine constructs to broaden acceptable definitions of Gilded Age manhood. By offering up his "heroes of modern life" as complicated and ambiguous characters (much like himself), Eakins helped redraw the borders of permissible masculine identities.[54]

Alternative Communities

Given Eakins's frequently expressed love of the human body, his extensive use of naked models in teaching, and his production of thousands of study photographs of nudes, it is perhaps surprising that he completed only fourteen canvases depicting nude or scantily clad figures during a career spanning more than forty years.[1] Painted largely during two discrete moments of his career, in the early to mid-1880s, when his personal and professional standing was on the rise, and at the close of the 1890s, when he had experienced a series of professional setbacks, these canvases both signaled and conditioned Eakins's changing masculine position. Portrayals of the male nude are an obvious site at which to examine an artist's construction of masculinity, but in Eakins's case they are all the more resonant given the marked visual and ideological transformations that they underwent over the course of his professional life.

Fulfilling the ideological potential embodied in his portrait *Professor Benjamin Howard Rand*—of gender as an oscillating and malleable commodity—Eakins began during the late 1870s and early 1880s to attain a number of the traditional signs of late-Victorian manhood. Although the period brought him few commissions, and while critics continued to disparage his art, Eakins achieved a measure of success through his tenure as teacher at the Pennsylvania Academy of the Fine Arts. In 1879 he rose from his volunteer position as instructor of anatomy to professor of drawing and painting after the death of the Academy's longtime instructor Christian Schuessele. In 1882 he was promoted, this time to director of instruction, his salary climbing from six hundred to twelve hundred dollars a year. Now heading instruction at America's oldest academy of fine arts, Eakins revamped the school's traditional curriculum by promoting

nude life drawing, dissections, and extensive anatomy lectures. Under his controversial tenure the Academy was established as the country's most progressive school of art.[2] Held in high regard by the majority of his students, and on good terms with both Fairman Rogers and Edward Coates—the two chairmen of the committee on instruction under whom he served—Eakins thrived, despite occasional conflicts with the Academy's largely conservative board. Even reporters hostile to Eakins's paintings commented with increasing frequency on his overall importance to American art. Expressing sentiments that were quickly gaining ground in the early 1880s, a critic for the *American Art Review* opined that "in spite of [his] mannerisms, Mr. Eakins is one of our best artists."[3]

In addition to his professional accomplishments, Eakins also enjoyed what his contemporaries would have certainly understood as personal successes. In 1884 he married Susan Macdowell, one of his most promising Academy pupils. Leaving his father's house, he rented a small apartment near the Academy, where he lived with his wife. Now earning a living, enjoying a measure of respect, married, and residing in his own home, Eakins had by the middle 1880s attained many important indices of manhood that had eluded him throughout his youth.

Buoyed by the relative stability of his professional and personal standing, Eakins began to experiment more freely with his art. From the close of the 1870s, Eakins expanded his artistic horizons by creating magazine illustrations and commercial sculptures, experimenting with photography, and conducting motion-study experiments with Eadweard Muybridge at the University of Pennsylvania. By the early 1880s there were obvious shifts not only in his artistic media but also in his choice of subjects. It is no coincidence that when his masculinity was most stable, Eakins discontinued the virile scenes of sporting champions that had been a staple of his early art, turning instead to contemporary and historical genre scenes, a series of landscape paintings, and portraits of friends and students, as well as male nudes.

Despite Eakins's limited production of nudes, it is for his depictions of naked men that the artist is most frequently remembered today. Works such as *The Gross Clinic* and *The Swimming Hole* (see Plate 7) have largely come to characterize his artistic practice for late-twentieth-century audiences. In the nineteenth century as well, critics gave considerable attention to the painter's nudes, not because he depicted them more frequently than other Victorians, but rather because of their unusual presentation.

While Eakins's nudes were criticized for the same "verity" and lack of "artistry" that Gilded Age critics found objectionable in many of his other works, audiences were most unsettled by Eakins's reluctance to offer narrative explanations for his models' naked state. The nudes from the early 1880s either did not sufficiently mitigate the figures' nudity by placing the scene at a proper temporal or geographic distance from contemporary Philadelphia, or they refused to offer acceptable narrative justification to legitimate their models' undress.[4]

While Victorian critics could endure the exposed buttocks of the male patient in Eakins's 1875 portrayal of the *Gross Clinic* (even as they were unsettled by the graphic depiction of blood), many were profoundly disturbed by his depiction of Christ's body in *The Crucifixion* of 1880 (Fig. 33). The narrative elements that made the *Clinic*'s use of a male nude acceptable were precisely what period audiences sensed was absent in *The Crucifixion*. This ostensibly religious image was hardly radical for its choice of subject, depicting the death of a partially clothed Christ, but audiences were genuinely astonished by the manner in which Eakins seemed to have drained the image of religious significance. As a critic reviewing the work for the *Art Amateur* wrote of the painting in 1882, "The mere presentation of a human body suspended from a cross and dying a slow death under an Eastern sun cannot do anybody any good. . . . no doubt we may trust implicitly to what [Eakins] tells us about a body so suspended as we see this one, but there is nothing artistic in this realism because it does not stir any noble emotions."[5] Even more favorable reviewers were struck by the fact that the painting's "conception is at variance with that traditional in any school, all the commonly accepted accessories of the scene being absent."[6]

The precision and specificity of Eakins's rendering of a lone man dying an agonizing death made it difficult for audiences to connect this crucifixion with traditional biblical narratives. By humanizing and particularizing Christ, and so focusing our attention on what we might call the subnarrative of a man's demise, Eakins managed to dislodge the overarching metanarratives of salvation and grace that audiences expected to find. In *The Crucifixion,* as in most of Eakins's paintings of naked men from the 1880s, what unsettled viewers was not the absence of narratives per se, for all of these images created their own subnarratives through their specificity, but rather the absence of familiar metanarratives that reassured conservative audiences that the painting's nudity had social justification.

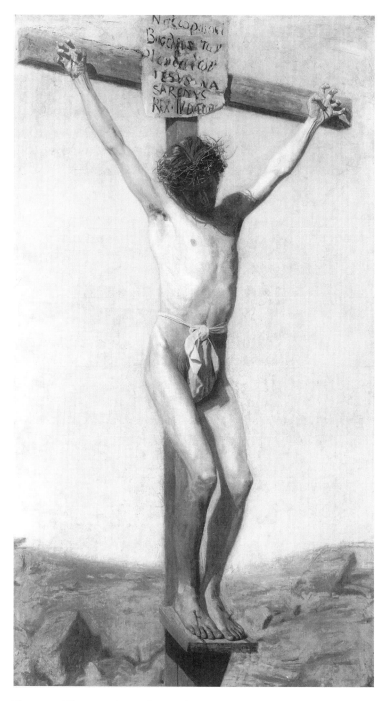

Figure 33. Thomas Eakins, *The Crucifixion*, 1880. Oil on canvas, 243.8 × 137.2 cm. Philadelphia Museum of Art: given by Mrs. Thomas Eakins and Miss Mary Adeline Williams.

This unwillingness on Eakins's part to provide socially acceptable explanations for the nudity of his male figures can certainly be understood, in part, as an expression of his artistic philosophy. By illustrating nudes without narrative excuses, the painter's canvases make the case for the value of nudes in their own right. Just as Eakins's teaching practice stressed the importance of studying the naked body for the creation of great art, his paintings made the complementary contention that nudes were a fitting subject of high art.

Nowhere in Eakins's oeuvre is this point more forcefully made than in *The Swimming Hole* (1885; see Plate 7). Portraying six nude men and a red setter dog arranged variously along a massive stone pier and in the light-dappled water, this quiet scene of a summer day's leisure has frequently been interpreted by twentieth-century critics as a nostalgic image of the late nineteenth century, recalling an earlier preindustrial world.[7] The painting was exhibited by the artist during his lifetime first as *Swimming* and then as *The Swimmers;* its title was altered (apparently by Eakins's widow, Susan Macdowell) for the painter's memorial exhibition in New York in 1917 to *The Swimming Hole,* and finally was changed to *The Old Swimming Hole* for a private gallery exhibition four years later.[8] The fact that many twentieth-century viewers have described the painting as nostalgic seems particularly understandable given the title's transformation; not coincidentally, "The Old Swimmin'-Hole" was the title of James Whitcomb Riley's popular poem of 1883 that paid tribute to a bygone age. For many twentieth-century viewers, Eakins's scene was evidently conflated with the saccharine sentiments of the poet's verse. As Riley's final stanza reads:

> Oh! the old swimmin'-hole! When I
> last saw the place,
> The scenes was all changed, like the
> change in my face;
> The bridge of the railroad now crosses
> the spot
> Whare the old divin'-log lays sunk and
> fergot.
> And I stray down the banks whare the
> trees ust to be—
> But never again will theyr shade
> shelter me!

> And I wish in my sorrow I could strip
> to the soul,
> And dive off in my grave like the old
> swimmin'-hole.[9]

Despite its more recently acquired associations, for Eakins and his con-
temporaries *Swimming* was a distinctly modern image, untinged by nos-
talgia. None of the painting's period reviewers even hinted at nostalgia in
their discussions of the work; instead, they commented on the canvas's
ties to explicitly modern pursuits such as science and photography.[10]
Notwithstanding the painting's lack of props and its vague narrative
(which allow *Swimming* to appear both timely and timeless), and despite
my claim for its essential modernity, I do not want to suggest that the past
is altogether absent from the scene. The canvas contains historical narra-
tives integral to its modernity that reveal much about Victorian manhood,
as we shall see when we consider the canvas's patron, Eakins's artistic prac-
tice, and the complex construction of artistic communities.

 Swimming was one of Eakins's rare commissions, ordered by the sum-
mer of 1884 by Edward Coates, chairman of the committee on instruc-
tion at the Pennsylvania Academy.[11] Like many of the artist's infrequent
commissions, *Swimming* was ultimately rejected by its patron, who in this
case claimed that the painting was "unrepresentative" of Eakins's oeuvre.[12]
As previous scholars have suggested, the canvas may have been understood
by Coates as a not so subtle visual articulation of Eakins's teaching phi-
losophy. Given the painting's bold depiction of nude men, Coates may
have worried that the canvas would be taken by Academy board mem-
bers, students, and the general public as a statement of the patron's sup-
port for Eakins's controversial study of the naked body. Such legitimation
was instantly accorded by the Academy's practice of listing the names of
the painting's owners in the annual exhibition catalogue. The Academy
catalogue of 1885 clearly lists *Swimming* as being in the collection of
Coates, even though Eakins's patron would ultimately decline to accept
the work, requesting in its place the artist's more conventional *Pathetic
Song* (1881; Fig. 34).[13] Coates's rejection of the canvas surely had much to
do with what *Swimming* said about the painter's artistic practices, but
unlike earlier scholars I am less interested in assessing why Coates declined
the commission than in determining why Eakins painted this particular
work in the first place. While we possess no record of Eakins's response
to the painting's rejection, we can assume his surprise, given the pains he

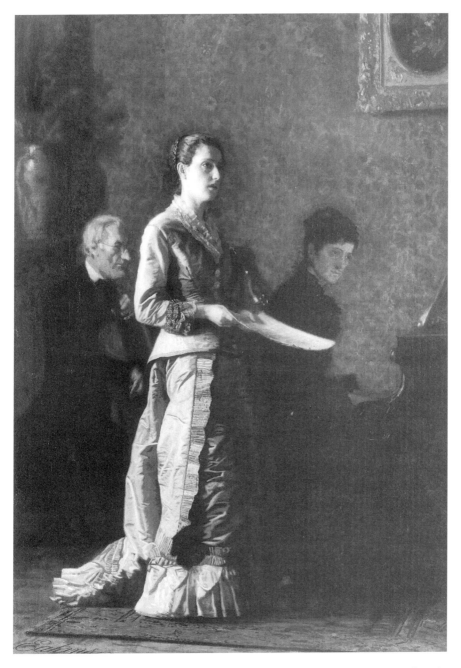

Figure 34. Thomas Eakins, *The Pathetic Song,* 1881. Oil on canvas, 114.3 × 82.6 cm. In the collection of the Corcoran Gallery of Art, Washington, museum purchase, gallery fund.

took to create a personalized scene that would resonate with its intended patron. Eakins's precise rendering has allowed scholars to identify the sitters as (from left to right) Talcott Williams, Benjamin Fox, J. Laurie Wallace, Jesse Godley, Harry the dog, George Reynolds, and Thomas Eakins; the body of water as Dove Lake on Mill Creek, just outside Philadelphia; and the pier, on which several of the men rest, as the dilapidated foundations of a razed mill building.[14] It seems certain that Coates would have recognized most of the figures depicted in the painting because all but one of the men were students under Eakins at the Academy. And as one scholar has pointed out, it is also likely that the place was well known to Coates, a site just half a mile from Haverford College, where Eakins's patron had studied as an undergraduate.[15]

Given their familiarity with the area, both Coates and Eakins would have known that Dove Lake was a recently formed man-made reservoir. In 1873 the owner of the meadow surrounding the ruined mill building, on whose foundations Eakins's swimmers stand, produced the "swimming hole" site by flooding his fields, thus creating a lake for the use of his nearby copper rolling mill. In meeting his factory's industrial requirements, the landowner created a lake that was also used extensively for both swimming and boating.[16]

In picturing *Swimming*'s "artificial" landscape, Eakins points subtly to the recreation available to men of the middle class because of the changes wrought by industrialization. If the solidifying industrial economy of late-nineteenth-century America that led directly to the creation of the lake also gave rise to opportunities for leisure, modern enterprises such as rolling mills increased recreational pursuits by permitting certain classes of men to acquire greater wealth and so maximize their available time for play. The emerging industrial processes, and the capital required to develop them, also link Coates to this leisure economy, for the money he earned as a speculator in industry allowed him the time and resources to cultivate his interest in the arts.[17] *Swimming* is thus overdetermined by industry, with both the funds for its commission and the site depicted by-products of industrial production. Far from recalling the virtues of a simpler past, Eakins's canvas seems to point to the ways in which the modern capitalist industrial world allowed middle-class men to form communal ties through their newfound leisure.

As a painting that so obviously depicts a homosocial community, the image is significant for the ways that Eakins chose to unite (and, just as

significant, not to unite) his swimmers.[18] The models are bound by the dominant compositional triangle, through their nudity, and, of course, through their placement along the edge of the lake. These formal and thematic linkages are essential in holding the men together because, surprisingly enough, none of the figures seems to look at any other; the men have their gazes fixed at the reflective water below them. Further emphasizing their separation is Eakins's treatment of these diminutive figures as tiny (albeit nude) portraits. Each man is portrayed with a distinctive head and posture, just as each is absorbed in his own world. Much like the artist's depictions of his famous rowers from the early 1870s, the men of *Swimming* are bound into their communities by their participation in a like exercise, even as they are arrayed at distinct moments of their swim.

Within this community Eakins provides himself with a unique position, given that the various titles he assigned to the work stress his centrality to the canvas's narrative. By labeling the painting both *Swimming* and *The Swimmers,* the artist draws attention to his activity, since he (and his dog Harry) are the only figures in the scene that actually swim. If the work's titles emphasize Eakins's importance to the painting's narrative, so, too, does his unusual placement in the composition. Just as we understand the authority wielded by the conductor in *The Concert Singer* (1892; Fig. 35)—based on the positioning of the maestro's hand in the lower left-hand corner of the canvas—so might we perceive Eakins's placement in *Swimming* as a sign of the artist's power (Fig. 36). He is positioned at the picture plane, with his back to viewers and an arm outstretched toward the pier, a stance that suggests his directorial role; given his profession, though, Eakins directs, not a stage production, but the painterly composition of his completed canvas.

Eakins's apparent willingness to picture his ties to the canvas's creation is closely linked to his growing success as a teacher and artist. During the previous decade, Eakins boasted few of the career benchmarks that the period's middle class valued as obvious signs of manhood. In canvases from the 1870s, then, when his masculinity was most precarious, the painter prudently chose to distance himself from his canvas's creation; in the 1880s, as his profession came to augment his masculine position, Eakins understandably sought to emphasize his responsibility for his paintings' production. Although the decade brought the artist few commissions, and critics continued to disparage his art, Eakins's teaching at the prestigious Pennsylvania Academy gave him a growing income and social status.

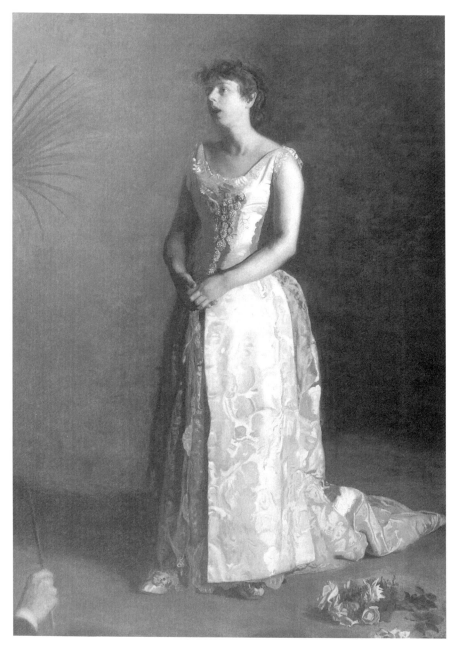

Figure 35. Thomas Eakins, *The Concert Singer,* 1892. Oil on canvas, 190.5 × 137.2 cm. Philadelphia Museum of Art: given by Mrs. Thomas Eakins and Miss Adeline Williams.

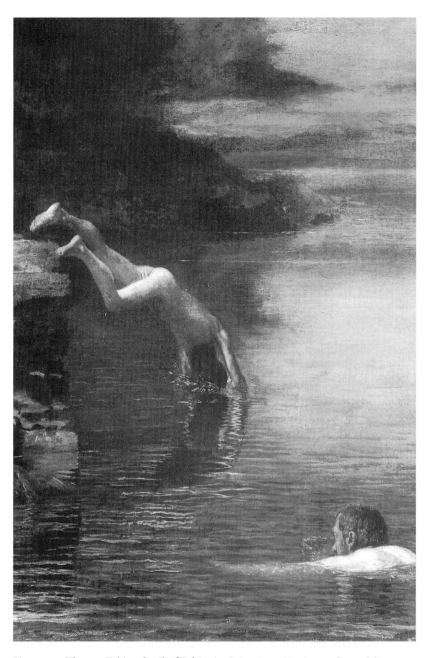

Figure 36. Thomas Eakins, detail of Eakins in *Swimming,* 1885. Amon Carter Museum, Fort Worth. Purchased by the Friends of Art, Fort Worth Art Association, 1925; acquired by the Amon Carter Museum, 1990, from the Modern Art Museum of Fort Worth through grants and donations from the Amon G. Carter Foundation, the Sid W. Richardson Foundation, the Anne Burnett and Charles Tandy Foundation, Capital Cities/ABC Foundation, the *Fort Worth Star-Telegram,* the R. D. and Joan Dale Hubbard Foundation, and the people of Fort Worth.

Just as Eakins's self-portrait in *Swimming* may be read as evidence of his newly acquired professional standing, so the portraits of his students similarly bolster their teacher's position. It is no coincidence that most of the men of Eakins's canvas stand on a platform left by ruins from the eighteenth century or early nineteenth century, before diving into a body of water created in the late nineteenth century. Anchored by the solid foundations of the past, Eakins's students are pictured symbolically, on the threshold of modern artistic practice. While their teacher swims alone in deep water, far from the traditional foundations of conventional American art, the students are illustrated in varying states of readiness to follow their mentor. One gingerly tests the waters as he grips the foundation with his left hand, a second stands at the edge of the pier contemplating his next move, as a third is shown plunging into the lake. Just as the canvas allegorizes Eakins's swimming with the act of painting, so it collapses the men's commitment to the water with their allegiance to their teacher and his brand of art.

The student who comes closest to following in Eakins's wake is clearly the diving figure of George Reynolds, who has flung himself from the pier. Frozen between pier and water, Reynolds is pictured at an in-between moment; formally linked to the stone foundation through the large compositional triangle, the diver is also related closely to the water by his prominent arching reflection. Viewers may anticipate that in a soon-to-be-realized future moment, Reynolds will take his place alongside his teacher. The student's faithfulness to his mentor's art is mirrored not only in the canvas but also in a hostile review of Eakins's painting that addressed what the critic perceived to be the bad influence that compositions such as *Swimming* exerted on the artist's students. The anonymous reporter wrote that "the mischief which [*Swimming*] exerts is only to be judged by these reflections of it which disfigure the work of most of the older students."[19]

By being reflected in the lake, and hence in Eakins's brand of modern artistic practice, Reynolds confirms the critic's lament at the same time that his portrait pictorially expresses *Swimming*'s ideological promise. If many of Eakins's portraits from the 1870s establish the artist's sitters as paragons for Eakins's own professional development, *Swimming* seems to flip that equation on its head by illustrating a group of men edging closer to the professional model established by Eakins himself.[20]

This depicted desire among Eakins's students to emulate their teacher and, on another level, Eakins's desire to be masculine might be taken as the ideological glue of the canvas. Eve Kosofsky Sedgwick, in explaining how desire functions to bind homosocial relationships, argues that same-sex desire need not be genital, or even explicitly erotic, to join its participants into a community.[21] Despite their obvious physicality, the men of *Swimming* aspire to that which is expressly *not* bodily. In the masculine economy of the painting, the men seek to emulate the ideological construction of Eakins, who is pointedly depicted without a body; he is the one figure in the canvas whose physicality is visually obscured by his immersion in the lake. Herein lies one of the painting's greatest ironies: although on its surface the canvas appears to be about nothing but the body, it ultimately challenges reductive definitions of gender that are based solely on man's corporeality.[22]

Given my general argument about the fluctuating and unstable nature of Eakins's masculine position, one might conclude that the nudes offered him reassurance through their apparently essentialized construction of masculine identity. Because conventional narrative elements are so frequently absent from Eakins's depictions of the male nude, because distinctions between "male" and "female" are apparently defined by nothing more than biological differences, it is not difficult to read the images as advocating a definition of manhood that is predicated primarily on the physical differences between men and women. Such a reading is only heightened by late-twentieth-century clichés about Victorian conceptions of gender, which tend to stress Gilded Age beliefs in biological determinism; yet despite the canvas's minimal narrativity, and notwithstanding our own cultural prejudices, all of Eakins's paintings of nudes reveal complex identity constructions that ultimately repudiate solely biological foundations for gender.

It is important to acknowledge that only in a single finished painting at the close of his career did Eakins ever depict either male or female genitals.[23] Despite his interest in physiology, not to mention the efficiency with which the depiction of genitals would demonstrate the model's sex, Eakins chose not to rely on such obvious signs. In the Metropolitan Museum of Art's version of *Arcadia* (ca. 1883; Fig. 37), Eakins represented three nude figures lounging in a pastoral setting.[24] At first glance it is easy to interpret all three bodies as male, but close inspection reveals that the

model lying with her back to the viewer is actually a woman. What announces the woman's sex is the small bun in which her hair is tied at the nape of her neck rather than any uniquely female bodily feature (Fig. 38). Although all the models are naked, what alerts us to the woman's sex is a cultural construction of "femaleness" (namely, her hairstyle), rather than the picturing of any biological differences. In the end Eakins's constructions of gender were rarely as straightforward as the mere essentialization of anatomical parts.

If Eakins's canvases of nudes strive to disrupt period assumptions about rigid gender definitions, it is in the artist's various nude study photographs that this reworking of gender finds its fullest expression. Produced during the 1880s and 1890s as study aids for a select circle of students at the Pennsylvania Academy and the Art Students' League, the images were not constrained by considerations for a viewing public as were canvases such as *Swimming*. Largely freed from conventional notions of decorum, many of these photographs cast male subjects in reclining poses that drew heavily from the syntax of female nudes (Fig. 39). Not only are various male figures illustrated in unconventional attitudes, but, given Elizabeth Johns's observation of Eakins's penchant for depicting men and women with tall, thin physiques, the study photographs reinforced the message of the artist's canvases by offering "scientific" evidence for gender's social production.[25]

Despite the apparent novelty of subjects presented in the *Arcadia* series, *Swimming,* and Eakins's study photographs, the notion of gender as a socially produced and malleable commodity was not unique to the 1880s. More than a decade earlier, Eakins's contemporary Winslow Homer produced a series of paintings of affluent men and women that seemingly anticipate the gender ideology of *Swimming*.[26] As a canvas depicting leisure-class recreation at water's edge, Homer's *Long Branch, New Jersey* (1869; Fig. 40) possesses many superficial affinities with Eakins's *Swimming*. Dressed in the latest Continental styles and leaning slightly toward the brow of a long, jagged bluff, the principle women of *Long Branch* peer blithely toward the shore.

With nearly a quarter of the canvas filled by the bluff's eroded face, viewers can scarcely miss the precariousness of the women's position, even as the figures themselves appear oblivious to any threat. On its surface, the danger seems to emanate from the natural world—as represented by the treacherous bluff—and perhaps implicitly by characteristics inherent in the women's essential nature that leave them unaware. But on a deeper

level, Homer offers signs that their predicament is tied less to nature than to culture. The wind—as evidenced by the white flag in the distance and the women's billowing skirts—actually pushes them back from the brink, just as the small leashed dog pulls its mistress away from the edge. What throws the women forward is their up-to-the-minute attire: their high-heeled shoes pitch them forward while their long, constricting corsets limit their ability to compensate by leaning back.[27] While nature subtly works to stave off danger, the women's stylish trappings threaten to cast them over the edge. Homer may dress his women to illustrate how they are socially formed, just as Eakins stripped his men down to make a similar point, but both artists make clear how middle-class identities are fashioned through forces within and beyond one's control.

If the body did not specifically define manhood for Eakins and his circle, it did unite teacher and students in a shared culture, as it isolated them from more conservative Victorians. The nudity in *Swimming* was simply a sign of the students' allegiance to Eakins's methods, offering visual and ideological affirmation of what was essentially the painter's atelier. Given Eakins's continued inability during the 1880s to sell his paintings, his improved masculine position rested heavily on his association with the students of his atelier. During this decade, his success as an instructor became both the source of his acceptance in larger Philadelphia society and a means of coping with the public's criticism of his art, for if most Philadelphians could not appreciate Eakins's skills as a painter, his devoted students and friends certainly could.[28]

What makes *Swimming* distinctive is obviously not the canvas's ability to tie its creator into a larger community of artists—for that, after all, is the implicit goal of all atelier scenes—but rather the novel alliance that the canvas represents between Eakins and his men. Frédéric Bazille's painting *The Studio on the rue La Condamine* (1870; Fig. 41) is more typical of late-nineteenth-century atelier paintings, portraying the artist with brushes and palette in hand, surrounded, not by his students, but by his artistic peers. Whereas established painters such as Bazille and Henri Fantin-Latour created canvases linking themselves to notable artists and critics, Eakins's lack of prominent supporters forced him to modify this formula, so expressing his identity through his relationship to students.[29]

Eakins's atelier certainly stood as an outward symbol of his accomplishment, but it also fostered the formation of a private sphere—or "club," as Fairman Rogers called it—that helped counterbalance the masculine

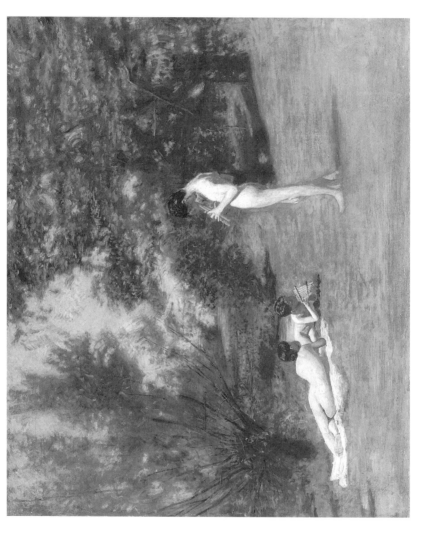

Figure 37. Thomas Eakins, *Arcadia*, ca. 1883. Oil on canvas, 98.1 × 114.3 cm. Metropolitan Museum of Art, New York, bequest of Miss Adelaide Milton de Groot, 1967.

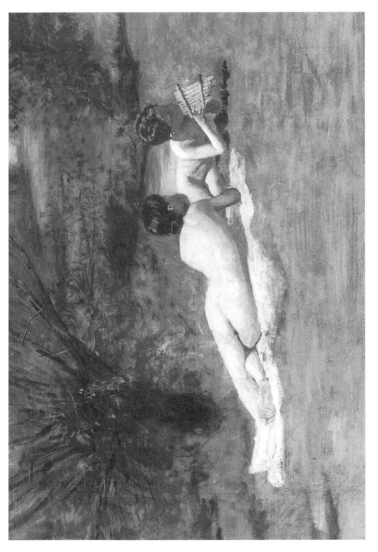

Figure 38. Thomas Eakins, detail of reclining figure in *Arcadia*, ca. 1883. Metropolitan Museum of Art, New York, bequest of Miss Adelaide Milton de Groot, 1967.

Figure 39. Circle of Eakins, *Male Nude Reclining on a Draped Sofa*, ca. 1885. Albumen print, 7.3 × 11 cm. The Pennsylvania Academy of the Fine Arts, Charles Bregler's Thomas Eakins Collection, purchased with the partial support of the Pew Memorial Trust.

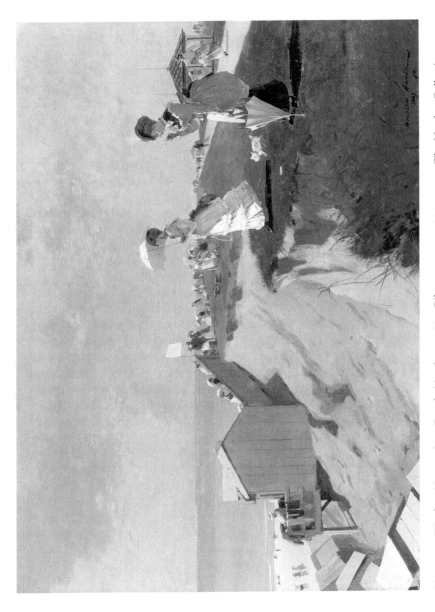

Figure 40. Winslow Homer, *Long Branch, New Jersey*, 1869. Oil on canvas, 40.6 × 55.2 cm. The Hayden Collection. Courtesy, Museum of Fine Arts, Boston.

Figure 41. Frédéric Bazille, *The Studio on the rue La Condamine*, 1870. Oil on canvas, 97 × 127 cm. Louvre, Paris. Giraudon/Art Resource, New York.

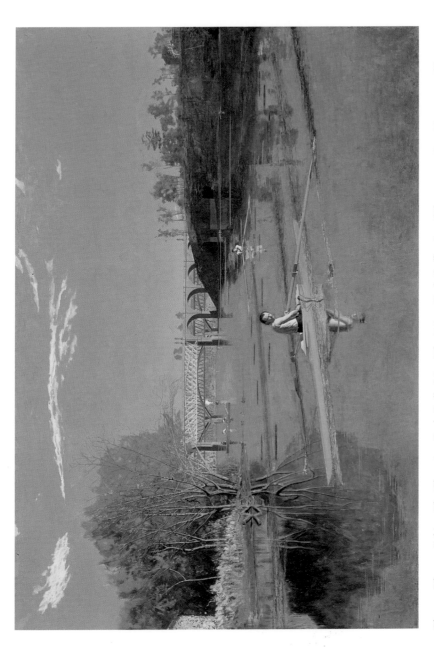

Plate 1. Thomas Eakins, *The Champion, Single Sculls (Max Schmitt in a Single Scull)*, 1871. Oil on canvas, 81.9 × 117.5 cm. The Metropolitan Museum of Art, New York, purchase, 1934, The Alfred N. Punnett Endowment Fund and George D. Pratt Gift, 1934.

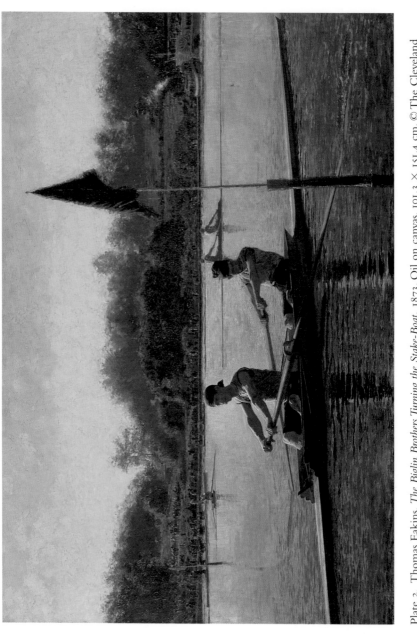

Plate 2. Thomas Eakins, *The Biglin Brothers Turning the Stake-Boat*, 1873. Oil on canvas, 101.3 × 151.4 cm. © The Cleveland Museum of Art, 1999, The Hinman B. Hurlbut Collection, 1984.27.

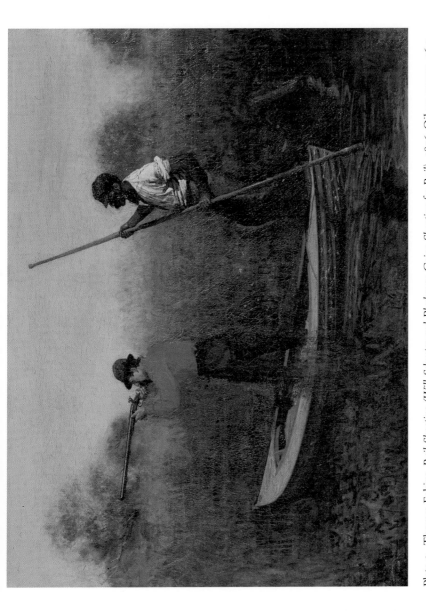

Plate 3. Thomas Eakins, *Rail Shooting (Will Schuster and Blackman Going Shooting for Rail)*, 1876. Oil on canvas, 56.2 × 76.8 cm. Yale University Art Gallery, bequest of Stephen Carlton Clark, B.A. 1903.

Plate 4. Thomas Eakins, *William Rush Carving His Allegorical Figure of the Schuylkill River,* 1877. Oil on canvas on Masonite, 51.1 × 66.4 cm. Philadelphia Museum of Art, gift of Mrs. Thomas Eakins and Miss Mary Adeline Williams.

Plate 5. Thomas Eakins, *Professor Benjamin Howard Rand,* 1874. Oil on canvas, 152.4 × 121.9 cm. Jefferson Medical College of Thomas Jefferson University, Philadelphia, Pennsylvania.

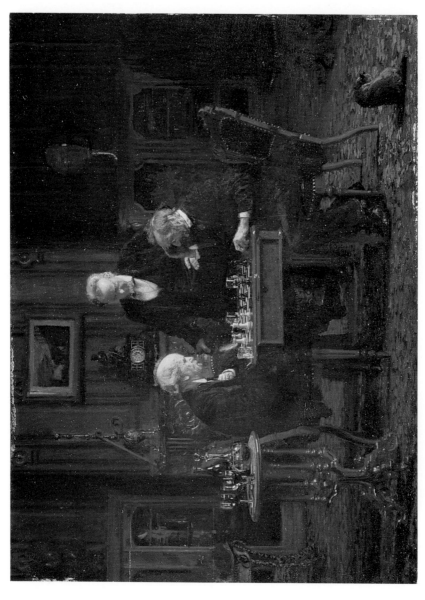

Plate 6. Thomas Eakins, *The Chess Players*, 1876. Oil on wood, 29.8 × 42.6 cm. The Metropolitan Museum of Art, New York, gift of the artist, 1881.

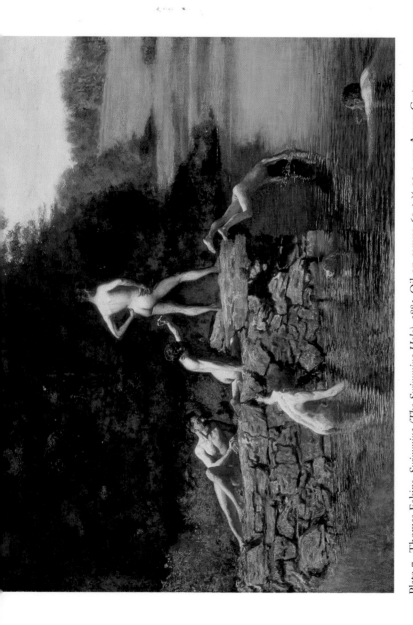

Plate 7. Thomas Eakins, *Swimming (The Swimming Hole)*, 1885. Oil on canvas, 69.5 × 92.4 cm. Amon Carter Museum, Fort Worth. Purchased by the Friends of Art, Fort Worth Art Association, 1925; acquired by the Amon Carter Museum, 1990, from the Modern Art Museum of Fort Worth through grants and donations from the Amon G. Carter Foundation, the Sid W. Richardson Foundation, the Anne Burnett and Charles Tandy Foundation, Capital Cities/ABC Foundation, *Fort Worth Star-Telegram*, the R. D. and Joan Dale Hubbard Foundation, and the people of Fort Worth.

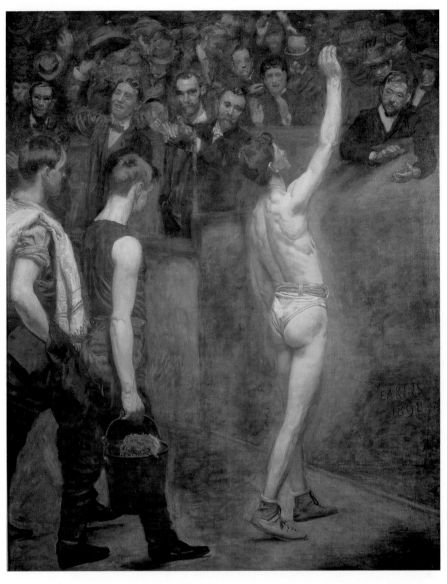

Plate 8. Thomas Eakins, *Salutat,* 1898. Oil on canvas, 127.3 × 101.6 cm. Addison Gallery of American Art, Phillips Academy, Andover, Massachusetts, gift of an anonymous donor.

prescriptions of middle-class society.[30] In performing its cultural work, Eakins's club closely followed the precedent established by a host of Gilded Age fraternal societies. As Mark Carnes has argued, late-century secret societies owed their immense popularity to the ways in which they enabled middle- and upper-class men to cope with the emotional bifurcation imposed on their lives by the gender-based constraints of Victorian society. According to Carnes, the rituals of such organizations allowed men to verbalize stereotypically feminine emotions that they could not articulate in daily life, thereby providing them with a socially acceptable emotional outlet, unavailable elsewhere in Gilded Age society.[31] What these modern clubs effectively fostered was the creation of a private feminized culture for men, a counterbalance to the masculinized culture in which members spent most of their professional and domestic lives.

A significant difference between the traditional secret societies and Eakins's atelier was, of course, that the artist's club was concerned, not with creating another feminized space, but with fostering a masculine culture to offset Eakins's still tenuous position in Victorian society. The atelier—like the secret societies—provided needed balance to its members' public lives, but for Eakins such balance necessitated the creation of a private culture that allowed him more fully to experience the security of a stable masculine position. The men of his circle were, in fact, famous for their fierce support of the man they called "The Boss." Writing in 1884, Earl Shinn spoke of Eakins's "distinct genius for teaching," while Charles Bregler, who studied under Eakins both at the Pennsylvania Academy and at the Art Students' League, noted that the painter's students possessed "love, loyalty, devotion and complete faith in the ultimate recognition of [Eakins's] masterly painting."[32]

In many ways *Swimming* represents the creation of an alternative community, one that largely possessed the same criteria of manhood as middle-class Philadelphia society but nonetheless viewed Eakins's achievements in a more positive light. If the men of Eakins's canvas could never fully stand apart from the dominant ideologies of their culture, they could reinterpret the success of their teacher's work, thereby reinscribing him more securely within "the masculine." If society, emblematized by reluctant patrons and unsympathetic art critics, still possessed misgivings about Eakins's worth, the painter could now escape to the security of his atelier, where *he* provided the masculine template against which others were measured.

In resisting the temptation to set *Swimming* in an imaginary pastoral setting—and so distance himself from the masculine requirements of Victorian culture—Eakins created an image of metaphorical *and* practical value. Just as the canvas's narrative offers symbolic reassurance about the painter's place within his atelier, the painting also suggests pragmatic strategies for managing society's expectations. By illustrating the power of same-sex communities to reinforce one's identity within and against the forces of larger cultures, *Swimming* offered a practical model for daily life.

Eakins's communities of students and friends would become even more important to him toward the century's close, for his increased professional success in the late 1870s and early 1880s came to an abrupt halt in February 1886, when he was forced to tender his resignation as director of instruction at the Pennsylvania Academy. Perhaps the single most written-about incident in the artist's career, his resignation had profound effects on his life and art.[33] Traditionally, historians have attributed Eakins's dismissal to his removal of a loincloth from a male model's genitals during a mixed-sex class on anatomy. But as scholars have recently concluded, this incident served merely as the pretext for Eakins's ouster, discontent having been growing steadily against him from several quarters. Kathleen Foster and Cheryl Leibold have explained the complicated confluence of events that ultimately forced the artist's resignation, namely, that conservative board members and some amateur students had long disliked Eakins's use of the nude in teaching, that the board members also might have wanted to avoid giving him a promised raise in salary, that some professional students were displeased because composition was slighted in Eakins's classes in favor of the human figure, and finally that a number of the Academy's junior professors sought Eakins's removal for the sake of their own advancement.[34]

Eakins's ouster took an obvious and immediate toll. Losing what his sister Fanny termed his "high position," Eakins forfeited his twelve-hundred-dollar annual salary, as well as the respect of many in proper Philadelphia society.[35] The loss of income compelled the artist and his wife to move back into his father's house, relying once more on the elder Eakins for support. During 1886 and much of 1887, Eakins's artistic production dropped off precipitously. In the first six months of 1887, the

painter was unable to produce a single canvas. Finally in July, most likely at the urging of a good friend, the physician Horatio C. Wood, Eakins retreated to a ranch in the Dakota Territory to recuperate from the "exhaustion" suffered during the previous year and a half.[36]

In succumbing to exhaustion, Eakins joined the ranks of Victorian scholars and clergymen, artists and businessmen who had similarly been depleted, for by the final quarter of the century, mental breakdowns were an increasingly common problem of the middle classes. During the nineteenth century most doctors understood the body as a closed system, holding a fixed quantity of nervous energy. Quantities varied from person to person, but the danger of exhausting one's supply was ever present. George M. Beard, a prominent New York neurologist, identified the ailment in 1869, popularizing it with the publication of his influential book, *American Nervousness* (1881).[37] Beard called the disorder "neurasthenia," explaining it as a bodily reaction against society's modernization. According to Beard, people with lower levels of nervous energy were unable to cope with the increasingly rapid pace of modern society. The problem was thought particularly acute in the United States, for Americans perceived their technologies to be the most advanced. Beard indicted the periodical press, steam power, the sciences, the telegraph, and the increased mental activity of women for encouraging Americans to experience life more fully, thus depleting their finite energy reserves.[38] Taxed by the whirl of modern society, these reserves ran out when roles and duties demanded more energy than people could safely expend.[39]

Perhaps fittingly for a disease that possessed no single cause, neurasthenia had no fixed set of symptoms, nor did it have a single cure. Beard himself admitted that the disorder's symptoms "are largely of a *subjective* character [emphasis in original]." He cautioned doctors that "if two cases are treated precisely alike in all the details from beginning to end, it is probable that one of them is treated wrong."[40] In addition to being commonly treated with prescribed drugs and dietary restrictions, patients who acquired neurasthenia from excessive intellectual work were most frequently admonished to engage in vigorous outdoor exercise, while those who took ill because of excessive emotional excitement were usually thought to require isolation and rest.[41] Despite such prescriptions, the treatments administered to neurasthenics ultimately had more to do with a patient's sex than with the search for the disease's underlying cause. Both

the subjective task of determining the disorder's symptoms and causes and Victorian society's predisposition to understand women as overly emotional ensured that women were most frequently administered "rest cures." Popularized by Eakins's friend Dr. S. Weir Mitchell, the rest cure effectively infantilized sufferers by closeting patients alone in their bedrooms, removing from them all previously held responsibilities, save the obligation to rest.[42] In a society where women were understood to be both domestic and weak, it made perfect sense to cure them of the strains of modernity by ensuring their submission to what was, after all, their essential nature. Men, by contrast, were frequently assumed to have fallen ill as a result of intellectual overexertion. In most cases they were advised to recover with a "camp cure," of the kind commonly prescribed by Horatio C. Wood. Wood sent his patients out into the wilderness to sleep outdoors, eat simple food, and relax their brains. As an antidote to their overcivilized condition, the doctor advised retreating to what he probably conceived of as a lost natural state.[43]

Eakins, not surprisingly, was treated with Wood's athletic camp cure. On the B-T Ranch, in what is now North Dakota, Eakins recuperated by adopting the life of a cowboy. So immersed was the artist in his wrangling chores that the manager of the ranch was reputed to have refused Eakins's offer of payment for his stay. Given what twentieth-century scholars have argued about the disease as a means through which Victorians might mediate troubling social and personal transformations, it seems particularly apt that Eakins selected his camp cure.[44] Having failed to maintain the tenets of manhood in polite Philadelphia society, Eakins recuperated by being hypermanly in the territories. Unable to sustain the ephemeral success of his profession, he cultivated a vigorous notion of manhood that, because of its essentially physical nature, remained wholly within his control.[45]

While allowing Eakins to reaffirm his masculinity through the expression of a manly ideal grounded in physical activity, the remedy also permitted him to downplay his humiliation at the Academy. Because the patient's sex implicitly determined both the root of the sufferer's neurasthenia and the required remedy, Eakins was never forced to confront the underlying causes of his breakdown. Wood's prescription, and Eakins's obvious acceptance of a camp cure, effectively signaled that the artist had acquired the disease from the intense "brain-work" required for his scientific approach to art, and not through emotional overload caused by his

treatment by the Academy's hostile board. The vigorous therapy rejuvenated Eakins's mind and also helped to rehabilitate his reputation by suggesting a more masculine source for his breakdown.

When Eakins began to paint once more upon his return from the Dakota Territory, it was clear that his subject matter had again shifted. In the immediate aftermath of the Academy scandal, Eakins retreated from depictions of nude men, throwing his energies increasingly into a series of head-and-shoulder portraits of students and friends.[46] While he never again portrayed nude male figures, during the late 1890s Eakins produced a series of paintings illustrating seminude athletes that are reminiscent of his rowing canvases from twenty years earlier. With his masculine position again problematized, it seems logical that Eakins would turn once more to picturing successful, physically active men of the type that had metaphorically bolstered his identity in the 1870s. It is less easy to explicate the metaphorical functions of the head-and-shoulder portraits that would come increasingly to define his later work.[47]

Between 1885 and 1890, Eakins painted more than a dozen bust portraits that twentieth-century scholars have associated with his interest in "types" (see Fig. 42). Given the canvases' regular size (most are 61 by 50.8 centimeters), their formal similarities (almost all show the sitter's head and shoulders in three-quarter profile), and the generic nature of many of their titles (such as *The Art Student, The Bohemian,* and *Portrait of an Artist*), Kate Rubin concludes that, "viewed individually, the late portraits are penetrating studies of character; as a group, however, they form a portrait gallery of the eminent men and women of Philadelphia in Eakins's day and the range of social types that he observed around him." In general agreement with Rubin, Nicolai Cikovsky Jr. connects the portrait series to the nineteenth-century fascination with pseudoscientific character studies. Cikovsky believes that Eakins sought to use the "objectivity of scientific methodology" to describe the "life and types" of America.[48]

If this series is a chronicle of American types, we must note from the outset that it offers a very limited range. Of the roughly sixteen head-and-shoulder portraits that Eakins created between his dismissal from the Academy and the end of the decade, at least thirteen depict his students, from both the Pennsylvania Academy of the Fine Arts and the Art Students' League.[49] Lloyd Goodrich accurately characterizes the series when he notes "that few of the sitters were eminent . . . [The paintings] were

personal documents, tokens of friendship, and many were inscribed 'To my friend.'"[50] Instead of collecting the works himself, Eakins gave most of the canvases to their sitters. Hence, his project was nothing like that of his English contemporary G. F. Watts, who sought to paint and display a collection of Britain's most eminent men, but then neither did it closely resemble Géricault's fascination with strange types, or van Gogh's interest in average citizens.

Yet if Eakins's aim was not, at the very least, to study types in a highly selective group of people around him, how might we explain the series of generic titles given to his portraits? The answer lies in understanding the context of their display, for the vast majority of these portraits were exhibited—if they were publicly seen at all—at the annual exhibitions of the Pennsylvania Academy of the Fine Arts and at the Art Students' League. Given the small, tightly knit community of artists and patrons in Philadelphia toward the end of the century, it is likely that many of Eakins's student sitters would have been known to museum viewers, even though their names were not always attached to their images. If some members of the public were oblivious to the sitters' identities, the painter's subjects certainly were well known to the directors, staff, and students of the Academy. When Eakins exhibited his *Portrait of an Artist* (ca. 1890; The Manoogian Collection, Detroit) and *Portrait of a Student* (ca. 1890; John R. and Eleanor R. Mitchell Foundation, Mount Vernon, Ill.) at the annual exhibition in 1891, the sitters, James Wright and Samuel Murray, respectively, as former pupils at the Academy, would certainly have been recognized by many.[51]

That Eakins did not see the need to identify sitters who were well known in his Philadelphia circles seems to be borne out by an examination of the exhibition history of the artist's portrait of George Reynolds. First exhibited at the Academy in 1885, Reynolds's likeness was titled simply *Portrait* (1885; Fig. 42). If Eakins's project was the recording of national types, the "portrait" designation, given during Academy exhibitions to many of his sitters, seems at the very least peculiar. But when the canvas was again shown at the Universal Exposition in Paris in 1889, Eakins exhibited the work under the title *The Veteran—Portrait of George Reynolds.*[52] This renaming of the work for its new context strongly suggests that both Reynolds's identity and his status as a veteran would have been instantly discerned by Philadelphia audiences. Eakins clearly understood the need to give specificity to Reynolds's image once it left Philadelphia.

Figure 42. Thomas Eakins, *The Veteran,* 1885. Oil on canvas, 56.5 × 38.2 cm. Yale University Art Gallery, bequest of Stephen Carlton Clark, B.A. 1903.

These portraits served two important functions for Eakins. First, they provided him with patrons of a sort, for even if his students did not pay for their pictures, they at least were happy to own them. Unlike many of Eakins's sitters, who refused even to pick up their portraits, his students were certainly delighted that their teacher sought to depict them. Second, every time the pictures were exhibited at the Academy, they served to promote both Eakins and the "loyal" students who had backed him. Their exhibition forced the Academy's conservative board, and the junior professors who were hostile to Eakins, to confront both the man they had ousted and the paying students he took with him to form the Art Students' League. With their similar format and presentation, these head-and-shoulder likenesses of the artist's students and friends offered yet another means of depicting Eakins's supportive community. In many ways these paintings were effective, not because of their generic titles, but precisely because the sitters would have been so readily identified even without them.[53]

Although Eakins's head-and-shoulder portraits were frequently displayed alongside his boxing and wrestling canvases from the late 1890s, the later sporting paintings are usually assumed to possess closer affinities with the artist's scenes of famous scientists and athletes from early in his career. Consider, for example, Eakins's boxing painting *Salutat,* or, as it was originally known, *Dextra Victrice Conclamantes Salutat* ("he salutes the cheering crowd with his victorious right hand") (1898; see Plate 8) in comparison with the *Gross Clinic.*[54] In an apparent reworking of Gross's portrait, *Salutat* depicts the inside of a crowded amphitheater, with a strong light illuminating a male figure standing slightly off-center. In each canvas the audience members have come to admire the skills of the scene's dominant male, and not incidentally to observe the event's spectacle. Yet despite these strong formal and thematic linkages, Eakins's late nudes perform many of the same metaphorical functions as his modest bust portraits of students and friends. Rather than linking Eakins to heroic athletes or complicating the identities of famous scientists, Eakins's late portraits and nudes picture the artist's adaptation to late-century models of manhood.

In *Salutat* all six figures standing along the bleacher's railing are identifiable portraits of men in the artist's circle. From left to right, Eakins portrayed his brother-in-law Louis Kenton, the reporter Clarence Cranmer, the painter David Wilson, the lithographer and photographer Louis Husson, the sculptor Samuel Murray, and his father, Benjamin Eakins.[55] If the

audience in the earlier clinic painting merely offers a dark backdrop for Gross's heroic operation, here the members of the audience interact with the protagonist. As a reporter for the *Art Collector* wrote disapprovingly of the painting during its first showing at the Pennsylvania Academy in 1899, "Eakins has brought [the spectators] so far forward as to give the impression that both victor and audience might easily shake hands."[56]

Much of the canvas's dynamism comes from the artist's intermingling of audience and actors. Near the center of the canvas a strong vertical accent, begun by the edge of the amphitheater's grandstand and continued by a carved wooden finial capping its corner, provides an axis around which the figures are arrayed. In order to solidify the connections between the men in the stands and those in the arena, Eakins pairs figures in the crowd with the boxer and his seconds. Standing erect, with his hand upstretched, the boxer Billy Smith is formally reflected in Clarence Cranmer, who stands cheering, with his right arm extended. In addition to their similar articulation, boxer and reporter are forcefully joined by the canvas's only patches of strong blue pigment, displayed along the waistband of Smith's trunks and on Cranmer's bow tie. Walking closely behind one another and several paces behind the boxer, Smith's two seconds find their reflections in David Wilson and Louis Husson, who stand together at Cranmer's left.

If Dr. Gross stood alone in the spotlight of Eakins's earlier canvas as a self-made man, then *Salutat*'s pugilist seems to be of a more complicated construction. Although Smith is clearly the focus of the scene, he remains carefully linked both to his seconds and to the audience. The visual coupling of the boxer with Cranmer, a professional sports writer, is fitting in that the newsman was responsible, at least in part, for generating interest among the public in the boxer's exploits. Smith's success would hardly have been meaningful if Philadelphians could not follow the boxing results made available by the news media. The journalist's pairing with Smith might also acknowledge Cranmer's role in initiating Eakins's interest in boxing. Without the reporter's encouragement and ultimately his help in convincing boxers to pose, Eakins might never have depicted Smith. By tying the boxer formally to his audience, the painting acknowledges the complex production of fame, success, and manhood at the close of the nineteenth century.[57]

By effecting links between the boxer and his vocal supporters, *Salutat* also visualizes the economic ties between an athlete and his patrons. With-

out backing from paying spectators, even talented fighters have little chance of financial success. But the same audience that supports Smith also serves to solidify the artist's position. Goodrich recounts that while painting the prizefighting scenes, Eakins would persuade friends who had stopped by his studio to stay and have their portraits included in the audience.[58] In the canvas's narrative, the audience members' portraits clearly stand for Smith's admirers, but only because of their real-life support of Eakins. Distinctions between boxer and painter are ultimately elided in the work through the painting's "sharing" of audiences.

Eakins might well have been consciously aware of this blurring of identities, for on the back of a sketch for *Salutat*—presented as a gift to a supporter—Eakins inscribed, "He salutes the cheering crowd with his victorious right hand. To his friend Sadakichi Hartmann, Thomas Eakins." By juxtaposing the title of the work with his third-person reference to himself, Eakins leaves the "he" of the inscription ambiguous. We are left to wonder whether the pronoun finally refers to the boxer surrounded by the crowd or to Eakins, with his right hand upstretched across his large canvas, painting to the great approval of his friends. Such a reading would have been strengthened in the context of *Salutat*'s first exhibition in 1899 at the Pennsylvania Academy. If Eakins's head-and-shoulder portraits of students and friends offered visual reminders to the Academy's professors, students, and patrons of Eakins's dismissal and of his devotees outside the Academy, *Salutat* presented an even stronger endorsement of the artist through its description of rows of cheering fans.

Smith is viewed from behind, with upraised arm and only a hint of his face visible—a pose that recalls that of the naked models in Eakins's series *William Rush Carving His Allegorical Figure of the Schuylkill River*. In each case nude figures strike poses for male onlookers who clearly value their physicality. Rush appreciates the model's build as a formal prototype for creating his allegorical sculpture, while *Salutat*'s audience applauds the boxer's physical abilities, his achievements and success as a pugilist. The sculptor appreciates the body merely for its corporality, whereas the boxing fans are additionally impressed with the mind's successful manipulation of flesh.

While I have begun to suggest the significance of *Salutat* for male viewers, it would be reductive to assume that it encourages an exclusively masculine viewing position.[59] Smith's body may be visually consumed by an

all-male audience in the painting's narrative, but the boxer's physique was also available to female viewers at the Academy's annual exhibition. This novel painting presented women with a socially legitimate means by which to glimpse an illegal, all-male world while simultaneously affording them a rare opportunity to gaze at a finely formed male nude. Rather than presenting an idealized or classicized image of the male body, Eakins's canvas offered women an apparent window onto the lives of their male contemporaries. That female audiences might have seized upon this "respectable" opportunity to inspect Smith's body is suggested by the public reception accorded *The Corbett-Fitzsimmons Fight,* which was filmed and distributed by the Veriscope Company in 1897. Originally intended to bring prizefights to paying male enthusiasts throughout the country, the film surprised its creators by drawing large crowds of women to its various venues. Given the intense interest Eakins displayed in boxing during the late 1890s, it is quite possible that he attended a screening of *The Corbett-Fitzsimmons Fight* during its Philadelphia run in June and July 1897, where he could have observed firsthand its appeal to women.[60]

Because a host of turn-of-the-century production companies seized on the success of *The Corbett-Fitzsimmons Fight,* producing films that actively encouraged (and commodified) a female viewing position, what makes *Salutat* remarkable is less its acknowledgment of the male body as a potential site for female desire per se than its reworking of the era's art historical conventions for depicting nudes. For Gilded Age audiences, who expected "nudes" to portray passive, and typically anonymous, women (such as those of the *William Rush* series), *Salutat* offered a striking departure with its illustration of an active and identifiable male. Despite the similar positioning and shared nudity of *William Rush's* model and *Salutat's* boxer, the figures ultimately have few ideological connections. While the model's discarded clothing, draped over the chair in the foreground, hints at her everyday appearance, Smith's ruddy face and neck, contrasting as they do with his pallid torso, suggest his weekday labor; if the model's body appears natural in its naked state, it is Smith's body (coloring) that presents the very signs that reassure viewers that his nudity is merely transitional. The contrast is only heightened by the obvious pairing of the model with an inanimate sculpture, on the one hand, and the forceful linkage of Smith with a prosperous young man, on the other. If the allegorical nymph represents the power of Rush's imagination to transform the model, then the

middle-class reporter surely offers an optimistic assessment of what the working-class Smith can achieve through his own agency.[61]

The great irony is that the canvas's obvious emphasis on the body and its suggestion of the individual boxer's ability to advance his position through his physicality are directly tied to the untenability of the ideology of the self-made man at the close of the nineteenth century. Because faith in this ideology was so thoroughly entrenched, Americans' tacit acknowledgment of an individual's dependence on institutional forces and recognition of his limited ability to achieve success on his own led, not to its wholesale abandonment, but rather to a reevaluation of what precisely a man might control. Unwilling to discard their belief in free agency, but becoming increasingly aware that hard work and determination alone often failed to produce success, Americans unconsciously refined notions of manliness by turning inward, exercising increasingly tight rein over one of the few domains that remained firmly within their control—their bodies.

The self-culture books that only twenty years earlier had advised a balance of mental and physical exertions now frequently argued for the primacy of physical development. Writers at the close of the century still emphasized the importance of moral refinement but increasingly related it to physical improvement. In his introduction to *The Portrait Gallery of Pugilists of America* (1894), Billy Edwards interprets the period as "the golden age of *muscular development*," establishing "a perfect manhood [emphasis in original]."[62] Expressing similar sentiments, John Boyle O'Reilly explains in the *Ethics of Boxing and Manly Sport* (1888) that an athlete's "second wind" is both a physical and a "moral" phenomenon. "Many who go down at the first trials," declares O'Reilly, "would have held on to a virtuous and happy end had the failing character been sustained at the period of early weakness." Writing in 1900, Teddy Roosevelt, the era's most prominent boxing advocate, noted with pleasure that a modern boy is "forced by the opinion of all his associates of his own age to bear himself well in manly exercises and to develop his body—and therefore, to a certain extent, his character—in the rough sports which call for pluck, endurance, and physical address."[63] In the century's final decade, physical development, rather than hard work, was increasingly linked with morality and success.

Because of the ways in which the ascendancy of physical development altered more traditional notions of success at the century's close, Eakins's depiction of Smith seems particularly apt. Rather than illustrating one of

the era's famous champion heavyweights, the painter selected a lesser-known featherweight fighter who had never won his class. In his day, Smith would not have been seen by Victorian audiences as the period's most famous or talented boxer, but instead as an individual who had developed his personal physicality to its highest degree. That Eakins's interest in Smith was not rooted solely in the fighter's ability to win bouts is made explicit by the artist's *Between Rounds* (1899; Philadelphia Museum of Art), representing a momentary respite from a bout of 1898 that Smith would go on to lose.[64]

Despite its apparent departure from the rhetoric of older styles of manhood, the new masculine paradigm of bodily manhood helped salvage elements of the self-made man by allowing a greater number of men to achieve "success." One might even say that by altering the meaning of success so that it stood primarily for a man's ability to master his physical self, bodily manhood made good on the ideology of the self-made man by ensuring that hard work led to success. If success meant (at least) physical development, then under this new system of manhood, hard work always produced results. But none of this is to say that adherents of physical manhood did not value traditional signs of achievement in business or government; it is merely an indication of how the body's importance had altered since the 1870s. Whereas the Biglins' well-formed bodies represented nothing more than a by-product of their success, Smith's physique was both a potential stepping-stone to more traditional markings of accomplishment and a self-contained measure of his achievement. Because success rested on the foundation of personal accomplishment (now rooted in a man's physical development), men without societal achievements were thought to have realized individual success merely by transforming their bodies. If more traditional notions of achievement continued to elude them, perhaps their "successful" physicality helped compensate for other deficiencies.

By arguing that *Salutat* links Smith, and by extension Eakins, to a rhetoric of physical and moral development, I am not trying to assert that by the late 1890s boxing was exclusively tied to an ideology of self-improvement. As Michael Hatt is careful to explain, *Salutat* derives much of its meaning from the contested nature of boxing at the turn of the century. Quoting both the sport's advocates and its detractors, Hatt notes that boxing either promoted traditional male virtues, such as ethics or self-reliance, or represented brutal and animalistic aggression. As Hatt writes, "Essentially, there is a tussle here over the question of masculinity. . . . The

problem was to resolve the incompatibility of these two masculinities, and thereby maintain the sense of masculinity as unified and singular."[65]

Although I agree with Hatt's analysis of boxing as a field of competing ideological positions, I think it unlikely that Eakins's boxing images worked toward building a "singular" masculinity. On the contrary, I postulate that Eakins reveled in the very ambiguities that many of his contemporaries saw as problematic. Given that he was rarely, if ever, in sync with the dominant strictures of period manhood, his interest was rather in disrupting unified understandings of the masculine. If Eakins *had* sought to deny the complexities of turn-of-the-century culture, he might easily have adopted the strategy—embraced by many of his contemporaries—of setting his canvases far from modern urban centers, thus downplaying the economic and social realities of his day.

Although Winslow Homer produced his canvases almost exclusively for wealthy urbanites, his later paintings typically eschew all signs of modern society. In canvases such as *Winter Coast* (1890; Fig. 43), men are cast as solitary figures who battle against the elemental forces of nature. Sarah Burns has recently argued that Homer's late seascapes were both informed and made popular by many of the same concerns that I have detected in *Salutat*. Noting anxiety over the untenable ideology of the self-made man in turn-of-the-century America, Burns sees the paintings as celebrating a cult of artistic and natural power, holding out to viewers the possibility of the myth's revitalization. She suggests that Homer's late canvases appealed to men increasingly constrained by bureaucratic and corporate structures gaining sway in late-Victorian culture, both because they focused on the raw power of nature and because period critics and buyers understood Homer as a rugged dissenter from social norms who appeared unaffected by market forces.[66] Whereas Homer's canvases dealt with middle- and upper-class unease by allowing his buyers to imagine a powerful natural world beyond the structural forces of turn-of-the-century America, Eakins's late paintings came increasingly to illustrate man's entanglement in those structures.

As with many of Eakins's portraits, *Salutat* worked in a general sense to picture the complex and contradictory nature of identity formation, for the sake of naturalizing the artist's awkward position; but it also served as a kind of affirmation, suggesting not simply that Eakins's route to manhood was one among a series of possible alternatives, but rather that his development was emblematic of the now dominant means by which men

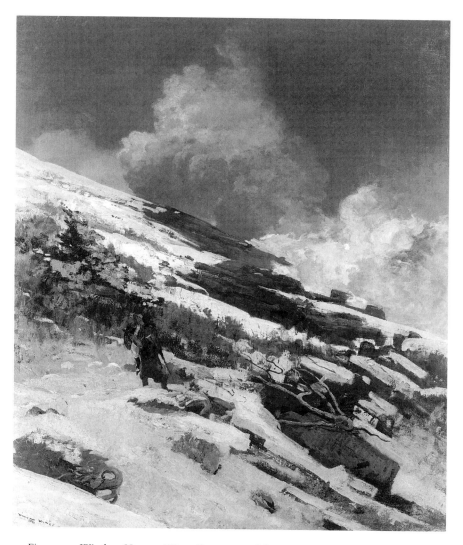

Figure 43. Winslow Homer, *Winter Coast,* 1890. Oil on canvas, 91.4 × 80.3 cm. Philadelphia Museum of Art: The John G. Johnson Collection.

were made manly. Such a message was communicated through Victorian audiences' understanding of *Salutat*'s subject and, equally significant, through their knowledge of the painting's setting and through their experience of the canvas in its original exhibition venue.

The site of Smith's bout has been identified by scholars as the Arena, a popular hall for Philadelphia boxing matches during the 1890s.[67] The

building was erected in 1886 on the northeast corner of Broad and Cherry Streets, diagonally across from the Pennsylvania Academy. Originally constructed to display panoramic history paintings, the building made its debut with a display of the "Battle of Gettysburg."[68] Panoramas, introduced into the United States from France by the American painter John Vanderlyn (1775–1852), attempted to re-create popular events and scenic wonders for audiences unable to experience them firsthand. Painted quickly and covering hundreds of square feet of canvas, panoramic paintings were never considered great works of art, but they were admired for the seeming verity of the spectacles they displayed. In many respects panoramas were enjoyed by nineteenth-century audiences for the very reasons that high-art critics disparaged Eakins's work. His canvases were faulted for their excessive reliance on science and their ensuing verisimilitude—precisely the strengths of panoramic displays. As a popular place of amusement that encouraged an experiential approach to entertainment, the Arena presented an ideological (and physical) divergence from the Academy's sober collection of framed didactic paintings.

Eakins not only set his boxing canvas in a building long associated with popular culture but also reintroduced that work into the Academy building that stood in economic, social, and physical opposition to the Arena across the street.[69] As an image of an illegal sport that possessed clear associations with primitivism and the underside of proper nineteenth-century behavior, the canvas offered a strong antidote to the moralizing and decorous paintings at the Academy's annual exhibition.[70] The opposition that began with subject matter and was continued in varying approaches to art and entertainment, and then in the two buildings' physical opposition, culminates in *Salutat's* portrayal of dominant models of identity formation.

In picturing the self-made man's demise through reference to the ways in which an individual's identity is wrought by institutional affiliation, markets, patronage, and the press, Eakins compelled audiences to confront the anxiety-inducing manner in which Gilded Age men were made. While these structural forces were not new to the century's close, they became of concern as significant numbers of men acknowledged their inability to attain the financial independence enjoyed by their fathers' generation. As the unprecedented consolidation of power and capital of the late nineteenth century shut down traditional avenues of advancement, the delimiting capacities of institutions were suddenly of great concern.[71] Because

the depicted forces were ones with which Eakins had grappled through-
out his career, his understanding of the canvas differed markedly from that
of the majority of his peers. Just as *Salutat*'s illustration of a local hero who
had carved out a niche for himself among admiring friends and associates
must have gratified Eakins by offering public testament to how he had
navigated the canvas's structural forces—producing a stable, if localized,
identity position—the depiction of a little-known fighter formed by
powers largely outside his control surely caused discomfort for middle-
class men desperate to assert their independence.[72] In an irony that was
perhaps not lost on Eakins, what had once been the artist's personal anx-
ieties came, by the century's close, to occupy the thoughts of nearly all
Victorian men.

Epilogue

Discourse and Agency

The discourse of gender circulating in Gilded Age society constituted a historically specific web of ideologies that both constrained and enabled the production of identity. Subjected to a host of masculine ideals (and, for that matter, ideals of whiteness, heterosexuality, and middle-class propriety), Gilded Age Americans were measured by criteria they could neither determine nor control. And yet if Eakins and his contemporaries could not dictate the standards by which they might be evaluated, they could, and moreover did, engage in symbolic interventions, making selective use of manhood's fluid and complex codes to craft more comfortable subject positions.

It might be argued that in reading Eakins's masculinizing strategies as acts of agency, I risk diluting any meaningful notion of political action by equating legislative agendas and public mobilization with fashion choices and the production of art. In pointing to the various ways in which creative acts may alternately advance and hinder ideological positions, I am not suggesting that all forms of human activity are equally efficacious, but simply that in a culture structured through discourse, all social practices have the potential to influence identity. In nineteenth-century America, and increasingly today, white, middle-class Americans are most effectively policed, not by laws or repressive state apparatuses, but rather by internalized discourses that seem natural, normal, and right. Eakins could not overturn dominant paradigms of gender (or of race or class), but his activities—along with those of millions of other Americans similarly engaged in making sense of their lives—did shift the terms of the debate, thus allowing for the expansion and contraction of those discourses that policed the borders of what Victorians could imagine about themselves and others.

Notes

Introduction

1. For more on discourse theory, see Michel Foucault, "The Discourse on Language," in *The Archaeology of Knowledge and the Discourse on Language* (New York: Pantheon Books, 1972), 215–37. My understanding of paintings as material objects that sit at the intersection of social activities that both give and receive meanings is also indebted to Richard Butsch's understanding of "social practices," as synthesized from the work of Anthony Giddens and Raymond Williams. See Richard Butsch, "Leisure and Hegemony in America," in *For Fun and Profit: The Transformation of Leisure into Consumption,* edited by Richard Butsch (Philadelphia: Temple University Press, 1990), 6–9; see also Anthony Giddens, *Profiles and Critiques in Social Theory* (Berkeley and Los Angeles: University of California Press, 1982), 8–11, 32–39; Raymond Williams, *Problems in Materialism and Culture* (London: Verso, 1980), 31–49.

2. As one might suspect from my reference here to the role of the "canvases' narratives," my examination of discourse pays more attention to the formal qualities of the paintings than might be expected from Foucault. In this, my project resembles that of deconstructivists or New Historicists. For Foucault's relation to New Historicism, see Frank Lentricchia, "Foucault's Legacy: A New Historicism?" in *The New Historicism,* edited by H. Aram Veeser (New York: Routledge, 1989), 231–42.

1. Manly Associations

1. Letter from Earl Shinn to Elizabeth Hines, 3 March, 1867, in the Cadbury Collection, Swarthmore College; quoted in Kathleen A. Foster, *Thomas Eakins Rediscovered: Charles Bregler's Thomas Eakins Collection at the Pennsylvania Academy of the Fine Arts* (New Haven, Conn.: Yale University Press, 1997), 123. For additional examples of Eakins's abiding interest in sports, see his many letters from

Paris, written to family and friends, that speak fondly of rowing. Eakins's letters in Charles Bregler's Thomas Eakins Collection at the Pennsylvania Academy of the Fine Arts, dated October 1, 1866; October 8, 1866; October 30, 1866; June 21, 1867; June 28, 1867; July 2, 1869.

2. Eakins's only work that might be considered an exception to this is *Margaret in Skating Costume* (ca.1871; The Philadelphia Museum of Art). Aside from its title, this bust-length portrait offers few visual cues linking Margaret to an athletic, outdoor world.

3. I use the term "separate spheres" only because it is the dominant phrase that has structured debate. Nancy Cott has persuasively argued that discussions of the divisions between men and women in nineteenth-century America might more profitably focus on "separate cultures." See Nancy Cott, "On Men's History and Women's History," in *Meanings for Manhood: Constructions of Masculinity in Victorian America,* edited by Mark C. Carnes and Clyde Griffen (Chicago: University of Chicago Press, 1990), 205–11.

4. The one scholar who has devoted significant attention to Eakins's constructions of masculinity is Michael Hatt. See "The Male Body in Another Frame: Thomas Eakins's *The Swimming Hole* as a Homoerotic Image," in *Journal of the Philosophy of the Visual Arts: The Body* (London: The Academy Group, 1993), 8–21; "Muscles, Morals, Mind: The Male Body in Thomas Eakins' *Salutat,"* in *The Body Imaged: The Human Form and Visual Culture since the Renaissance,* edited by Kathleen Adler and Marcia Pointon (Cambridge: Cambridge University Press, 1993), 57–69.

5. "The Society of American Artists Second Annual Exhibition," *New York Daily Tribune,* March 22, 1879.

6. Sadakichi Hartmann, *A History of American Art* (Boston: L. C. & Company, 1902), 1:192, 200–203.

7. Carroll Smith-Rosenberg, *Disorderly Conduct: Visions of Gender in Victorian America* (New York: Alfred A. Knopf, 1985), 90.

8. For a more detailed explication of how these cultural forces impinged on men's identities, see Gail Bederman, *Manliness and Civilization: A Cultural History of Gender and Race in the United States, 1880–1917* (Chicago: University of Chicago Press, 1995), 11–15.

9. The first scholar to suggest Eakins's problematic masculine position was David Lubin; see *Act of Portrayal: Eakins, Sargent, James* (New Haven, Conn.: Yale University Press, 1985), 16–18. Joseph F. Kett, *Rites of Passage: Adolescence in America, 1790 to the Present* (New York: Basic Books, 1977), 31, 144, lists some of the cultural markers indicating the attainment of manhood: marriage, leaving home for good, joining a church, or entering a profession. For views of veterans as masculine, see E. Anthony Rotundo, "Body and Soul: Changing Ideals of American Middle-Class Manhood, 1770–1920," *Journal of Social History* 16, no. 4 (Summer 1983): 28; George M. Fredrickson, *The Inner Civil War: Northern Intellectuals and*

the Crisis of the Union (New York: Harper and Row, 1968), 175–76. For the Civil War service of Eakins's high school classmates, see Frank H. Taylor, *Philadelphia in the Civil War, 1861–1865* (Philadelphia: The City of Philadelphia, 1913), 300; Nicholas H. Maguire, "Contribution of the Central High School of Philadelphia to the War," pamphlet, 1864. For the importance of work, see E. Anthony Rotundo, *American Manhood: Transformations in Masculinity from the Revolution to the Modern Era* (New York: Basic Books, 1993), 167–69, 178–93; Robert L. Griswold, *Fatherhood in America: A History* (New York: Basic Books, 1993), 13–14; Michael Kimmel, *Manhood in America: A Cultural History* (New York: Free Press, 1996), 44–50.

10. Rotundo, *American Manhood,* 191, 178. See also Griswold, *Fatherhood in America,* 13–14. In an expression of concern that would have been widely understood in Victorian America, a family friend consoled Benjamin Eakins over the costs of Thomas's European education. While pleased with the opportunities presented to the younger Eakins, Thomas Huttner explained to Benjamin that "at the same time I am almost sorry for you as I feel very sensibly the greatness of the sacrifice you made in allowing him to part [?] for Paris. Though [?] judging from his past career and all I know of his already industrious character I have no doubt he will amply repay you for it when he returns in a few years—a man, an artist." In Huttner's analysis, Eakins's ability to repay his father was explicitly linked to attainment of a profession and of manhood. Letter from Henry F. Huttner to Benjamin Eakins, dated San Francisco, January 29, 1867, in Charles Bregler's Thomas Eakins Collection at the Pennsylvania Academy of the Fine Arts.

11. Kathleen A. Foster and Cheryl Leibold, *Writing about Eakins: The Manuscripts in Charles Bregler's Thomas Eakins Collection* (Philadelphia: University of Pennsylvania Press, 1989), 45, 128; Lloyd Goodrich *Thomas Eakins,* vol. 1 (Cambridge, Mass.: Harvard University Press, 1982), 36; letter from Eakins to Benjamin Eakins, dated September 20, 1867, Pennsylvania Academy of the Fine Arts.

12. Letter from Thomas to Benjamin Eakins, dated March 17, 1868, Pennsylvania Academy of the Fine Arts.

13. Letter from Thomas to Benjamin Eakins, dated June 24, 1869, Pennsylvania Academy of the Fine Arts. For other evidence of Eakins's unease in accepting his parents' support, see his letter addressed to his father, November [1867], and another to his mother and aunt Eliza, November 1867, Pennsylvania Academy of the Fine Arts.

14. For the most illuminating discussion of Eakins's rowing paintings, see Elizabeth Johns, *Thomas Eakins: The Heroism of Modern Life* (Princeton, N.J.: Princeton University Press, 1983), 19–45.

15. As early as 1862, the English visitor Anthony Trollope noted that traditionally attired Quakers were becoming a rarity in Philadelphia; see Anthony Trollope, *North America* (1862), edited by Robert Mason (Aylesbury, England: Penguin Books, 1968), 151.

16. Johns, *Thomas Eakins,* 20, 39. Johns was the first art historian to identify the rowers' dress and explain the evolution of racing sculls.

17. "Five Mile Pair-Oared Match Race," *Aquatic Monthly and Nautical Review,* June 1872, 57.

18. Both Elizabeth Johns and Michael Fried have discussed Eakins's complicated relation to craft traditions; see Johns, *Thomas Eakins,* 83–91, 95–102, 104–14; and Michael Fried, *Realism, Writing, Disfiguration: On Thomas Eakins and Stephen Crane* (Chicago: University of Chicago Press, 1987), 19–20. Perhaps not coincidentally, Eakins traded one of his early boating scenes, *Starting Out after Rail* (1874), to James C. Wignall, a Philadelphia shipbuilder, for a boat; see Gordon Hendricks *The Life and Work of Thomas Eakins* (New York: Grossman Publishers, 1974), 327.

19. Robert B. Johnson, *A History of Rowing in America* (Milwaukee: Corbitt and Johnson, 1871), 250.

20. *National Police Gazette,* April 6, 1867, 3.

21. The April 1873 issue of *Aquatics Monthly and Nautical Review,* 830–33, offered a long article on the most prominent American boatbuilders, which included a list of every boat the builders had produced during the preceding year, along with their buyers' names. Some regattas even embroidered the winning scull's name onto the trophy flags, instead of recording the name of the winner. The *Baltimore American,* October 22, 1872, stated: "The New York Rowing Club was awarded the silk flag with the Maryland coat of arms, and the blue pennant, on which is to be emblazoned the name of the winning boat and the date of the race, which were the prizes for the victors in the first race"; quoted in *Aquatic Monthly and Nautical Review,* November 1872, 486.

22. Eakins's desire to legitimate his profession by linking himself with "scientific" craftsmen and mechanics is particularly understandable given the longstanding republican fears of art's potential to corrupt, and in light of John Kasson's description of a thriving nineteenth-century rhetoric that called for the replacement of the fine arts with the useful arts. Both by depicting his links to the boatbuilders and by portraying their products, Eakins took advantage of his alignment with machine aesthetics, while never truly renouncing his ties to the high arts. See John F. Kasson, *Civilizing the Machine: Technology and Republican Values in America, 1776–1900* (New York: Grossman Publishers, 1976), 139–80, esp. 139–47.

23. For more on Eakins's perspective systems, see Foster, *Thomas Eakins: Rediscovered,* 51–71, 123–43; Amy B. Werbel, "Perspective in the Life and Art of Thomas Eakins" (Ph.D. diss., Yale University, 1996).

24. Johns, *Thomas Eakins,* 20–21; Foster, *Thomas Eakins: Rediscovered,* 126.

25. Bryan J. Wolf, *The Invention of Seeing* (New Haven, Conn.: Yale University Press, forthcoming).

26. "Pair-Oared Race," *New York Times,* May 21, 1872, 1; Editorial, *The Spirit of the Times: A Chronicle of the Turf, Field, Sports, and the Stage,* May 25, 1872, 228;

F. J. Engelhardt, "The Biglin-Coulter-Cavitt Match," *Turf, Field, and Farm* 16 (May 24, 1872): 335; "Great Pair-Oared Race," *New York Clipper,* June 1, 1872, 68; "Five Mile Pair-Oared Match Race," *Aquatic Monthly and Nautical Review,* June 1872, 56–58.

27. Although not all twentieth-century observers agree that John is, in fact, backing, I will argue that this was nonetheless how the painting was interpreted by nineteenth-century audiences. For more on the modern debate surrounding John's role in the painting's narrative, see Helen Cooper, *Thomas Eakins: The Rowing Pictures* (New Haven, Conn.: Yale University Art Gallery, 1996), 127 n. 48.

28. "The Philadelphia Exhibition—II," *American Architect and Building News* 8 (December 25, 1880): 261, 308. In the spring of 1873 Eakins sent to Gérôme, his former teacher in Paris, a watercolor of John Biglin. In a now-famous letter Gérôme wrote back to his pupil, praising the work but remarking on the static quality produced, Gérôme claimed, by Eakins's decision to show the rowers in midstroke. His mentor urged Eakins to depict rowers at either the start or the finish of their stroke, thereby producing an effect of motion. As Gérôme stated, "Deux moments sont à choisir pour nous autres peintres, les deux phases extrêmes de l'action, soit quand il est porté en avant les rames étant en arrière, soit quand il est penché en arrière, les rames en avant: vous avez pris un point intermédiare de là l'immobilité." [Two moments are to be chosen by us painters, the two extreme phases of the action, either when he is carried forward with the oars behind, or when he is leaning back, the oars in front: you have taken an intermediate point hence the immobility.] Letter dated May 10, 1873; quoted in Goodrich, *Thomas Eakins,* 1:113–14.

29. Reverend J. G. Wood, *Athletic Sports and Recreations for Boys* (London and New York: George Routledge and Sons, 1871), 238.

30. *Goulding's New York City Directory for 1875–1876* (New York: Lawrence G. Goulding, 1875), 97; *Turf, Field, and Farm* 15 (November 15, 1872): 314; *New York Times,* May 12, 1924, 17; *New York Herald Tribune,* May 12, 1924, 11. We know that Eakins perceived mechanics and boatmen to be of a distinct social class, for in a letter to his mother (October 8, 1866, Pennsylvania Academy of the Fine Arts) he wrote that "the quays of the Seine are always full of people weekdays as well as Sundays fishing. Some seem to be poor people, mechanics or boatmen. Many however are well dressed people some with sporting costume."

31. Philip Gilbert Hamerton, *The Intellectual Life* (Boston: Roberts Brothers, 1873), 5. Hamerton's book went through numerous editions into the early decades of the twentieth century. The second quotation is from John Stuart Blackie, *On Self-Culture: Intellectual, Physical, and Moral* (New York: Scribner, Armstrong, and Company, 1874), 58. While some Americans had argued much earlier in the century that spiritual and physical health were intertwined, the concept became widely embraced only in the 1870s and 1880s. For examples of early advocates, see Harvey Green's introduction to Kathryn Grover, ed., *Fitness in American Cul-*

ture: Images of Health, Sport, and the Body, 1830–1940 (Amherst: University of Massachusetts Press, 1989), 7–8; for other nineteenth-century discussions on the value of balancing the physical and mental, see Johnson, *A History of Rowing in American,* 11–23; and Blackie, *On Self-Culture,* 58. For a twentieth-century explication of this phenomenon, see Burton J. Bledstein, *The Culture of Professionalism: The Middle Class and the Development of Higher Education in America* (New York: W. W. Norton, 1978), 254–58.

32. Harry Brod, "Themes and Theses of Men's Studies," in *The Making of Masculinities: The New Men's Studies,* edited by Harry Brod (Boston: Allen and Unwin, 1987), 14. Calling both true and exaggerated the perception that "the American work force had become profoundly bifurcated between office and the workshop, and that manual work was an activity now performed mainly by factory hands and other wage earners in large scale settings," Stuart Blumin notes that the number of artisans in Philadelphia actually rose slightly between 1860 and 1880. Stuart M. Blumin, *The Emergence of the Middle Class: Social Experience in the American City, 1760–1900* (Cambridge and New York: Cambridge University Press, 1989), 259.

33. The different class standing of the brothers is also a sign of the broad appeal that the sport held for both middle- and working-class Americans. For a discussion of nineteenth-century American rowing as an activity transcending class divisions, see Thomas C. Mendenhall, *A Short History of American Rowing* (Boston: Charles River Books, 1980), 23.

34. Robert Roosevelt, *The Game Birds of the Coasts and Lakes of the Northern States of America* (New York: Carleton Publishers, 1866), 193; see also Lieutenant Colonel P. Hanker, *Instructions to Young Sportsmen, in All That Relates to Guns and Shooting* (Philadelphia: Lea and Blanchard, 1846), 209; Frank Forester, *Field Sports in the United States and the British Provinces of America,* vol. 1 (London: Richard Bentley, 1848), 295, 296. That Eakins was also aware of the poleman's mental role seems clear from the draft text of letter from 1874, presumably sent to his former teacher, Gérôme. As Eakins writes, "It is principally in remembering well the places that to a novice seem all alike after having once turned the head, that the good pushers distinguish themselves"; quoted in Foster, *Thomas Eakins: Rediscovered,* 135.

35. Foster, *Thomas Eakins: Rediscovered,* 138.

36. Eakins's description of his working method is recounted by two of his former students, Charles Bregler and Henry McBride. McBride dates the talk to April 9, 1887; quoted in Charles Bregler, "Thomas Eakins as a Teacher," *The Arts* 17 (March 1931): 384; Henry McBride Papers, Beineke Rare Book Library, Yale University, Box 16, Folder 441.

37. For more on the importance of race in the construction of turn-of-the-century manhood, see Bederman, *Manliness and Civilization.*

38. For more on whiteness as a racial construct, see Richard Dyer, *White* (New York: Routledge, 1997); Ruth Frankenberg, *White Women, Race Matters:*

The Social Construction of Whiteness (Minneapolis: University of Minnesota Press, 1993); and David Roediger, *Toward the Abolition of Whiteness: Essays on Race, Politics, and Working Class History* (London: Verso, 1994).

39. Blacks appear in only ten of Eakins's canvases: *A Negress* (ca. 1867; San Francisco, California Palace of the Legion of Honor); *Pushing for Rail* (1874; Metropolitan Museum of Art); *Whistling for Plover* (1874; Brooklyn Museum), *Rail Shooting* (1876); *The Dancing Lesson* (1878); *Shad Fishing at Gloucester on the Delaware River* (1881; Philadelphia Museum of Art); *Drawing the Seine* (1882; Philadelphia Museum of Art); *The Red Shawl* (ca. 1890; Philadelphia Museum of Art); *Portrait of Henry O. Tanner* (ca. 1902; Hyde Collection, Glens Falls, New York); and *William Rush Carving His Allegorical Figure of the Schuylkill River* (1908).

40. First exhibited by Eakins under the title *Negro Boy Dancing*, the work was also titled by the artist *Study of Negroes, The Dancing Lesson*, and *The Negroes*. Foster, *Thomas Eakins: Rediscovered*, 250 n. 42.

41. Albert Boime, *The Art of Exclusion: Representing Blacks in the Nineteenth Century* (Washington, D.C.: Smithsonian Institution Press, 1990), 100–101; for a reading of minstrelsy's varied cultural functions, see Eric Lott, *Love and Theft: Blackface Minstrelsy and the American Working Class* (New York: Oxford University Press, 1993).

42. For readings of *The Dancing Lesson* as a sympathetic depiction of African American life, see Hugh Honour, *The Image of the Black in Western Art*, vol. 4, *From the American Revolution to World War I* (Cambridge, Mass.: Harvard University Press, 1989), 189; Donelson F. Hoopes, *Eakins: Watercolors* (New York: Watson-Guptill Publications, 1971), 44; for the most sophisticated discussion of the painting, see Alan C. Braddock, "Eakins, Race, and Ethnographic Ambivalence," *Winterthur Portfolio* 33 (Summer/Autumn 1998): 135–61.

43. "Fine Arts. Eleventh Exhibition of the Water-Color Society. II," *Nation*, February 28, 1878, 157.

44. For more on representations of blacks in American sculpture, see Kirk Savage, *Standing Soldiers, Kneeling Slaves: Race, War, and Monument in Nineteenth-Century America* (Princeton, N.J.: Princeton University Press, 1997).

45. Eric Foner, *Reconstruction: America's Unfinished Revolution, 1863–1877* (New York: Harper and Row, 1988), 82–85.

46. Quoted in ibid., 85.

47. Despite my claims for sport's ability to offer metaphorical balance to men's lives, I remain aware of the scathing critiques many observers have leveled against sports. For example, the Frankfurt school theorist Theodor Adorno, *Prisms*, translated by Samuel Weber and Shierry Weber (Letchworth, England: Garden City Press, 1967), 81, contended that "modern sports . . . seek to restore the body some of the functions of which the machine has deprived it. But they do so only in order to train men all the more inexorably to serve the machine." In language almost as dark, historian Donald Mrozek (*Sport and American Mentality* [Knoxville:

University of Tennessee Press, 1983], 11), calls sports "the religious ritual of the machine age—sacrifice without purpose, performance without magic, obsolescence without compensation, and value without meaning." For a nineteenth-century critique of sports, see Thorstein Veblen, *The Theory of the Leisure Class,* introduction by Robert Lekachman (New York: Penguin Books, 1979 [1899]), 254–59.

48. For a valuable discussion of the impossibility of determining the commonalities of realist productions, see Michael Davitt Bell, *The Problem of American Realism: Studies in the Cultural History of a Literary Idea* (Chicago: University of Chicago Press, 1993), 1–9. For other useful writings on the cultural and social construction of American realism, see David Shi, *Facing Facts: Realism in American Thought and Culture, 1850–1920* (New York: Oxford University Press, 1995); Miles Orvell, *The Real Thing: Imitation and Authenticity in American Culture, 1880–1940* (Chapel Hill: University of North Carolina Press, 1989); Philip Fisher, *Hard Facts: Setting and Form in the American Novel* (Oxford: Oxford University Press, 1987); Amy Kaplan, *The Social Construction of American Realism* (Chicago: University of Chicago Press, 1988); Walter Benn Michaels, *The Gold Standard and the Logic of Naturalism* (Berkeley and Los Angeles: University of California Press, 1987); Eric Sundquist, ed., *American Realism: New Essays* (Baltimore: Johns Hopkins University Press, 1982); Fried, *Realism.*

49. As many scholars have demonstrated in recent years, it is reductive to understand sentimentality as standing in simple opposition to realism in nineteenth-century culture. Despite their ideological overlap, however, it is nonetheless correct to assert that sentimentality never possessed the consistently masculine air of realism. For Eakins's debts to sentimental ideology, see Martin A. Berger, "Sentimental Realism in Thomas Eakins's Late Portraits," in *Sentimental Men: Masculinity and the Politics of Affect in American Culture,* edited by Mary Chapman and Glenn Hendler (Berkeley and Los Angeles: University of California Press, 1999), 244–58.

50. In a letter written to his father from Paris on October 29, 1868, Eakins recalled that "Gérôme tells us every day that finish is nothing that head work is all & that if we stopped to finish our studies we could not learn to be painters in a hundred life times & he calls finish needle work & embroidery & ladies' work to deride us"; quoted in Foster and Leibold, *Writing about Eakins,* 208–9. After visiting Eakins's studio in Paris during the summer of 1868 with their father, Benjamin, Fanny Eakins wrote that her brother "had not yet finished any of his paintings (that is lady's work, he says) and of course they are rough looking, but they are very strong and all the positions are fine and the drawing good"; quoted in Lloyd Goodrich, *Thomas Eakins: His Life and Work* (New York: Whitney Museum of American Art, 1933), 24. For an explication of Western painting that sees detail (and nineteenth-century realism) as gendered female, see Naomi Schor, *Reading in Detail: Aesthetics and the Feminine* (New York: Methuen, 1987), esp. 4,

42–47. For a discussion of the masculine (and feminine) resonances of nineteenth-century realism, see Shi, *Facing Facts,* 7–9, 34–36.

51. The *New York Clipper,* for example, is filled with references to large crowds of women who attended sculling matches. See the Aquatics column in the following issues: April 30, 1859, 15; July 21, 1866, 114; July 13, 1867, 106; July 15, 1871, 117. For articles insisting on the importance of women attending and appreciating rowing races and other sporting events, see the *New York Clipper,* May 14, 1859, 28; "Woman and Out-Door Sport," *The Turf, Field, and Farm,* 16 (April 11, 1873), 236. For a reference to rowing as an appropriate sport for women to participate in, see Johnson, *A History of Rowing in America,* 23; Henry Hall, ed., *The Tribune Book of Open-Air Sports* (New York: Tribune Association, 1887), 305. Judging from the many red parasols and dresses of the figures on the riverbanks in Eakins's *Biglin Brothers Turning the Stake* and *The Biglin Brothers Racing,* the painter clearly recognized the sport's appeal to women. By the start of the twentieth century, rowing's associations were more exclusively masculine, being deemed "too rough or physically too severe" for women. J. Parmly Paret, *The Woman's Book of Sports: A Practical Guide to Physical Development and Outdoor Recreation* (New York: D. Appleton and Company, 1901), 122.

52. Jules D. Prown, Paul Mellon Professor of American and British Art at Yale University, has long lectured on the mechanical "springlike" qualities of *John Biglin in a Single Scull.*

53. "The Ward-Biglin Sculling Match," *New York Clipper,* September 7, 1872, 178.

54. S.R.F., "The International Boat Race," *The Spirit of the Times: A Chronicle of the Turf, Field, Sports, and the Stage,* May 25, 1872, 225; *The Spirit of the Times: A Chronicle of the Turf, Field, Sports, and the Stage,* November 30, 1872, 247, 251.

55. William Wood, *Manual of Physical Exercises* (New York: Harper and Brothers, 1870), 105; see also 104. For other examples of rowers likened to machines, see Walter Bradford Woodgate, *Oars and Sculls, and How to Use Them* (London: George Bell and Sons, 1875), 2, 135; Blackie, *On Self-Culture,* 75; *The Spirit of the Times: A Chronicle of the Turf, Field, Sports and the Stage,* November 30, 1872, 247.

56. Anson Rabinbach, *The Human Motor: Energy, Fatigue, and the Origins of Modernity* (Berkeley and Los Angeles: University of California Press, 1992), 3.

57. Mark Seltzer, *Bodies and Machines* (New York and London: Routledge, 1992), 27, 28. For a historical examination of machine culture and productivism, see Rabinbach, *The Human Motor.* For the aesthetics of machinery, see Kasson, *Civilizing the Machine.*

58. Mary P. Ryan, *Womanhood in America: From Colonial Times to the Present* (New York: New Viewpoints, 1975), 139, 144; Griswold, *Fatherhood in America,* 13–14; Nancy Chodorow, *The Reproduction of Mothering: Psychoanalysis and the Sociology of Gender* (Berkeley and Los Angeles: University of California Press, 1978), 4–6, 10, 178–80; Rotundo, "Body and Soul," 30; Michael S. Kimmel, "The

Contemporary 'Crisis' of Masculinity in Historical Perspective," in *The Making of Masculinities: The New Men's Studies,* edited by Harry Brod (Boston: Allen and Unwin, 1987), 137–53, esp. 141–43.

59. Eakins's rowing paintings were among his most widely exhibited works, being extensively displayed in New York, New Jersey, Illinois, Pennsylvania, Ohio, and Massachusetts. The artist's first sale was, in fact, of a John Biglin watercolor. For specific exhibitions and dates, see Cooper, *Thomas Eakins,* 136–39.

60. Daniel T. Rogers, *The Work Ethic in Industrial America, 1850–1920* (Chicago: University of Chicago Press, 1979), 102; see also 94–124, esp. 103–8.

61. S. Weir Mitchell, *Wear and Tear, or Hints for the Overworked* (Philadelphia: J. B. Lippincott, 1871), 19. For additional information on Mitchell as well as an interesting account of the affinities between Mitchell and Eakins, see Norma Lifton, "Thomas Eakins and S. Weir Mitchell: Images and Cures in the Late Nineteenth Century," in *Psychoanalytic Perspectives on Art,* edited by Mary Mathews Gedo (Hillsdale, N.J., and London: Analytic Press, 1987), 247–74.

2. Complicating the Heroes of Modern Life

1. Leon Edel, *Henry James: A Life* (New York: Harper and Row, 1985), 59–61, 722–25; William Veeder and Susan Griffin, eds., *The Art of Criticism: Henry James and the Practice of Fiction* (Chicago: University of Chicago Press, 1986), 3; see also 2, 4. In a book focusing on Henry James's odd and ambiguous portrayals of masculinity, Kelly Cannon notes that many of James's characters defy period masculine stereotypes. Much as I have argued for Eakins, Cannon claims for James that "it is hardly accidental, then, that James's fiction includes many characters who share [his] precarious relationship to the social norm." Kelly Cannon, *Henry James and Masculinity: The Man at the Margins* (New York: St. Martin's Press, 1994), 1, 29; see also Alfred Habegger, *Henry James and the "Woman Business"* (Cambridge: Cambridge University Press, 1989), 6.

2. Henry James, *The Portrait of a Lady* (New York: Penguin Books, 1984 [1881]), 62, 91, 95, 98, 169–71, 206, 207.

3. James, *Portrait of a Lady,* 311–13, 299, 380, 385; for Kelly Cannon's thoughts on James's *Portrait of a Lady,* see Cannon, *James and Masculinity,* 12–13, 15–16, 87–90, 109–12.

4. Lloyd Goodrich, *Thomas Eakins: His Life and Work* (New York: Whitney Museum of American Art, 1933), 59–60; Goodrich, *Thomas Eakins,* vol. 1 (Cambridge, Mass.: Harvard University Press, 1982), 325; Wayne Craven, *Sculpture in America* (New York: Thomas Y. Crowell Company, 1968), 23; David Sellin, *The First Pose, 1876: Turning Point in American Art* (New York: W. W. Norton, 1976), 59; Norma Lifton, "Thomas Eakins and S. Weir Mitchell: Images and Cures in the Late Nineteenth Century," in *Psychoanalytic Perspectives on Art,* edited by Mary Mathews Gedo (Hillsdale, N.J.: Analytic Press, 1987), 347. Elizabeth Johns notes

the unlikelihood that Rush would ever have worked from the nude figure. She also doubts that in the 1870s Eakins intended to link himself with Rush. Elizabeth Johns, *Thomas Eakins: The Heroism of Modern Life* (Princeton, N.J.: Princeton University Press, 1983), 102.

5. "The Lessons of a Late Exhibition," *Nation*, April 11, 1878, 251.

6. Marcia Pointon does suggest how Rush and Eakins derive their identities from the canvas's female figures, but only as the women are "evacuated of other meanings." While I will not suggest that *William Rush* be understood as a proto-feminist work, I do want to propose ways in which both the painting's male and female figures are complicated through their relation to one another. Marcia Pointon, *Naked Authority: The Body in Western Painting, 1830–1908* (Cambridge: Cambridge University Press, 1990), 24–25.

7. Eakins's very personal connections to the *William Rush* series are heightened by his decision to depict a naked model in the first place. Given that the sculptor carves a clothed figure, it would have made greater sense if his model had been dressed in the classical toga of his nymph. The model's nudity seems ultimately to relate more closely to Eakins and his artistic project than it does to Rush and the canvas's ostensible narrative.

8. Eakins's painterly tactic of complicating his sitters' masculinity is not unlike the identity negotiations that Joanne Blum has detected in the fiction of nineteenth-century women writers. Blum suggests that certain female writers employ a male/female double in their literature in an effort to subvert traditional gender roles, arguing the need for marginalized writers to obscure historic gender barriers by illustrating male and female characters who "overreach their culturally prescribed gender identities to relate to one another in such a way that the boundary between self and other becomes blurred." By destabilizing traditional patriarchal models of gender, these writers work (consciously or otherwise) to enlarge the parameters of acceptable social behavior. Joanne Blum, *Transcending Gender: The Male/Female Double in Women's Fiction* (Ann Arbor, Mich.: UMI Research Press, 1988), 1; see also Sandra M. Gilbert and Susan Gubar, *The Madwoman in the Attic* (New Haven, Conn.: Yale University Press, 1979).

9. Rozsika Parker and Griselda Pollock, *Old Mistresses: Women, Art, and Ideology* (London: Pandora Press, 1989), 80; see also 13, 35, 44, 50–51, 70, 80–113, 169; Pamela Gerrish Nunn, *Victorian Women Artists* (London: Women's Press, 1987), 18–19.

10. For Michael Fried's argument (which reinforces my own) that Eakins linked high art with crafts in his depictions of Rush, see Michael Fried, *Realism, Writing, Disfiguration: On Thomas Eakins and Stephen Crane* (Chicago: University of Chicago Press, 1987), 19–20.

11. Mrs. Lincoln Phelps, *The Educator: or Hours with My Pupils* (New York: A. S. Barnes and Co., 1868), 332–33.

12. Ibid., 31–32.

13. Given Eakins's practice of framing his works with simple, varnished wood frames, *Home Scene* may have possessed even closer visual links with Caroline's chalkboard before it was reframed in its current gold-leafed frame.

14. For a discussion of how Eakins's *Baby at Play* (1876) offers a similarly optimistic message on the potential for girls' development, see Jules D. Prown, "Thomas Eakins' *Baby at Play,*" *Studies in the History of Art* 18 (1985): 121–27.

15. Juliet Kinchin, "Interiors: Nineteenth-Century Essays on the 'Masculine' and the 'Feminine' Room," in *The Gendered Object,* edited by Pat Kirkham (Manchester and New York: Manchester University Press, 1996), 12–29.

16. *Philadelphia Evening Bulletin,* May 17, 1876, 1.

17. *Evening Telegraph,* June 16 1876,

18. For a discussion of the American literary tradition in which a sitter's psychological state is communicated through props, see Lori Merish, "'The Hand of Refined Taste' in the Frontier Landscape: Caroline Kirkland's *A New Home, Who'll Follow?* and the Feminization of American Consumerism," *American Quarterly* 45 (December 1993): 508, 522 n. 50.

19. According to Goodrich, "Mrs. Frishmuth was honorary curator of musical instruments at the Pennsylvania Museum and a collector of musical instruments." Lloyd Goodrich, *Thomas Eakins: A Retrospective Exhibition,* exhib. cat. (Washington, D.C.: H. G. Press, 1961), 114.

20. Margaret McHenry, *Thomas Eakins Who Painted* (Oreland, Pa.: privately printed, 1946), 31.

21. As recently as 1993, Julie S. Berkowitz, curator of art at the Jefferson Medical College, wrote of the "controlled clutter of disparate objects on the desk." In John Wilmerding, ed., *Thomas Eakins (1844–1919) and the Heart of American Life* (Washington, D.C.: Smithsonian Institution Press, 1994), 78.

22. Pointon, *Naked Authority,* 55. (Pointon mistakenly refers to Rand as "Professor Rankin.") For Pointon the painting's femininely gendered objects are interesting not so much for the ways they reflect on the sitter's identity, but for how they reinforce the author's larger argument about Eakins's propensity to deprive his depicted women of sight. According to her reading, the work is revealing for the ways in which it hints at a female presence that the canvas finally serves to negate. While offering insights into Eakins's oeuvre as a whole, the argument largely ignores Rand's portrait in an effort to formulate a broad synthetic thesis on women's subjugation. Considering that *Benjamin Rand* is a portrait of a male scientist at work, it seems equally fruitful to consider why the artist offered hints of a female presence as it is to question his decision to exclude a female figure from the completed canvas. Michael Fried notes Eakins's predilection for the color red, drawing attention to the ways in which the artist links red to the feminine. Fried, *Realism,* 45–46.

23. Despite the fact that a continuum model offers a more satisfactory explanation of sexuality than a polar model, I am aware that the continuum can exist

only between two points. While a continuum model allows for greater variation of gender constructions, it still reductively suggests that "the feminine" and "the masculine" exist at its ends.

24. David F. Labaree, *The Making of an American High School: The Credentials Market and the Central High School of Philadelphia, 1838–1939* (New Haven, Conn.: Yale University Press, 1989), 97–106.

25. For a summary of Rand's professional career and scholarly publications, see Franklin Spencer Edmonds, *History of the Central High School of Philadelphia* (Philadelphia: J. B. Lippincott Company, 1902), 340.

26. [Earl Shinn], "The Pennsylvania Academy Exhibition," *Art Amateur* 4 (May 1881): 115; "The Philadelphia Exhibition—II," *American Architect and Building News* 8 (December 25, 1880): 261, 308.

27. "Medical Department, U.S.A.," *Philadelphia Evening Bulletin*, May 30, 1876, 5.

28. Sarah Burns, *Inventing the Modern Artist: Art and Culture in Gilded Age America* (New Haven, Conn.: Yale University Press, 1996), 89–92, 159–61; Joseph A. Kestner, *Masculinities in Victorian Painting* (Aldershot, Hants: Scholar Press, 1995), 40–41; Neil Harris, *The Artist in American Society: The Formative Years* (Chicago: University of Chicago Press, 1982), 224–26. For the cultural mechanics that allied artists with feminine culture, see Anne Douglas, *The Feminization of American Culture* (New York: Anchor Books, 1977).

29. Johns, *Thomas Eakins*, 30–34, 72.

30. "The Water-Color Society Exhibition, II," *Nation*, February 18, 1875, 120.

31. Throughout his career, Eakins highlighted an interest in time's developmental potential, evidenced in his historical genre scenes such as *Seventy Years Ago* (1878), athletic canvases such as *Between Rounds* (1899), and the stop-action photographs taken with Eadweard Muybridge in the early 1880s.

32. For the single extended reading of the work, see Robert Wilson Torchia, "*The Chess Players* by Thomas Eakins," *Winterthur Magazine* 26 (Winter 1991): 267–76.

33. Michael Fried first came to this conclusion in *Realism*, 170 n. 46.

34. W. R. Henry, "The Game of Life," in *Chess Monthly, an American Chess Serial*, edited by Paul Morphy and Daniel Fiske, 4 (April 1860): 100. For additional examples, see "The Mimic Battle-Field," *Daily Graphic*, December 29, 1875, 460; H. R. Angel, ed., *The Book of Chess: Extracted and Translated from the Best Sources by H. R. Angel* (New York: D. Appleton and Co., 1868), vi.

35. For a description of Irving's painting, see "Fine Arts Exhibition of the National Academy of Design," *New York Times*, April 14, 1872, 3.

36. The life-dates of the two players are Bertrand Gardel (ca. 1808–85); George W. Holmes (ca. 1812–95). Foster and Leibold, *Writing about Eakins*, 378.

37. Letter from Thomas to Benjamin Eakins, Paris [23 or 24] February, 1868, Charles Bregler's Thomas Eakins Collection, Pennsylvania Academy of the Fine Arts.

38. It seems likely that period viewers would also have been aware of the differing portrayals of the three men. In 1880 Earl Shinn wrote of *The Chess Players* that "a twilight of feeling and poetry envelops it, out of which emerge three heads as solid, real, and well characterised as were ever done, one handsome and noble, one sly and miser-like, the third the Cavour-like 'bourgeoisie' of a foreign professor." Edward Strahan [Earl Shinn], "The Metropolitan Museum of Art," *Art Amateur* 2, no. 6 (May 1880): 116. Another period reviewer wrote of *The Chess Players* that "it is wholly admirable, and equally so for unity of composition and discrimination of character." "National Academy of Design Exhibition," *Nation*, May 30, 1878, 364.

39. For other scholarly studies that consider how masculinity may be reflected and modified through a range of male types, see Abigail Solomon-Godeau, "Male Trouble: A Crisis of Representation," *Art History* 16 (June 1993): 290; see also Carol Ockman, "Profiling Homoeroticism: Ingres's *Achilles Receiving the Ambassadors of Agamemnon*," *Art Bulletin* 75 (June 1993): 259–74; and Carol Ockman, *Ingres's Eroticized Bodies: Retracing the Serpentine Line* (New Haven, Conn.: Yale University Press, 1995).

40. Andrea Cornwall and Nancy Lindisfarne, "Dislocating Masculinity: Gender, Power and Anthropology," in *Dislocating Masculinities: Comparative Ethnographies*, edited by Andrea Cornwall and Nancy Lindisfarne (New York: Routledge, 1994), 18–23.

41. Since the early 1980s Oedipal themes have been detected by scholars in a number of Eakins's paintings. Writing in *Realism, Writing, Disfiguration*, for example, Michael Fried asserted that Dr. Gross may be read as both a reassuring symbol of healing (surgeon) and as a threatening father figure with a blood-drenched knife (castrator). Gross's bifurcated nature is, according to Fried, further complicated by the painting's equation of the surgeon's scalpel with the painter's brush, for such a conflation draws Eakins into the equation, casting him as both victim (eunuch) and aggressor (patricide). Fried even goes on to link *The Gross Clinic* with *The Chess Players* in formal terms, noting that both canvases focus attention on the horizontal plane at the center of the men's work, and suggesting a similar treatment of Gross's and Benjamin's heads as well as a like placement of the father figure in each work, towering over the subordinate characters. Fried, *Realism*, 67–69. See also David M. Lubin, *Act of Portrayal: Eakins, Sargent, James* (New Haven, Conn.: Yale University Press, 1985), 27–82. It is interesting to note that the painting's "paternal" theme is overdetermined, for the work makes reference to at least two fathers. While Benjamin Eakins stands before the chess table, Thomas Eakins's mentor, Gérôme, is represented by a framed photogravure of his work *Hail Caesar! We Who Are About to Die Salute You* (1859; Yale University Art Gallery), which hangs over the parlor's fireplace. The framed picture has been identified by Kathleen A. Foster. Foster, *Thomas Eakins Rediscovered*, 32.

42. During the 1860s and 1870s, Thomas was frequently listed in business directories of Philadelphia as a "teacher" and "writing teacher." See *McElroy's Philadelphia Directory 1866*, 216; James Gospill, *Gospill's Philadelphia City Directory 1873*, 452; Goodrich, *Thomas Eakins*, 1:8–9, 79–81; letter from Henry F. Huttner to Benjamin Eakins, San Francisco, January 29, 1867. The letter reads, in part: "I remember well how strongly [Thomas] always was opposed to going abroad before having seen thoroughly his native country." In Charles Bregler's Thomas Eakins Collection at the Pennsylvania Academy of the Fine Arts; Theodor Siegl, *The Thomas Eakins Collection* (Philadelphia: Philadelphia Museum of Art, 1978), 21.

43. E. Anthony Rotundo, "American Fatherhood: A Historical Perspective," *American Behavioral Scientist* 29 (September/October 1985): 8–13; see also Robert L. Griswold, *Fatherhood in America: A History* (New York: Basic Books, 1993), 14–15. In the context of Rotundo's discussions of patriarchal and modern fatherhood, it is interesting to refer back to Eakins's self-depiction in *The Champion, Single Sculls*. With his visual connections to both Schmitt and the Quakers, Eakins, as I have argued, may be read as a sort of liminal figure, metaphorically bridging the gap between older and newer systems of work and success. But since it would not be difficult to take Schmitt and the Quakers to represent models of modern and patriarchal fatherhood, respectively, we may also understand Eakins as a figure trying to mediate the distinct constraints imposed by these two versions of patriarchy.

44. Pointing to Sophocles' play in which a young man fulfills a prophecy by murdering his father and marrying his mother, Freud claimed that the ancient Greek myth represented not merely an isolated story but rather a universal metaphor. Freud's clinical studies suggested that male children in the pre-Oedipal stage consciously desired to rid themselves of their fathers, so that they might sleep with their mothers. Mixed with the child's desire to eliminate his father is what Freud termed "ambivalence." The boy may simultaneously possess "great affection for his father" as well as hate, and have both these attitudes "remain compatible." Because young boys have not fully separated their self-identity from that of their mothers, even as they have come to understand the pleasures achieved with their genitals, Freud claimed that the masculinity of a young boy is complicated by his bisexual nature. At this sexually ambiguous juncture the boy is forced to decide whether to pursue his desire of sexually possessing his mother or, instead, find another outside love object, in order to avoid the fear that his father's anger will result in his castration.

At the onset of the complex (here Freud is unclear about the catalyst for the crisis, perhaps fear of castration or the alarm of a biological clock), these feelings become subconscious, at which time a boy will usually begin to assert his identity as separate from that of his mother. As Freud states, for the son the task of separation "consists in detaching his libidinal wishes from his mother and employ-

ing them for the choice of a real outside love-object, and in reconciling himself with his father if he has remained in opposition to him, or in freeing himself from his pressure if, as a reaction to his infantile rebelliousness, he has become sub-servient to him. . . . By neurotics, however, no solution at all is arrived at: the son remains all his life bowed beneath his father's authority and he is unable to trans-fer his libido to an outside sexual object." For Freud's discussion of the Oedipus complex, see *The Standard Edition of the Complete Psychological Works of Sigmund Freud,* 24 vols., translated by James Strachey (London: Hogarth Press, 1953–73), 7:226 n. 1; 9:213–14; 11:171; 14:517–37; 19:33, 178–79, 256; 21:223–43.

45. Although the width and length of a chessboard are identical, the correct setup of the board requires that a white square be placed at the lower right-hand corner of each player. The board's ninety-degree rotation would place a black square on the right-hand side of each opponent and would therefore not be con-sidered technically correct. The only evident outcome of such an arrangement, however, is to reverse the starting positions of the king and queen on the board. While the game I suggest would be an "abnormal" one, it could progress as any standard chess game, aside from the one difference noted.

46. *The Catalogue of the 48th Annual Exhibition of the Pennsylvania Academy of the Fine Arts, 1877* (Philadelphia: Pennsylvania Academy of the Fine Arts, 1877), 10, lists Eakins's painting of "chess players" as being owned by "Benj. Eakins."

47. Eakins's own exhibition record books, now in the collection of the Penn-sylvania Academy of the Fine Arts, list the work as *The Chess Players,* as does a letter of 1881 from the artist to the Metropolitan Museum of Art. In Natalie Spassky, *American Paintings in the Metropolitan Museum of Art,* vol. 2, *A Catalogue of Works by Artists Born between 1816 and 1845* (Princeton, N.J.: Princeton Univer-sity Press, 1985), 602.

48. From its first showing at the Centennial Exposition in Philadelphia in 1876 through its donation by Eakins to the Metropolitan Museum of Art in 1881, *The Chess Players* was consistently praised. In the last quarter of the century the *Nation* judged it "wholly admirable," while the *Art Amateur* declared that "noth-ing [Eakins] has done has been so unreservedly admired by artists." Earl Shinn, writing in 1880, went so far as to call the work Eakins's "masterpiece." See "National Academy of Design Exhibition," *Nation,* May 30, 1878, 364; "An Extra-ordinary Picture Collection," *Art Amateur* 5 (July 1881): 24; Stranhan [Shinn], "The Metropolitan Museum of Art," 116.

49. Rotundo, "American Fatherhood," 13–14; Griswold, *Fatherhood in Amer-ica,* 14–15.

50. Stephen M. Frank, "'Rendering Aid and Comfort': Images of Father-hood in the Letters of Civil War Soldiers from Massachusetts and Michigan," *Jour-nal of Social History* 26 (Winter 1992): 5–7.

51. Frank, "'Rendering Aid and Comfort,'" 12. Making even broader claims for the war's effect on masculinity, Reid Mitchell has suggested that "men may

very well have fought during the Civil War for reasons having less to do with ide-
ology than with masculine identity." Reid Mitchell, *Civil War Soldiers: Their Expec-
tations and Their Experiences* (New York: Simon and Schuster, 1989), 18 (quoted in
Frank); see also Reid Mitchell, "The Northern Soldier and His Community,"
in *Toward a Social History of the American Civil War: Exploratory Essays,* edited by
Maris A. Vinovskis (Cambridge: Cambridge University Press, 1990), 78–92.

52. "National Academy of Design Exhibition," 364.

53. While my discussion has been limited to only three of Eakins's canvases,
the basic argument can be successfully applied to many of the artist's works. Paint-
ings that are particularly well suited to my reading of doubles that complicate
the identities of sitters include *The Gross Clinic* (1875), *The Agnew Clinic* (1889),
Salutat (1898), and *The Artist and His Father Hunting Reed Birds in the Cohansey
Marshes* (ca. 1874).

54. The expression "the heroes of modern life" is taken from the title of Eliz-
abeth Johns's book on Eakins, *Thomas Eakins: The Heroism of Modern Life* (1983),
which in turn was adapted from Charles Baudelaire's essay "The Painter of Mod-
ern Life" (1863).

3. Alternative Communities

1. Eakins's fourteen paintings depicting nude or partially clothed figures are
The Gross Clinic (1875), *William Rush Carving His Allegorical Figure of the Schuylkill
River* (1877, 1908), *The Crucifixion* (1880), three *Arcadia* paintings (ca. 1883–85),
Swimming (1885), *The Agnew Clinic* (1889), *Salutat* (1898), *Taking the Count* (1898;
Yale University Art Gallery), *The Wrestlers* (1899; Philadelphia Museum of Art),
Between Rounds (1899; Philadelphia Museum of Art), and *William Rush and His
Model* (1908; Honolulu Art Museum). Of these canvases, only the *William Rush*
series, two *Arcadia* paintings, and *The Agnew Clinic* portray nude women. In addi-
tion to his paintings, Eakins also produced a series of "Arcadian" sculptures illus-
trating nude men. According to Phyllis Rosenzweig, Eakins sculpted several
friezes of *A Youth Playing the Pipes* (1883) and at least four of *Arcadia* (1883). Phyl-
lis Rosenzweig, *The Thomas Eakins Collection of the Hirshhorn Museum and Sculp-
ture Garden* (Washington, D.C.: Smithsonian Institution Press, 1977), 110–11. For
a discussion of Eakins's sculpture, see Moussa Domit, *The Sculpture of Thomas
Eakins* (Washington, D.C.: The Corcoran Gallery of Art, 1969). For the most
extensive discussion of Eakins's photographic nudes, see Susan Danly and Cheryl
Leibold, eds., *Eakins and the Photograph: Works by Thomas Eakins and His Circle in
the Collection of the Pennsylvania Academy of the Fine Arts* (Washington, D.C.: Smith-
sonian Institution Press, 1994). For a period reference to one of two known exhi-
bitions during the artist's lifetime in which his photographs were publicly exhib-
ited, see "Loan Exhibition (Dec. 20, 1899—Jan. 5, 1900)," *Camera Notes* 3, no. 4
(April 1900): 214–15.

2. In an article devoted to the development of the city of Philadelphia, the New York–based *Harper's* magazine spoke of Philadelphia in sober terms yet proclaimed that the art school at the Pennsylvania Academy of the Fine Arts was "unsurpassed in this country." "A Clever Town Built by Quakers," *Harper's New Monthly Magazine,* February 1882, 336. For a nineteenth-century discussion of Eakins's progressive methods of teaching art, see William C. Brownell, "The Art Schools of Philadelphia," *Scribner's Monthly Illustrated Magazine* 18 (September 1879): 737–50; see also Earl Shinn, "A Philadelphia Art School," *Art Amateur* 10 (January 1884): 33. For a twentieth-century description of Eakins's artistic training and teaching methods, see Elizabeth L. C. Milroy, "Thomas Eakins' Artistic Training, 1860–1870" (Ph.D. diss., University of Pennsylvania, 1986).

3. S. G. W. Benjamin, "Society of American Artists: Third Exhibition," *American Art Review* (Boston) 1, no. 1 (1880): 261. See also S. G. W. Benjamin, *Art in America: A Critical and Historical Sketch* (New York: Harper and Brothers, 1880), 210; "Society of American Artists, New York," *American Architect and Building News,* May 20, 1882, 231; "Pennsylvania Academy Exhibition," *Art Amateur* 8 (December 1882): 8; "Art at the Academy: Second Annual Exhibition of the Philadelphia Society of Artists, Sixth Notice," *Philadelphia Press,* November 20, 1880, 5; *Harper's New Monthly Magazine,* March 1879, 495.

4. For more on the complicated resonances of the nude in Victorian art, see Alison Smith, *The Victorian Nude: Sexuality, Morality and Art* (Manchester and New York: Manchester University Press, 1996).

5. "The American Artists Supplementary Exhibition," *Art Amateur* 7 (June 1882): 2. Another reviewer noted that Eakins pictured Christ's death as "an event which actually occurred under certain understood circumstances." William Clark, [Philadelphia] *Evening Telegraph,* November 1, 1882.

6. M. G. Van Rensselaer, "Society of American Artists, New York," *American Architect and Building News,* May 20, 1882, 231.

7. For recent discussions of *Swimming* that take for granted the scene's nostalgic qualities, see Whitney Davis, "Erotic Revision in Thomas Eakins's Narratives of Male Nudity," *Art History* 17 (September 1994): 313–14; Randall C. Griffin, "Thomas Eakins's Construction of the Male Body, or 'Men Get to Know Each Other across the Space of Time,'" *Oxford Art Journal* 18, no. 2 (1995): 70–71. For a discussion of *Swimming* as both modern and classical, see Kathleen A. Foster, *Thomas Eakins Rediscovered: Charles Bregler's Thomas Eakins Collection at the Pennsylvania Academy of the Fine Arts* (New Haven, Conn.: Yale University Press, 1997), 178. For art historical sources informing Eakins's arcadian works, see Marc Simpson, "Thomas Eakins and His Arcadian Works," *Smithsonian Studies in American Art* 1, no. 2 (Fall 1987): 71–95.

8. The painting was first exhibited as *Swimming* (no. 88) at the Pennsylvania Academy of the Fine Arts annual exhibition in 1885. At the Louisville Industrial

Exhibition in 1886 it was titled *The Swimmers* (no. 70). And in 1887, at the Inter-State Industrial Exposition of Chicago, the painting was shown as *Swimming*. In 1917, at Eakins's New York Memorial Exhibition, it was labeled *The Swimming Hole* (no. 42), and at the Ferrargil Galleries in 1921 it was called *The Old Swimming Hole* (no. 4). From the curatorial files of the Amon Carter Museum, Fort Worth, and of the Philadelphia Museum of Art.

9. *The Complete Poetical Works of James Whitcomb Riley* (Bloomington and Indianapolis: Indiana University Press, 1993), 246.

10. "At the Private View: First Impressions of the Autumn Exhibition at the Academy of the Fine Arts," *Philadelphia Times,* October 29, 1885, 2; "Academy Exhibition. Second Notice," *The Press,* October 31[?] 1885. Photocopies in the curatorial file of *Swimming* at the Amon Carter Museum, Fort Worth.

11. Doreen Bolger, "'Kindly Relations': Edward Hornor Coates and *Swimming,*" in *Thomas Eakins and the Swimming Picture,* edited by Doreen Bolger and Sarah Cash (Fort Worth, Tex.: Amon Carter Museum, 1996), 36.

12. Letter from Edward H. Coates to Thomas Eakins, dated November 27, 1885, Pennsylvania Academy of the Fine Arts.

13. *Fifty-sixth Annual Exhibition Catalogue of the Pennsylvania Academy of the Fine Arts* (Philadelphia: Pennsylvania Academy of the Fine Arts, 1885), 13.

14. Sarah Cash identifies the various swimmers and the mill foundation in "'Friendly and Unfriendly': The Swimmers of Dove Lake," in *Thomas Eakins and the Swimming Picture,* edited by Doreen Bolger and Sarah Cash (Fort Worth, Tex.: Amon Carter Museum, 1996), 52–60. Elizabeth Johns identifies the body of water in "An Avowal of Artistic Community: Nudity and Fantasy in Thomas Eakins's Photographs," in *Eakins and the Photograph: Works by Thomas Eakins and His Circle in the Collection of the Pennsylvania Academy of the Fine Arts,* edited by Susan Danly and Cheryl Leibold (Washington, D.C.: Smithsonian Institution Press, 1994), 86, 93 nn. 48, 49. Whitney Davis places the scene near Bryn Mawr on "Trout Run" or "Mill Creek." Davis, "Erotic Revision," 311–13.

15. Davis, "Erotic Revision," 311.

16. Cash, "'Friendly and Unfriendly,'" 50.

17. Ibid., 36.

18. "Homosocial" here refers not only to the fact that the canvas depicts an all-male group, but also, of course, to Eve Kosofsky Sedgwick's particular reading of the homosocial as a means by which men construct identity and consolidate power through the exclusion of women and, by extension, more marginal male groups. Eve Kosofsky Sedgwick, *Between Men: English Literature and Male Homosocial Desire* (New York: Columbia University Press, 1985).

19. "Art: The Awards of Prizes at the Academy," *The American* [Philadelphia], November 7, 1885. Photocopy from *Swimming*'s curatorial file at the Amon Carter Museum, Fort Worth.

20. Martin A. Berger, "Painting Victorian Manhood," in Helen Cooper, *Thomas Eakins: The Rowing Pictures* (New Haven, Conn.: Yale University Art Gallery, 1996), 98–129.

21. Sedgwick, *Between Men*, 2.

22. While not dismissing the potential existence of an erotic subtext in *Swimming*, I contend that the majority of Eakins's male contemporaries would not have understood the canvas's narrative in sexual terms. Without attempting to refute Whitney Davis's intriguing argument that the final canvas offers a safe revision of the painter's homosexual fantasies, I do not believe that audiences in 1885—at a time when modern theories of sexuality were being codified—possessed the ability to comprehend the canvas in homosexual terms. Moreover, to acknowledge the nude male body as potential site for homosexual desire should not allow one to lose sight of the ways in which such bodies must also be implicated in the construction of heterosexual masculine identity. See Davis, "Erotic Revision," 301–41. See also Michael Hatt, "The Male Body in Another Frame: Thomas Eakins's *The Swimming Hole* as a Homoerotic Image," *Journal of the Philosophy of the Visual Arts: The Body* (London: The Academy Group, 1993), 8–21.

23. For the lone example, see the artist's *William Rush and His Model* (1908; Honolulu Academy of Arts). One might fairly argue that the depiction of genitals would not have been a socially acceptable practice for Eakins to engage in, so that the lack of such figures tells us more about period social constraints than about Eakins's conceptions of gender. I would argue, however, that it would have been very easy for Eakins to depict women in full frontal nudity if he had been willing to illustrate his women without pubic hair, in the idealized fashion of French academic circles. Such a depiction would have reinforced the point of gender as a biological construction to an even greater extent than would have been possible with an anatomically correct rendering, such as *William Rush and His Model,* for by eliminating pubic hair such a work would only have reinforced the model's lack of a phallus.

24. Eakins never referred to these paintings as *Arcadia;* the title was apparently given to the works after the artist's death either by his widow or by Lloyd Goodrich. Goodrich, *Thomas Eakins,* vol. 2 (Cambridge, Mass.: Harvard University Press, 1982), 236.

25. Johns, "An Avowal of Artistic Community," 77.

26. Other early paintings by Homer that proffer a similar message include *The Country School* (1871; The Saint Louis Art Museum), as well as *The Croquet Players* (1865; Albright-Knox Art Gallery, Buffalo), *A Game of Croquet* (1866; Yale University Art Gallery), *Croquet Scene* (1866; The Art Institute of Chicago), and *Artists Sketching in the White Mountains* (1868; Portland Museum of Art).

27. For more on the women's forward cant, referred to during the period as the "Grecian Bend," see David Kunzle, *Fashion and Fetishism: A Social History of*

the Corset, Tight-Lacing and Other Forms of Body-Sculpture in the West (Totowa, N.J.: Rowman and Littlefield, 1982), 142.

28. In an argument that parallels my own, Elizabeth Johns notes how Eakins fashioned a bohemian community through the creation of nude study photographs, and by extension through the culture of nudity that the painter fostered. Johns, "An Avowal of Artistic Community," 65–93. Johns makes a similar point in her discussion of *Swimming,* suggesting that the canvas may represent Eakins's ideal of a Platonic academy. Johns, "*Swimming:* Thomas Eakins, the Twenty-ninth Bather," in *Thomas Eakins and the Swimming Picture,* edited by Doreen Bolger and Sarah Cash (Fort Worth, Tex.: Amon Carter Museum, 1996), 68.

29. See Fantin-Latour's *An Atelier in the Batignolles* (1870; Musée d'Orsay, Paris).

30. In referring to the arrangement of classes under Eakins's tenure at the Academy, Fairman Rogers spoke of the art school as a "club of artists." Fairman Rogers, "The Schools of the Pennsylvania Academy," *Pennsylvania Monthly* 12 (June 1881): 453.

31. Mark Carnes, *Secret Ritual and Manhood in Victorian America* (New Haven, Conn.: Yale University Press, 1989); see the chapter " 'A Sort of Masonry': Secrecy and 'Manliness' in Early Victorian Brotherhoods," in James Eli Adams, *Dandies and Desert Saints: Styles of Victorian Manhood* (Ithaca, N.Y.: Cornell University Press, 1995), 61–106.

32. Earl Shinn, "A Philadelphia Art School," *Art Amateur* 10 (January 1884): 33; Charles Bregler, "Thomas Eakins as a Teacher," *The Arts* 17 (March 1931): 381.

33. For the standard discussion of Eakins's forced resignation, see Goodrich, *Thomas Eakins,* 1:281–95.

34. Kathleen A. Foster and Cheryl Leibold, *Writing about Eakins: The Manuscripts in Charles Bregler's Thomas Eakins Collection* (Philadelphia: University of Pennsylvania Press, 1989), 69–79; for additional information on the agitators who sought Eakins's dismissal from the Academy, see William I. Homer, *Thomas Eakins: His Art and Life* (New York: Abbeville Press, 1992), 173–76.

35. Foster and Leibold, *Writing about Eakins,* 131.

36. Dr. Wood was, in fact, one of the owners of the ranch. Goodrich, *Thomas Eakins,* 2:16.

37. For Beard's first published reference to the disease, see George M. Beard, "Neurasthenia or Nervous Exhaustion," *Boston Medical and Surgical Journal* 3 (April 29, 1869).

38. George M. Beard, *American Nervousness: Its Causes and Consequences* (New York: G. P. Putnam's Sons, 1881), 96; see also page 99 for additional causes; for a general overview, see Barbara Sicherman, "The Uses of a Diagnosis: Doctors, Patients, and Neurasthenia," *Journal of the History of Medicine and Allied Sciences* 32, no. 1 (January 1977): 35.

39. As Kevin Mumford has pointed out, Beard's theory points to an interesting paradox in Victorian culture, namely, that the rise of civilization, seen, of course, as a sign of advancement, would be harmful to civilized man. Kevin J. Mumford, " 'Lost Manhood' Found: Male Sexual Impotence and Victorian Culture in the United States," in *American Sexual Politics: Sex, Gender, and Race since the Civil War,* edited by John C. Fout and Maura Shaw Tantillo (Chicago: University of Chicago Press, 1993), 89.

40. George M. Beard, *A Practical Treatise on Nervous Exhaustion (Neurasthenia): Its Symptoms, Nature, Sequences, Treatment* (New York: William Wood and Company, 1880), 4, 134.

41. Beard, *Practical Treatise,* 107.

42. The gendered associations of the disease are readily apparent from the period's medical tracts. S. Weir Mitchell noted that the illness's defining feature "lies in overexcitability. . . . The strong man becomes like the average woman, the woman like the unschooled child." "Clinical Lecture on Nervousness in the Male," *Medical News and Library* 35, no. 420 (December 1877): 178–79, 182–83; see also S Weir Mitchell, *Wear and Tear, or Hints for the Overworked* (Philadelphia: J. B. Lippincott and Company, 1871); for a detailed discussion of the symbolic meanings of the rest cure for women, see Ellen L. Bassuk, "The Rest Cure: Repetition or Resolution of Victorian Women's Conflicts?" in *The Female Body in Western Culture: Contemporary Perspectives,* edited by Susan Rubin Suleiman (Cambridge, Mass.: Harvard University Press, 1986), 139–51; for the most famous nineteenth-century critique of enforced rest cures, see Charlotte Perkins Gilman, *The Yellow Wallpaper,* edited by Thomas L. Erskine and Connie L. Richards (New Brunswick, N.J.: Rutgers University Press, 1993 [1892]).

43. Horatio C. Wood, *Brain-Work and Overwork* (Philadelphia: Presley Blakiston, 1880), 90.

44. For neurasthenia as a cultural reaction, see T. J. Jackson Lears, *No Place of Grace: Antimodernism and the Transformation of American Culture, 1880–1920* (Chicago: University of Chicago Press, 1994), 47–58. Much like the nineteenth-century doctors who were reluctant to ascribe a single physiological cause to the disease, the twentieth-century cultural historian Tom Lutz is similarly unwilling to posit a single cultural meaning of neurasthenia. Just as the disease had no one cure, it had no precise symptoms because, according to Lutz, it represented a series of diverse reactions to cultural change. In Lutz's words, "Neurasthenia is less an ideological formation . . . than a multiaccented story, a story necessarily read differently from different social positions. Rather than being the source of a nearly universal cooptation, the heteroglossia of neurasthenia discourse (that is, its polysemic, overdetermined nature) accommodated both processes of cooptation and processes of contention, as well as processes that were not clearly defined as either." Tom Lutz, *American Nervousness, 1903* (Ithaca, N.Y.: Cornell University Press, 1991), 15; see also 22–26.

45. Wood saw his "camp cure" as being appropriate only for men who possessed "a certain amount of natural aptitude, and of robustness." For Eakins to have accepted this manly cure, he already had to have possessed physically masculine attributes. Wood's cure did not turn physical weaklings into men; it allowed those who were otherwise manly to recoup their lost mental vigor. Wood, *Brain-Work*, 106.

46. While Eakins had begun this series of portraits prior to his dismissal, they did not become his dominant genre until after his return from the Dakota Territory.

47. Goodrich calculates that Eakins painted about 145 "medium sized head and bust portraits . . . without hands or accompanying objects, against empty backgrounds." Goodrich, *Thomas Eakins*, 2:215.

48. Kate Kernan Rubin, "Thomas Eakins, *The Veteran*," *Yale University Art Gallery Bulletin* 39, no. 1 (Winter 1984): 21. See also Nicolai Cikovsky Jr.'s entry on *The Art Student* in *American Paintings from the Manoogian Collection*, exhib. cat. (Washington, D.C.: National Gallery of Art, 1989), 126–30; David M. Lubin, "Modern Psychological Selfhood in the Art of Thomas Eakins," in *Inventing the Psychological: Toward a Cultural History of Emotional Life in America*, edited by Joel Pfister and Nancy Schnog (New Haven, Conn.: Yale University Press, 1997), 133–66.

49. The sixteen portraits depict the following individuals: Frank Macdowell (ca. 1886), brother-in-law and student at the Pennsylvania Academy of the Fine Arts (PAFA) in 1881 (twice); Lillian Hammitt (ca. 1888), student at the PAFA from 1883 to 1886 and at the Art Students' League (ASL); George Reynolds (1885), student at the PAFA and at the ASL, where he was the organization's first curator; Arthur B. Frost (1886), student at the PAFA from 1878 to 1881; Walt Whitman (ca. 1887), friend and poet; James M. Wright (ca. 1890), student at the PAFA; Ella Crowell (ca. 1880), niece who was taught art informally; Blanch Hurlburt (1885–86), student at the PAFA; Franklin L. Schenck (ca. 1890), student at the ASL and its second curator (twice); Mrs. William Shaw Ward (1884), wife of sitter; Douglas Hall (ca. 1888), student at the PAFA and at the ASL; Edward Boulton (ca. 1888), student; Samuel Murray (1889), longtime friend and student at the ASL; Francis J. Ziegler (ca. 1890), student at the ASL.

50. Goodrich, *Thomas Eakins*, 2:215.

51. The annual exhibition of 1891 was, in fact, the first Academy show to which Eakins submitted paintings after his forced resignation in 1886. During the rest of the 1890s, the artist was once more a frequent contributor to the Academy's annual exhibitions.

52. The exhibition catalog of the fifty-sixth annual show at the Pennsylvania Academy in 1885 states that canvas number 90, titled *Portrait*, was owned by George Reynolds. The fact that the canvas pictured Reynolds is confirmed by a period review of the 1885 annual exhibition in the "The Fine Arts," *Evening Tele-*

graph, October 31, 1885, 4. For the portrait's title in France at the Universal Exposition of 1889, see *Exposition Universelle Internationale de 1889 à Paris, Catalogue Général Officiel,* Tome Premier, Groupe I. Oeuvres D'Art Classes 1 à 5 (Paris: Lille, 1889), 177.

53. It is not coincidental that Eakins turned increasingly to portraiture as his masculine position underwent further erosion, for portraiture was more highly regarded in the artistic hierarchy than genre painting and was historically the most lucrative category for American painters. It is somewhat ironic, then, that Eakins's continued lack of financial success came despite the fact that he expended most of his artistic energies producing canvases that were the traditional economic staple of American painters.

54. Although *Between Rounds* is dated 1899, Goodrich claims that it was actually begun before *Salutat.* Goodrich, *Thomas Eakins,* 2:149. For the most comprehensive discussion of Eakins's boxing canvases in their social context, see Marjorie Alison Walter, "Fine Art and the Sweet Science: On Thomas Eakins, His Boxing Paintings, and Turn-of-the-Century Philadelphia" (Ph.D. diss., University of California at Berkeley, 1995).

55. All of these figures are identified by Susan Eakins in a letter dated January 23, 1934, to the curator of the Addison Gallery of American Art. See the Addison's curatorial file on *Salutat.* Goodrich claims that the picture also contains a likeness of Charles Bregler, but I have been unable to identify him. Goodrich, *Thomas Eakins,* 2:151.

56. Mitschka, "Pennsylvania Academy of Fine Arts Exhibition as Seen and Heard," *Art Collector* 9 (February 1899): 102.

57. In Eakins's final boxing canvas, *Between Rounds* (1899), Cranmer is once again pictured as a central figure who helps construct the boxers' identities. Stationed at ringside in the canvas's lower left-hand corner, Cranmer keeps time for the bout's rounds. In this painting, time is no longer an unseen natural force that allows for human development and progression; it appears as a man-made product firmly under Cranmer's control. For a brief mention of Eakins's relationship with Cranmer by a friend of the latter, see Roland McKinney, *Thomas Eakins* (New York: Crown Publishers, 1942), 18.

58. Goodrich, *Thomas Eakins,* 2:147.

59. While I do not develop alternative viewing positions for gay male (or, for that matter, lesbian) viewers, it would be reductive to assume that *Salutat* permits only heterosexual viewing positions.

60. For more on the history and reception of *The Corbett-Fitzsimmons Fight,* see Charles Musser, *History of the American Cinema,* vol. 1, *The Emergence of Cinema: The American Screen to 1907* (New York: Charles Scribner's Sons, 1990), 194–200.

61. For reference to Smith's working-class roots, see Goodrich, *Thomas Eakins,* 2:277.

62. Billy Edwards, *The Portrait Gallery of Pugilists of America* (Philadelphia: Pugilistic Publishing Company, 1894), n.p.; emphasis in original.

63. John Boyle O'Reilly, *Ethics of Boxing and Manly Sport* (Boston: Ticknor and Company, 1888), xvi; Theodore Roosevelt, *The Strenuous Life: Essays and Addresses* (New York: The Century Company, 1900), 156.

64. Gordon Hendricks, *The Life and Works of Thomas Eakins* (New York: Grossman Publishers, 1974), 239.

65. Michael Hatt, "Muscles, Morals, Mind: The Male Body in Thomas Eakins' *Salutat*," in *The Body Imaged: The Human Form and Visual Culture since the Renaissance,* edited by Kathleen Adler and Marcia Pointon (Cambridge: Cambridge University Press, 1993), 60; see also 57–62.

66. Sarah Burns, *Inventing the Modern Artist: Art and Culture in Gilded Age America* (New Haven, Conn.: Yale University Press, 1996), 199–204.

67. Lloyd Goodrich, *Thomas Eakins: His Life and Work* (New York: Whitney Museum of American Art, 1933), 189; Carl S. Smith, "The Boxing Paintings of Thomas Eakins," *Prospects* 4 (1979): 414 n. 1.

68. Joseph Jackson, *Encyclopedia of Philadelphia* (Harrisburg, Pa.: National Historical Association, 1931), 2:535–36; quoted in Smith, "Boxing Paintings," 414.

69. As Marjorie Walter notes, Eakins also exhibited his boxing canvases in sports clubs. *Between Rounds* was displayed at the New York Athletic Club, while *Taking the Count* hung for a time at the Schuylkill Navy Athletic Club. Walter, "Fine Art and the Sweet Science," 229. Because period audiences were likely to have perceived athletic organizations as appropriate venues for these paintings, I am more interested in the works' potential impact in institutions dedicated to high art.

70. The argument that I have constructed for *Salutat* applies equally well to Eakins's other boxing paintings: *Between Rounds* (1899; Philadelphia Museum of Art), *Taking the Count* (1898; Yale University Art Gallery), as well as to *The Agnew Clinic* (1889; University of Pennsylvania School of Medicine).

71. Alan Trachtenberg, *The Incorporation of America: Culture and Society in the Gilded Age* (New York: Hill and Wang, 1982), 80–81.

72. That the work's message may have caused discomfort to Gilded Age men is suggested both by the painting's lackluster reviews and by the fact that it was not purchased until 1929, more than two decades after it was created. Goodrich, *Thomas Eakins,* 2:280.

Bibliography

Rather than listing in the bibliography all the articles and books cited in the notes, I have endeavored instead to list the most frequently mentioned and useful of those sources. For the most comprehensive bibliography of articles published on Eakins during his lifetime, see Elizabeth Milroy and Douglass Paschall, *Guide to the Thomas Eakins Research Collection with a Lifetime Exhibition Record and Bibliography* (Philadelphia: Philadelphia Museum of Art, 1996). For a review of recent scholarship, see the bibliographies included in Bolger and Cash, *Thomas Eakins and the Swimming Picture;* Foster, *Thomas Eakins Rediscovered;* Homer, *Thomas Eakins: His Art and Life;* Johns, *Thomas Eakins: The Heroism of Modern Life;* and Wilmerding, *Thomas Eakins (1844–1916) and the Heart of American Life.*

Ackerman, Gerald M. *The Life and Work of Jean-Léon Gérôme.* New York: Sotheby's Publications, Harper and Row, 1986.

Beard, George M. *American Nervousness: Its Causes and Consequences.* New York: G. P. Putnam's Sons, 1881.

———. "Neurasthenia or Nervous Exhaustion." *Boston Medical and Surgical Journal* 3 (April 29, 1869): 217.

———. *A Practical Treatise on Nervous Exhaustion (Neurasthenia): Its Symptoms, Nature, Sequences, Treatment.* New York: William Wood and Company, 1880.

Bederman, Gail. *Manliness and Civilization: A Cultural History of Gender and Race in the United States, 1880–1917.* Chicago: University of Chicago Press, 1995.

Benjamin, S. G. W. *Art in America: A Critical and Historical Sketch.* New York: Harper and Brothers, 1880.

Berger, Martin A. "Negotiating Victorian Manhood: Thomas Eakins and the Rowing Works." *Masculinities* 2, no. 3 (Fall 1994): 1–17.

———. "Sentimental Realism in Thomas Eakins's Late Portraits." In *Sentimental Men: Masculinity and the Politics of Affect in American Culture,* edited by Mary Chapman and Glenn Hendler, 244–58. Berkeley and Los Angeles: University of California Press, 1999.

Blackie, John Stuart. *On Self-Culture: Intellectual, Physical, and Moral.* New York: Scribner, Armstrong, and Company, 1874.

Bledstein, Burton J. *The Culture of Professionalism: The Middle Class and the Development of Higher Education in America* New York: W. W. Norton, 1978.

Blum, Joanne. *Transcending Gender: The Male/Female Double in Women's Fiction.* Ann Arbor, Mich.: UMI Research Press, 1988.

Blumin, Stuart M. *The Emergence of the Middle Class: Social Experience in the American City, 1760–1900.* Cambridge and New York: Cambridge University Press, 1989.

Bolger, Doreen, and Sarah Cash, eds. *Thomas Eakins and the Swimming Picture.* Fort Worth, Tex.: Amon Carter Museum, 1996.

Braddock, Alan C. "Eakins, Race, and Ethnographic Ambivalence." *Winterthur Portfolio* 33 (Summer/Autumn 1998): 135–61.

Bregler, Charles. "Thomas Eakins as a Teacher." *Arts* 17 (March 1931): 378–86.

———. "Thomas Eakins as a Teacher, Second Article." *Arts* 18 (October 1931): 28–42.

Brod, Harry, ed. *The Making of Masculinities: The New Men's Studies.* Boston: Allen and Unwin, 1987.

Brownell, William C. "The Art Schools of Philadelphia." *Scribner's Monthly Illustrated Magazine* 18 (September 1879): 737–50.

Burns, Sarah. *Inventing the Modern Artist: Art and Culture in Gilded Age America.* New Haven, Conn.: Yale University Press, 1996.

Butsch, Richard, ed. *For Fun and Profit: The Transformation of Leisure into Consumption.* Philadelphia: Temple University Press, 1990.

Cannon, Kelly. *Henry James and Masculinity: The Man at the Margins.* New York: St. Martin's Press, 1994.

Carelton, John William. *Walker's Manly Exercises.* Philadelphia: John W. Moore, 1856.

Carnes, Mark. *Secret Ritual and Manhood in Victorian America.* New Haven, Conn.: Yale University Press, 1989.

Carnes, Mark C., and Clyde Griffen, eds. *Meanings for Manhood: Constructions of Masculinity in Victorian America.* Chicago: University of Chicago Press, 1990.

Chodorow, Nancy. *The Reproduction of Mothering: Psychoanalysis and the Sociology of Gender.* Berkeley and Los Angeles: University of California Press, 1978.

Cooper, Helen. *Thomas Eakins: The Rowing Pictures.* New Haven, Conn.: Yale University Art Gallery, 1996.

Cornwall, Andrea, and Nancy Lindisfarne, eds. *Dislocating Masculinities: Comparative Ethnographies.* New York: Routledge, 1994.

Danly, Susan, and Cheryl Leibold, eds. *Eakins and the Photograph: Works by Thomas Eakins and His Circle in the Collection of the Pennsylvania Academy of the Fine Arts.* Washington, D.C.: Smithsonian Institution Press, 1994.

Davis, Whitney. "Erotic Revision in Thomas Eakins's Narratives of Male Nudity." *Art History* 17 (September 1994): 301–41.

D'Emilio, John, and Estelle B. Freedman. *Intimate Matters: A History of Sexuality in America.* New York: Harper and Row, 1988.

Doezema, Marianne. *George Bellows and Urban America.* New Haven, Conn.: Yale University Press, 1992.

Domit, Moussa. *The Sculpture of Thomas Eakins* Washington, D.C.: The Corcoran Gallery of Art, 1969.

Dyer, Richard. *White.* New York: Routledge, 1997.

Edmonds, Franklin Spencer. *History of the Central High School of Philadelphia.* Philadelphia: J. B. Lippincott Company, 1902.

Edwards, Billy. *The Portrait Gallery of Pugilists of America.* Philadelphia: Pugilistic Publishing Company, 1894.

Fink, Lois Marie. *American Art at the Nineteenth-Century Paris Salons.* Washington, D.C.: National Museum of American Art, 1990.

Foner, Eric. *Reconstruction: America's Unfinished Revolution, 1863–1877.* New York: Harper and Row, 1988.

Foster, Kathleen A. *Thomas Eakins Rediscovered: Charles Bregler's Thomas Eakins Collection at the Pennsylvania Academy of the Fine Arts.* New Haven, Conn.: Yale University Press, 1997.

Foster, Kathleen A., and Cheryl Leibold. *Writing about Eakins: The Manuscripts in Charles Bregler's Thomas Eakins Collection.* Philadelphia: University of Pennsylvania Press, 1989.

Foucault, Michel. *The Archaeology of Knowledge and the Discourse on Language.* New York: Pantheon Books, 1972.

Frank, Stephen M. "'Rendering Aid and Comfort': Images of Fatherhood in the Letters of Civil War Soldiers from Massachusetts and Michigan." *Journal of Social History* 26 (Winter 1992): 5–31.

Frankenberg, Ruth. *White Women, Race Matters: The Social Construction of Whiteness.* Minneapolis: University of Minnesota Press, 1993.

Fredrickson, George M. *The Inner Civil War: Northern Intellectuals and the Crisis of the Union.* New York: Harper and Row, 1968.

Freud, Sigmund. *The Standard Edition of the Complete Psychological Works of Sigmund Freud.* 24 vols. Translated by James Strachey. London: Hogarth Press, 1953–73.

Fried, Michael. *Realism, Writing, Disfiguration: On Thomas Eakins and Stephen Crane.* Chicago: University of Chicago Press, 1987.

Gedo, Mary Mathews, ed. *Psychoanalytic Perspectives on Art.* Hillsdale, N.J.: Analytic Press, 1987.

Giddens, Anthony. *Profiles and Critiques in Social Theory.* Berkeley and Los Angeles: University of California Press, 1982.

Gilbert, Sandra M., and Susan Gubar. *The Madwoman in the Attic*. New Haven, Conn.: Yale University Press, 1979.

Gilmore, David. *Manhood in the Making: Cultural Concepts of Masculinity*. New Haven, Conn.: Yale University Press, 1990.

Goodrich, Lloyd. *Thomas Eakins*. 2 vols. Cambridge, Mass.: Harvard University Press, 1982.

———. *Thomas Eakins: His Life and Work*. New York: Whitney Museum of American Art, 1933.

Griffin, Randall C. "Thomas Eakins's Construction of the Male Body, or 'Men Get to Know Each Other across the Space of Time.'" *Oxford Art Journal* 18, no. 2 (1995): 70–80.

Griswold, Robert L. *Fatherhood in America: A History*. New York: Basic Books, 1993.

Grover, Kathryn, ed. *Fitness in American Culture: Images of Health, Sport, and the Body, 1830–1940*. Amherst: University of Massachusetts Press, 1989.

Hamerton, Philip Gilbert. *The Intellectual Life*. Boston: Roberts Brothers, 1873.

Hartmann, Sadakichi. *A History of American Art*. 2 vols. Boston: L. C. Page and Company, 1902.

———. "Thomas Eakins." *Art News* 1 (April 1897): 4.

Hatt, Michael. "The Male Body in Another Frame: Thomas Eakins's *The Swimming Hole* as a Homoerotic Image." In *Journal of the Philosophy of the Visual Arts: The Body*, 8–21. London: The Academy Group, 1993.

———. "Muscles, Morals, Mind: The Male Body in Thomas Eakins' *Salutat*." In *The Body Imaged: The Human Form and Visual Culture since the Renaissance*, edited by Kathleen Adler and Marcia Pointon, 57–69. Cambridge: Cambridge University Press, 1993.

Hendricks, Gordon. *The Life and Work of Thomas Eakins*. New York: Grossman Publishers, 1974.

Homer, William I. *Thomas Eakins: His Art and Life*. New York: Abbeville Press, 1992.

Hoopes, Donelson F. *Eakins Watercolors*. New York: Watson-Guptill, 1971.

James, Henry. *The Portrait of a Lady*. New York: Penguin Books, 1984 [1881].

Johns, Elizabeth. *Thomas Eakins: The Heroism of Modern Life*. Princeton, N.J.: Princeton University Press, 1983.

Johnson, Robert B. *A History of Rowing in America*. Milwaukee, Wis.: Corbitt and Johnson, 1871.

Kasson, John F. *Civilizing the Machine: Technology and Republican Values in America, 1776–1900*. New York: Grossman Publishers, 1976.

Kestner, Joseph A. *Masculinities in Victorian Painting*. Aldershot, Hants: Scholar Press, 1995.

Kett, Joseph F. *Rites of Passage: Adolescence in America, 1790 to the Present*. New York: Basic Books, 1977.

Kimmel, Michael S. *Manhood in America: A Cultural History*. New York: Free Press, 1996.

Labaree, David F. *The Making of an American High School: The Credentials Market and the Central High School of Philadelphia, 1838–1939*. New Haven, Conn.: Yale University Press, 1989.

Lears, T. J. Jackson. *No Place of Grace: Antimodernism and the Transformation of American Culture, 1880–1920*. Chicago: University of Chicago Press, 1994.

Lifton, Norma. "Thomas Eakins and S. Weir Mitchell: Images and Cures in the Late Nineteenth Century." In *Psychoanalytic Perspectives on Art,* edited by Mary Mathews Gedo, 247–74. Hillsdale, N.J.: Analytic Press, 1987.

Lott, Eric. *Love and Theft: Blackface Minstrelsy and the American Working Class*. New York: Oxford University Press, 1993.

Lubin, David M. *Act of Portrayal: Eakins, Sargent, James*. New Haven, Conn.: Yale University Press, 1985.

———. "Modern Psychological Selfhood in the Art of Thomas Eakins." In *Inventing the Psychological: Toward a Cultural History of Emotional Life in America,* edited by Joel Pfister and Nancy Schnog, 133–66. New Haven, Conn.: Yale University Press, 1997.

Lutz, Tom. *American Nervousness, 1903*. Ithaca, N.Y.: Cornell University Press, 1991.

McHenry, Margaret. *Thomas Eakins Who Painted*. Oreland, Pa.: Privately printed, 1946.

McKinney, Roland. *Thomas Eakins*. New York: Crown Publishers, 1942.

Mendenhall, Thomas C. *A Short History of American Rowing*. Boston: Charles River Books, 1980.

Milroy, Elizabeth. "'Consummatum est . . .': A Reassessment of Thomas Eakins's Crucifixion of 1880." *Art Bulletin* 71 (June 1989): 270–84.

———. "Thomas Eakins' Artistic Training, 1860–1870." Ph.D. diss., University of Pennsylvania, 1986.

Mitchell, Reid. *Civil War Soldiers: Their Expectations and Their Experiences*. New York: Simon and Schuster, 1989.

———. "The Northern Soldier and His Community." In *Toward a Social History of the American Civil War: Exploratory Essays,* edited by Maris A. Vinovskis, 78–92. Cambridge: Cambridge University Press, 1990.

Mitchell, S. Weir. "Clinical Lecture on Nervousness in the Male." *Medical News and Library* 35, no. 420 (December 1877): 177–84.

———. *Wear and Tear, or Hints for the Overworked*. Philadelphia: J. B. Lippincott and Company, 1871.

Mrozek, Donald J. *Sport and American Mentality*. Knoxville: University of Tennessee Press, 1983.

Mumford, Lewis. *The Brown Decades: A Study of the Arts in America, 1865–1895*. New York: Dover, 1971 [1931].

Musser, Charles. *History of the America Cinema*. Vol. 1, *The Emergence of Cinema: The American Screen to 1907*. New York: Charles Scribner's Sons, 1990.

[National Gallery of Art]. *American Paintings from the Manoogian Collection*. Exhibition catalog. Washington, D.C.: National Gallery of Art, 1989.

O'Reilly, John Boyle. *Ethics of Boxing and Manly Sport*. Boston: Ticknor and Company, 1888.

Parker, Rozsika, and Griselda Pollock. *Old Mistresses: Woman, Art, and Ideology*. London: Pandora Press, 1989.

[Pennsylvania Academy of the Fine Arts]. *Memorial Exhibition of the Works of the Late Thomas Eakins*. Philadelphia: Pennsylvania Academy of the Fine Arts, 1917.

Pointon, Marcia. *Naked Authority: The Body in Western Painting, 1830–1908*. Cambridge: Cambridge University Press, 1990.

Porter, Fairfield. *Thomas Eakins*. New York: George Braziller, 1959.

Prown, Jules D. "Thomas Eakins' *Baby at Play*." *Studies in the History of Art* 18 (1985): 121–27.

Rabinbach, Anson. *The Human Motor: Energy, Fatigue, and the Origins of Modernity*. Berkeley and Los Angeles: University of California Press, 1992.

Roediger, David. *Toward an Abolition of Whiteness: Essays on Race, Politics, and Working Class History*. London: Verso, 1994.

Rogers, Daniel T. *The Work Ethic in Industrial America, 1850–1920*. Chicago: University of Chicago Press, 1979.

Roosevelt, Theodore. *The Strenuous Life: Essays and Addresses*. New York: The Century Company, 1900.

Rotundo, E. Anthony. *American Manhood: Transformations in Masculinity from the Revolution to the Modern Era*. New York: Basic Books, 1993.

———. "Body and Soul: Changing Ideals of American Middle-Class Manhood, 1770–1920." *Journal of Social History* 16, no. 4 (Summer 1983): 23–38.

Rubin, Kate Kernan. "Thomas Eakins, *The Veteran*." *Yale University Art Gallery Bulletin* 39, no. 1 (Winter 1984): 20–24.

Ryan, Mary P. *Womanhood in America: From Colonial Times to the Present*. New York: New Viewpoints, 1975.

Savage, Kirk. *Standing Soldiers, Kneeling Slaves: Race, War, and Monument in Nineteenth-Century America*. Princeton, N.J.: Princeton University Press, 1997.

Schor, Naomi. *Reading in Detail: Aesthetics and the Feminine*. New York: Methuen, 1987.

Sedgwick, Eve Kosofsky. *Between Men: English Literature and Male Homosocial Desire*. New York: Columbia University Press, 1985.

Sellin, David. *The First Pose, 1876: Turning Point in American Art*. New York: W. W. Norton, 1976.

Seltzer, Mark. *Bodies and Machines*. New York and London: Routledge, 1992.

Shi, David E. *Facing Facts: Realism in American Thought and Culture, 1850–1920*. New York: Oxford University Press, 1995.

Simpson, Marc. "Thomas Eakins and His Arcadian Works." *Smithsonian Studies in American Art* 1 (Fall 1987): 71–95.

Smith, Carl S. "The Boxing Paintings of Thomas Eakins." *Prospects* 4 (1979): 403–19.

Smith-Rosenberg, Carroll. *Disorderly Conduct: Visions of Gender in Victorian America*. New York: Alfred A. Knopf, 1985.

Spassky, Natalie. *American Paintings in the Metropolitan Museum of Art*. Vol. 2, *A Catalogue of Works by Artists Born between 1816 and 1845*. Princeton, N.J.: Princeton University Press, 1985.

Suleiman, Susan Rubin, ed. *The Female Body in Western Culture: Contemporary Perspectives*. Cambridge, Mass.: Harvard University Press, 1986.

Taylor, Frank H. *Philadelphia in the Civil War, 1861–1865*. Philadelphia: City of Philadelphia, 1913.

Trachtenberg, Alan. *The Incorporation of America: Culture and Society in the Gilded Age*. New York: Hill and Wang, 1982.

Walter, Marjorie Alison. "Fine Art and the Sweet Science: On Thomas Eakins, His Boxing Paintings, and Turn-of-the-Century Philadelphia." Ph.D. diss., University of California at Berkeley, 1995.

Werbel, Amy B. "Perspective in the Life and Art of Thomas Eakins." Ph.D. diss., Yale University, 1996.

Williams, Raymond. *Problems in Materialism and Culture*. London: Verso, 1980.

Wilmerding, John, ed. *Thomas Eakins (1844–1916) and the Heart of American Life*. Washington, D.C.: Smithsonian Institution Press, 1994.

Wolf, Bryan J. *The Invention of Seeing*. New Haven, Conn.: Yale University Press, forthcoming.

Index

Note: Page numbers in italic refer to illustrations.

Eakins, Thomas (*continued*)
paintings of); patrons of, 44, 90, 92, 110,
112; photography, 86, 90, 98; portraits
of students and friends, 86, 109–10, 112,
147nn.46–47, 147n.49, 148n.53;
preparatory drawings by, 16, *18,* 30; as
professionally successful, 85, 93, 99; as
professionally unsuccessful, 11, 12, 41,
43–44, 106; realism of, 30, 40–41, 120;
relationship with his father, 76–78; and
rowers, 44; and rowing (*see* rowing,
paintings of); scientific mind-set of, 16,
67–68, 120; sculptures by, 86, 141n.1;
self-sufficiency desired by, 11–12; sports
interests of, 7; tall, thin physiques of fig-
ures used by, 98; as a teacher of writing,
77, 139n.42; time represented by, 70–71;
watercolor of John Biglin, 129n.28;
white patriarchal control in works
of, 30.
WORKS : *The Agnew Clinic,* 141n.1,
141n.53, 149n.70; *Arcadia* paintings,
97–98, *100–101,* 141n.1, 144n.24;
Arcadia sculptures, 141n.1; *The Artist
and His Father Hunting Reed Birds in
the Cohansey Marshes,* 27, *28,* 29, 30,
141n.53; *The Biglin Brothers Racing,* 3,
22, 23, 26, 133n.51; *The Concert Singer,*
93, *94; Courtship,* 54; *The Dancing Les-
son,* 30, *31,* 32, 131n.39; *Drawing the
Seine,* 131n.39; *The Gross Clinic,* 8, *9;
Home Scene,* 54, *56,* 57–58, 136n.13; *In
Grandmother's Time,* 54; *John Biglin in a
Single Scull,* 43–44, *45,* 133n.52; *Male
Nude Reclining on a Draped Sofa,* 98, *102;
Margaret in Skating Costume,* 126n.2; *A
May Morning in the Park,* 67, *69; Mrs.
William D. Frishmuth,* 60, *63; A Negress,*
131n.39; *The Pathetic Song,* 90, *91; Per-
spective Drawing for "The Pair-Oared
Shell,"* 16, *18; Portrait of an Artist,* 110;
Portrait of a Student, 110; *Portrait of*

Henry O. Tanner, 131n.39; *Portrait of
Mary Arthur,* 54, *55; Pushing for Rail,*
131n.39; *Rail Shooting,* 29–30, 39,
131n.39, Plate 3; *The Red Shawl,*
131n.39; *Between Rounds,* 117, 137n.31,
141n.1, 148n.54, 148n.57, 149nn.69–70;
Seventy Years Ago, 137n.31; *Shad Fishing
at Gloucester on the Delaware River,*
131n.39; *Starting Out after Rail,* 128n.18;
Taking the Count, 141n.1, 149n.69; *The
Veteran,* 109, 110, *111,* 147n.52; *Whistling
for Plover,* 131n.39; *William Rush and
His Model,* 141n.1, 144n.23; *The Writing
Master,* 78, *81; A Youth Playing the Pipes,*
141n.1. See also *The Biglin Brothers Turn-
ing the Stake-Boat; The Champion, Single
Sculls; The Chess Players; The Crucifixion;
The Gross Clinic; Professor Benjamin
Howard Rand; Salutat; Swimming;
William Rush Carving His Allegorical
Figure of the Schuylkill River*
economic depression of 1873, 10
education, 38, 39, 57
Edwards, Billy, 116
Emancipation Group (Ball), 35, *36*
Emmett, Dan, 32
The End of the Game (Irving), 72

Fairmount Park (Philadelphia), 17
Fantin-Latour, Henri, 99
fatherhood, patriarchal vs. modern, 77, 80,
82, 139n.43
father-son relationships, 80, 82, 83
female-male doubles. *See* male-female
doubles
femininity: and art, 41, 67; and biological
determinism, 65, 97; and consumption,
44; of craft traditions, 52, 54; cultural
markers of, 41, 54, 57, 58; of detail, 41,
132n.50; of fine art, 41, 67; props associ-
ated with, 64–65; of realism, 40–41;
reproduction of, 49, 52, 57; as socially

Compositor:	Impressions Book and Journal Services, Inc.
Text and display:	Bembo
Printer and binder:	Edwards Brothers, Inc.